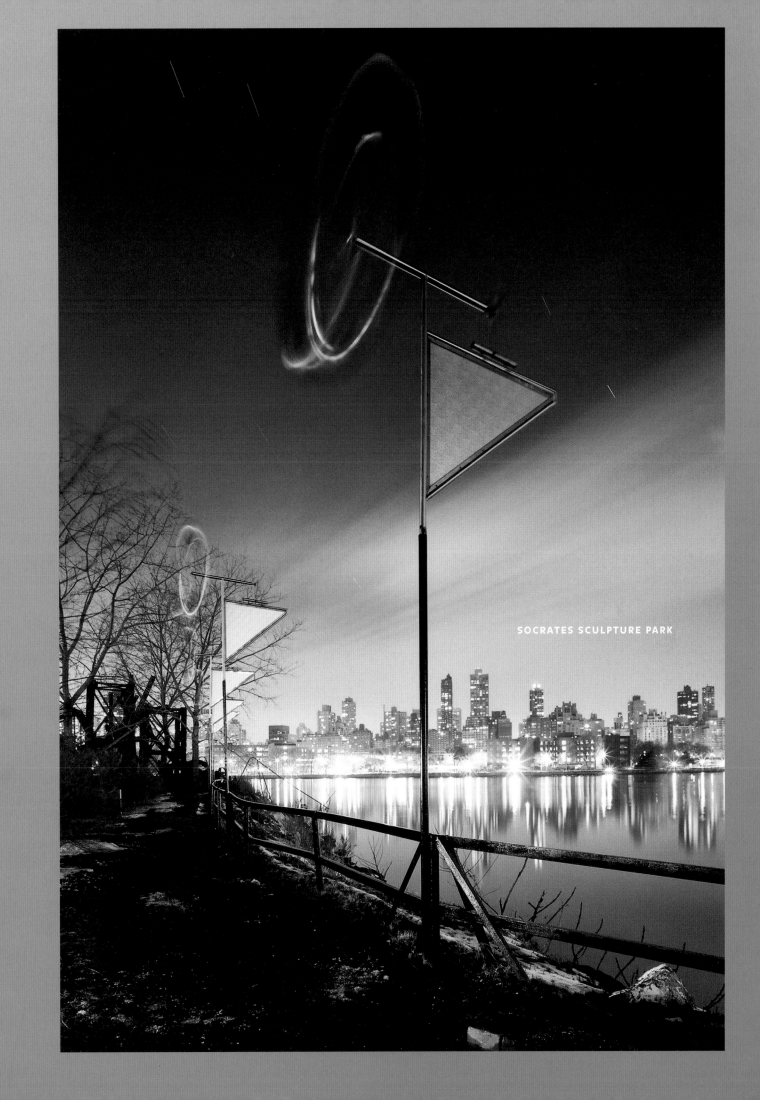

SOCRATES SCULPTURE PARK

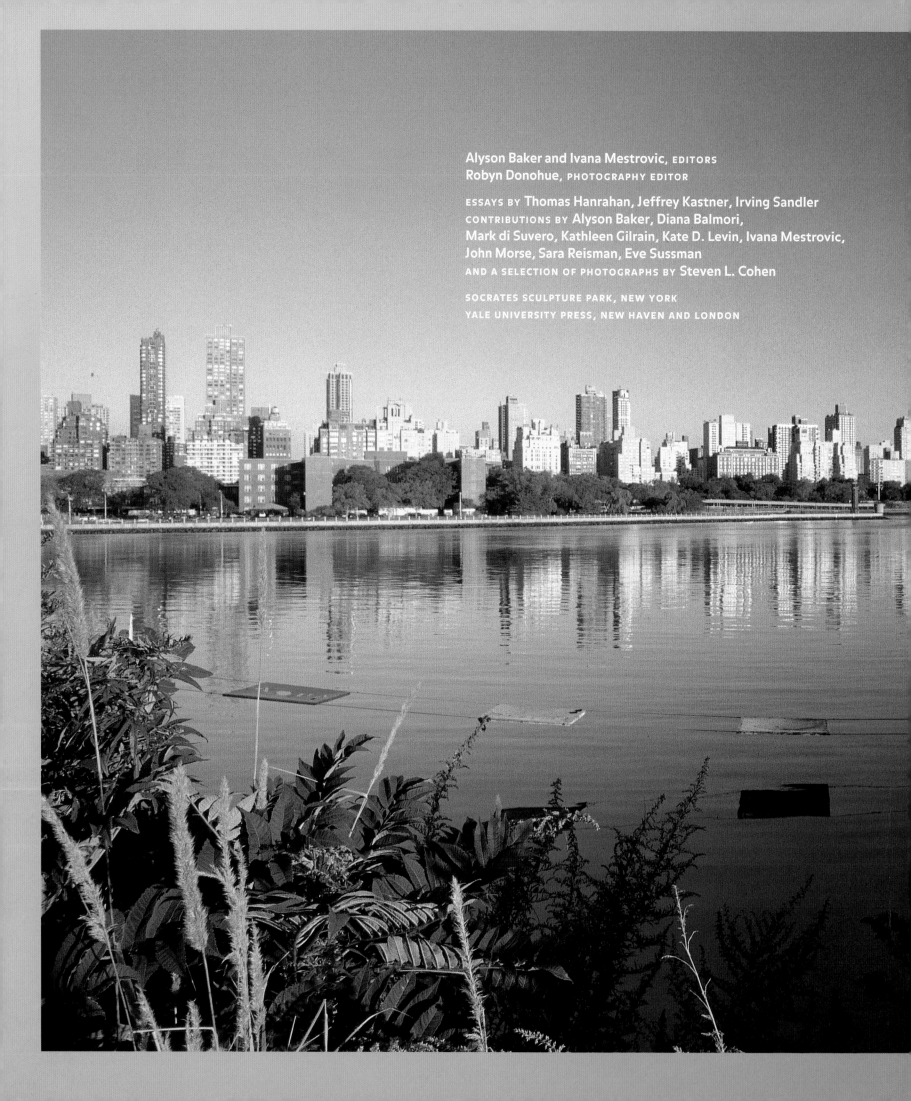

Alyson Baker and Ivana Mestrovic, EDITORS
Robyn Donohue, PHOTOGRAPHY EDITOR

ESSAYS BY Thomas Hanrahan, Jeffrey Kastner, Irving Sandler
CONTRIBUTIONS BY Alyson Baker, Diana Balmori,
Mark di Suvero, Kathleen Gilrain, Kate D. Levin, Ivana Mestrovic,
John Morse, Sara Reisman, Eve Sussman
AND A SELECTION OF PHOTOGRAPHS BY Steven L. Cohen

SOCRATES SCULPTURE PARK, NEW YORK
YALE UNIVERSITY PRESS, NEW HAVEN AND LONDON

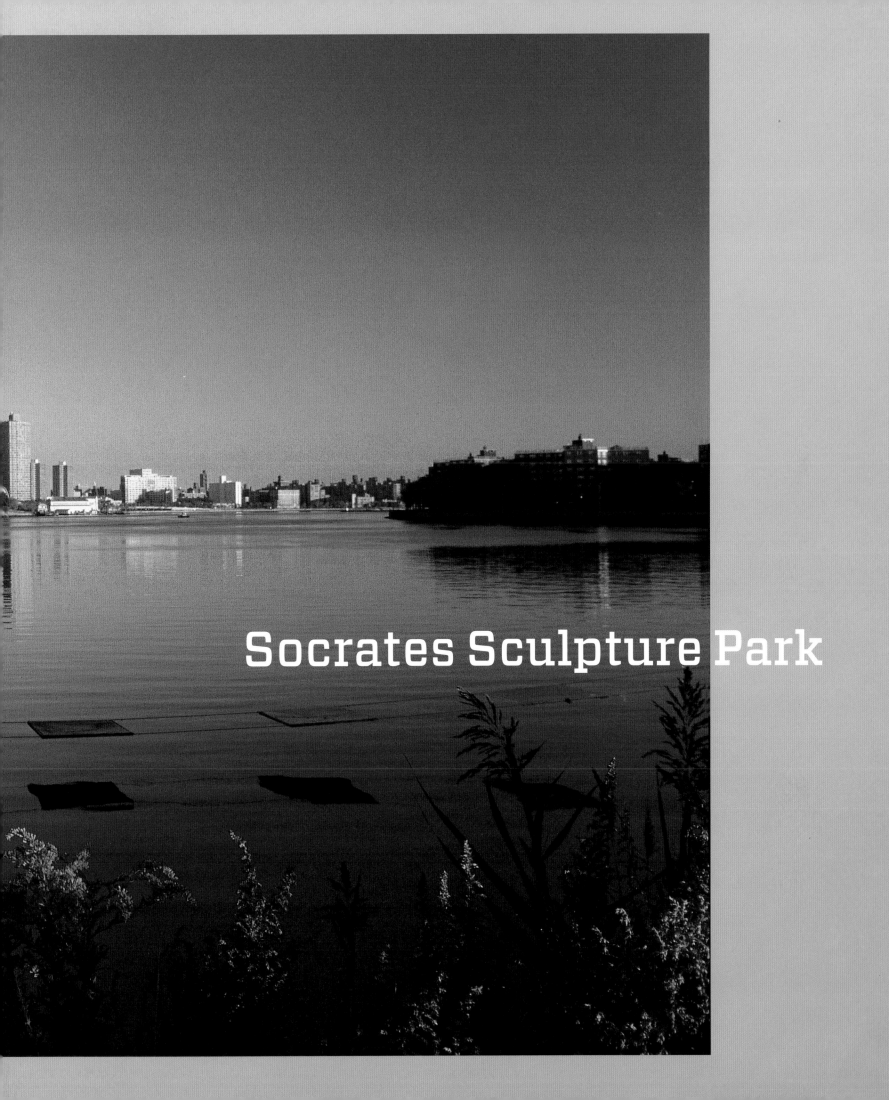

Socrates Sculpture Park

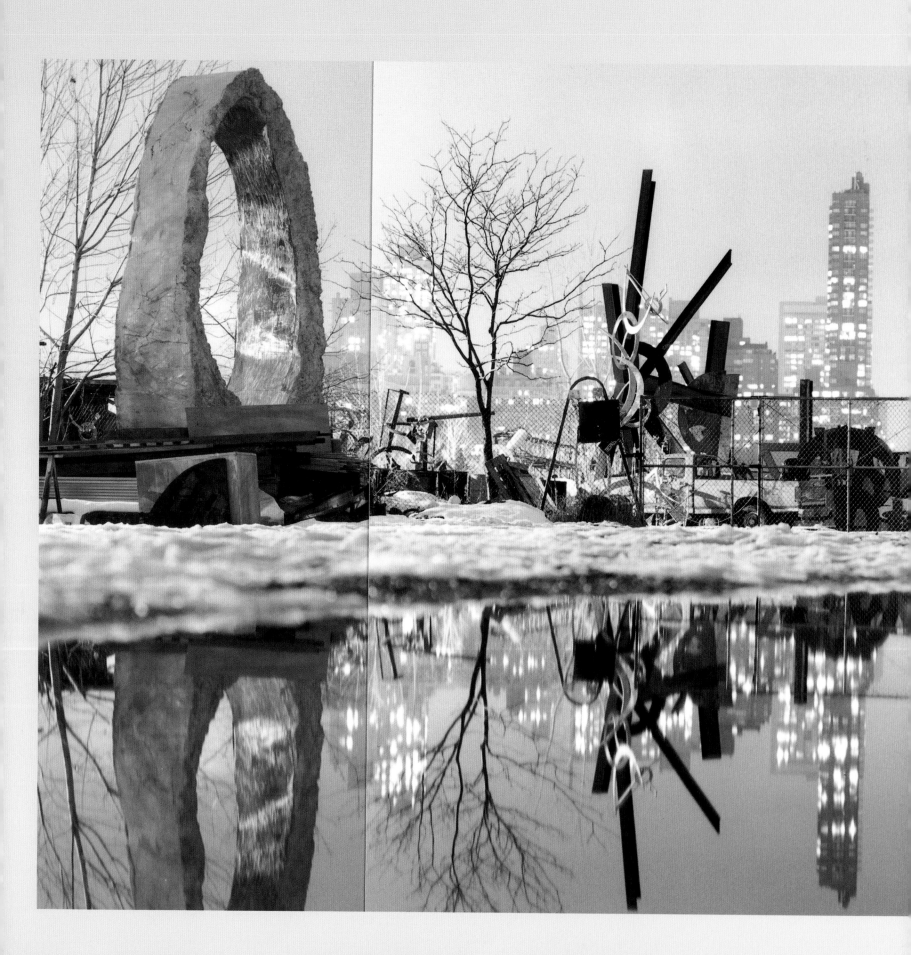

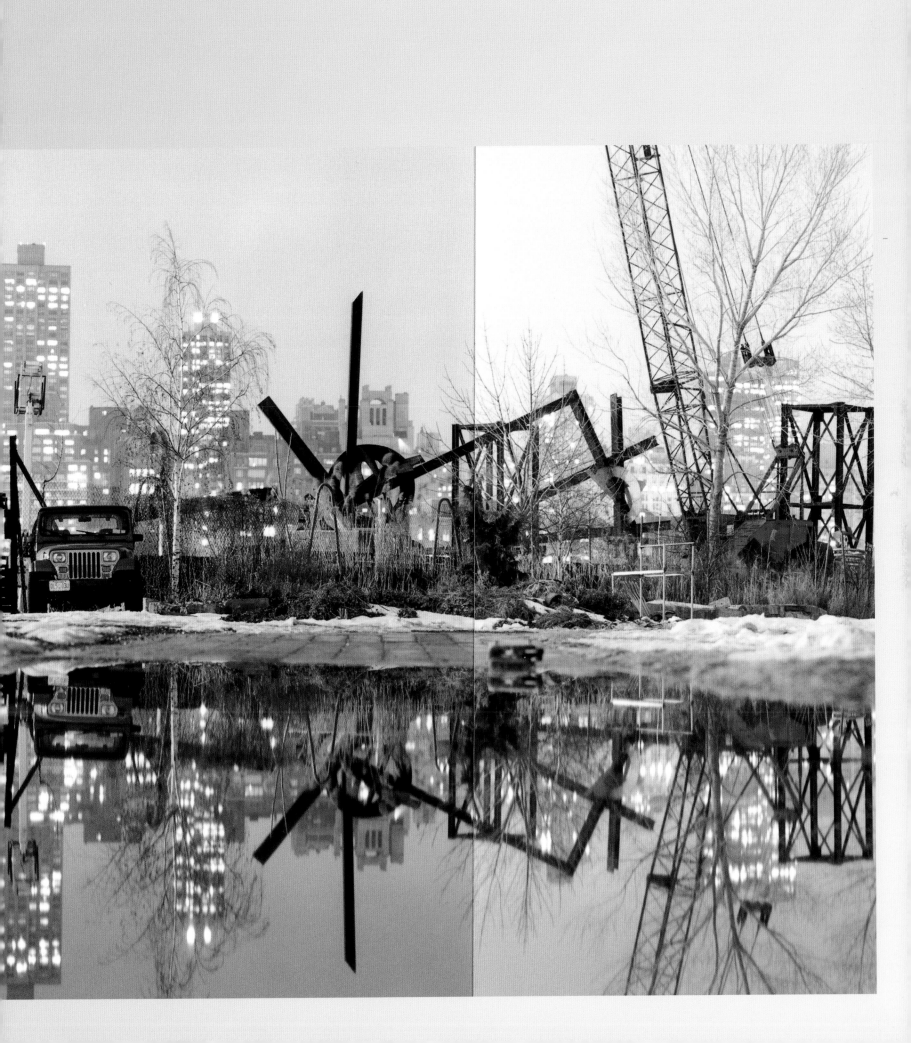

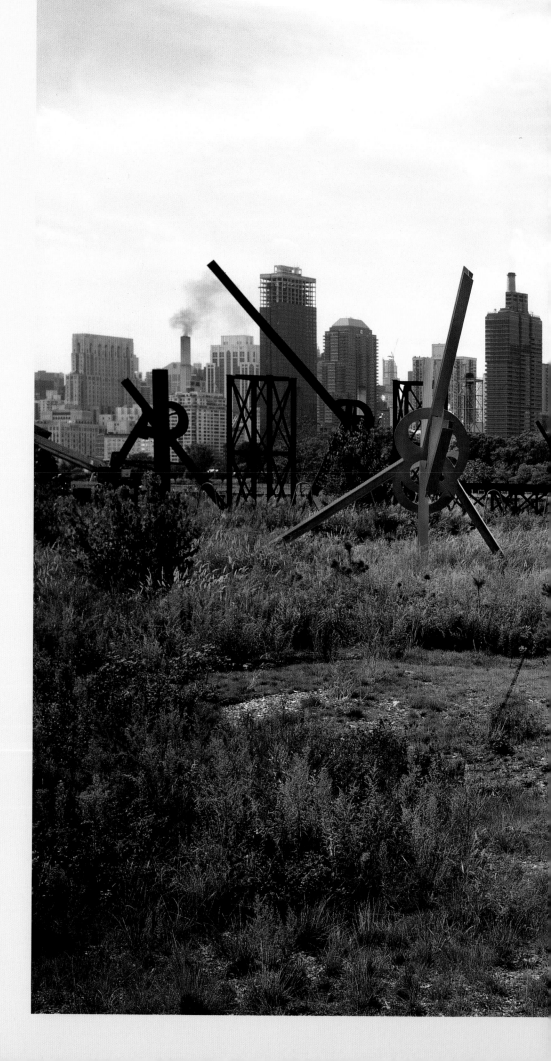

"During the past twenty years, the City of New York has supported the transformation of Socrates Sculpture Park from an industrial landfill and illegal dumping area into a community waterfront park and world-renowned sculpture gallery. We are pleased to partner with Socrates Sculpture Park to create and take the necessary steps to preserve this space. Public art and waterfront parks are among our highest priorities and these goals are successfully combined on the banks of the East River at Socrates Sculpture Park."

ADRIAN BENEPE,
Commissioner of the City of New York
Department of Parks & Recreation

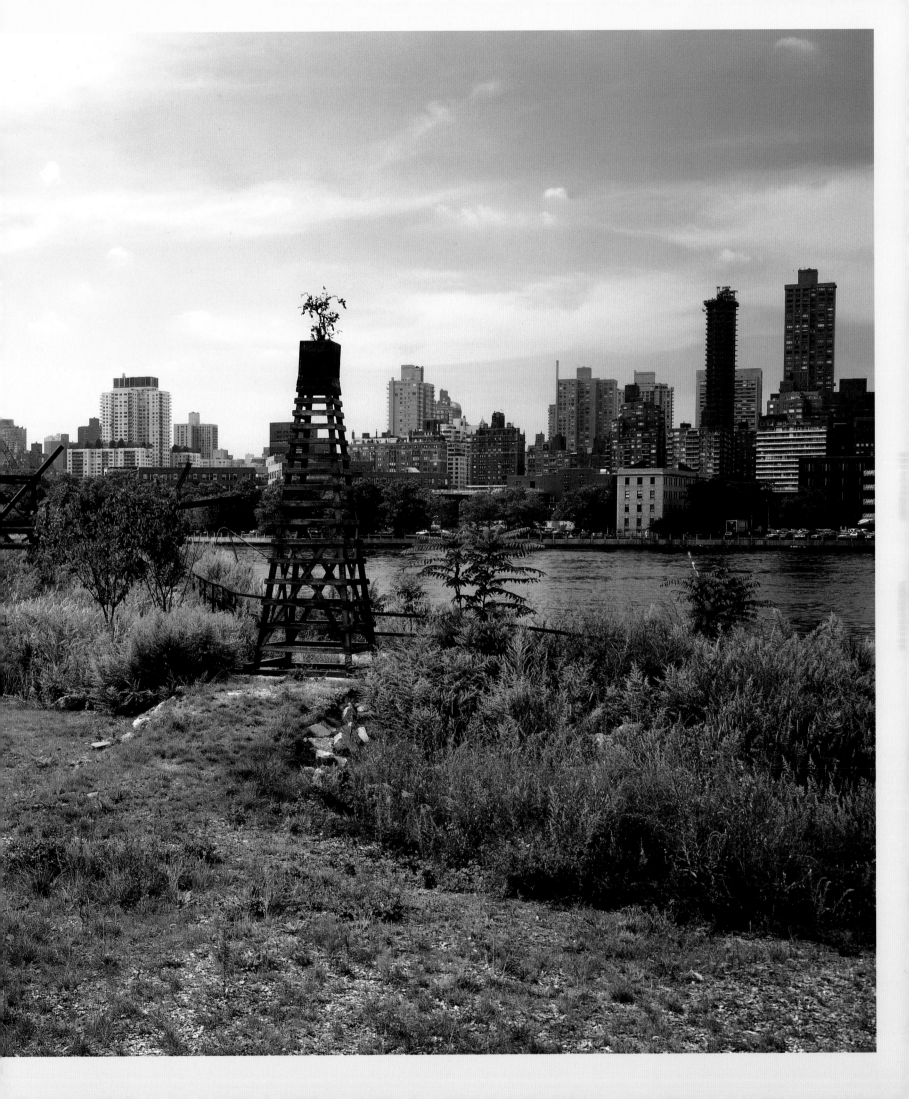

This book was published in September 2006 on the occasion of the 20th anniversary of Socrates Sculpture Park.

Funding for the publication has been provided by the Charles River Fund.

A portion of the proceeds from the sale of this book benefits Socrates Sculpture Park and its programs.

Preceding pages:
Front cover: Beth Galston, *Tree/ House*, 1994
Page 1: Bill and Mary Buchen, *Wind Gamelan*, 1991
Pages 2–3: Suzy Surek, *Aqua Lumina*, 1996 (DETAIL)
Pages 4–5: Adam Cvijanovic, *New City*, 2003 (DETAIL)
Pages 6–7: Outdoor studio, 2000
Pages 8–9: (LEFT) Mark di Suvero, *Erk Thru Able Last*, 1987 (RIGHT) Jody Pinto, *Watchtower for Hallets Cove*, 1987

See page 240 for photography credits.

All texts © 2006 by the authors

The views expressed in "'Round Art" by Kate D. Levin are not necessarily those of the City of New York.

Cover design: Barbara Glauber and Emily Lessard/ Heavy Meta

ISBN-13 978-0-300-12098-1
ISBN-10 0-300-12098-2

Library of Congress Control Number: 2006929057

socrates sculpture park
city of new york parks & recreation
© 2006 Socrates Sculpture Park
P.O. Box 6259, 32–01 Vernon Boulevard
Long Island City, NY 11106
www.socratessculpturepark.org

Distributed by Yale University Press
P.O. Box 209040, 302 Temple Street
New Haven, CT 06520-9040
www.yalebooks.com

The paper in this book meets the guidelines for permanence and durability of the Committee on Production Guidelines for Book Longevity of the Council on Library Resources.
10 9 8 7 6 5 4 3 2 1

Printed and bound in Italy

CONTENTS

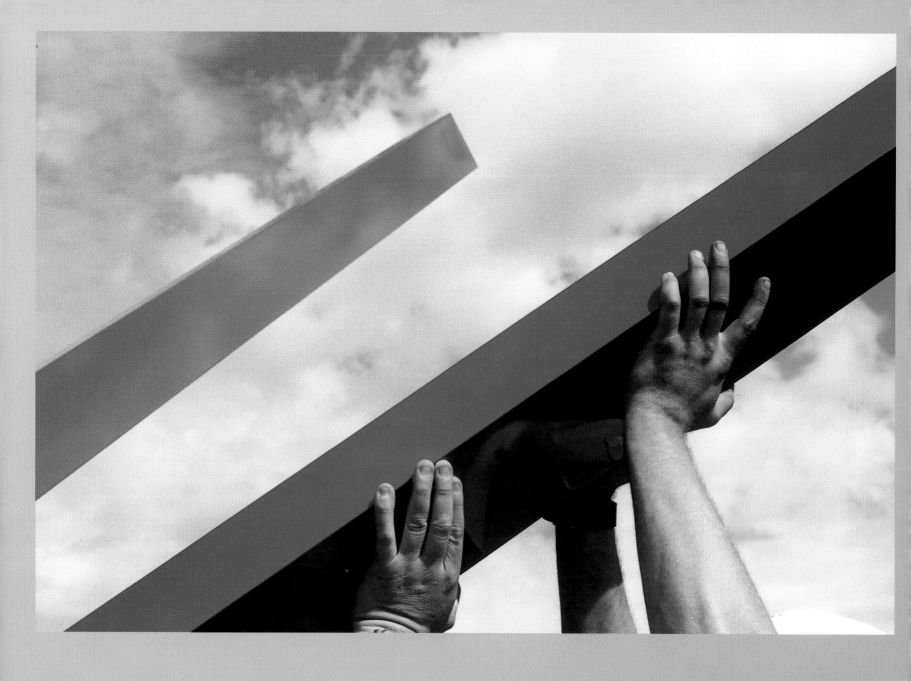

Inner-vision

The "inner-vision"
is the most important dimension
of original artistic or scientific thinking.
To imagine what was not there
and how to achieve it, not dream but
work toward it, cause it to be—isn't this
the root/route of any artistic or scientific
achievement?

If you can't dream it, you can't do it.

To bring the green of nature, the
vision of the flow of waters to a
concrete ruined dump is a worthwhile
struggle for those who would rebuild
their cities, rejuvenate and regenerate
their communities. The green of nature
is so necessary to human health—the joy
of growth in springtime, or summer's
maturity—that parks become a physical
necessity in a city like New York.

From the swimmer-diver view:
imagine being a springboard,
and being a springboard, feel the
swimmer bouncing on it, the joy
of the springboard giving to the perfect
swimmer the high arch, the perfect
dive. There is joy in fountains, water's
power in a running river and to have
been part of so much living sculpture is
improbable and gives hugely to the
spirit/energetics. That the improbable
becomes real can be immensely joyous.

To see these artists bridge that
gap between the imagined and the
realized: see it from a young artist's
point-of-view—a chance! Maybe the

biggest piece you've ever built, to
be among one's peers, to have
that dream made real; this is Socrates
Sculpture Park.

All art feeds the spirit, some more,
some less. Let's try: let's become
trees grown to our full-shape outer-
leaves' reach, and ask the tourist
Inuit which tree is the most beautiful,
the chestnut or the pine?

To have a chance to be "shown"
to the artworld and then…And finding
one's self working together (is
this competition?) and the palpable
friendship among artists becomes
a source of energy, of artists respecting
and helping each other. This
was beyond competition, with others
helping, equipment and the team
from Spacetime ready to do the
multi-task: welding, cherry-picker,
organizing, materials, etc.

We had the joy of springboards
inside of trees, felt the subsequent
growth of the Socrates artists'
successes that came through; as shows,
medals, commissions, professorships,
foundations, GLAD of them! Being
part of a team making art public, the
visit is free. We have given as we
could: Isamu Noguchi in the beginning;
Dick Bellamy with connections and
constant support; Enrico Martignoni
with passion, skill, and overtime;
Martin Friedman with essential guid-
ance; Ivana Mestrovic with organizing
and poetry; and the workers from
the neighboring housing projects; the

volunteers more than can be named
here; the donors; the brilliant board of
trustees; and myself sometimes
contributing more than just my name.

To have become a city park was such
a long climb that only a few know all of
it. But because it was so improbable, yet it
had happened, it has become a source
of spirit/energy for the exhibiting artists
and they made many beautiful works.
You doubt it? Ask them.

And you could have asked them,
you could have been one of those
that walked through the Park and seen
them/us working on the sculptures.
Visibly, artists working art. Right in front
of you. And the gamelan bells calling
Peace, Harmony. What we have done,
others can do in other cities, countries,
bringing together the cultural unity
of this century, the creative energy of the
community and region, and a dedication
(NO! a passion) for a renewal of desolate
industrial zones, through an inner-
vision-made-real in art.

In a place where the inner-vision,
the dream, and the realization come
together there is a feeling of wonder.
Those who have made the art have
the happy enrichment of wonder at their
works. The public, freely wandering
through a park that is neither gallery nor
museum and seeing the art, are given
the "what is it?" of wonder.

Socrates said, "Wisdom begins
with wonder."

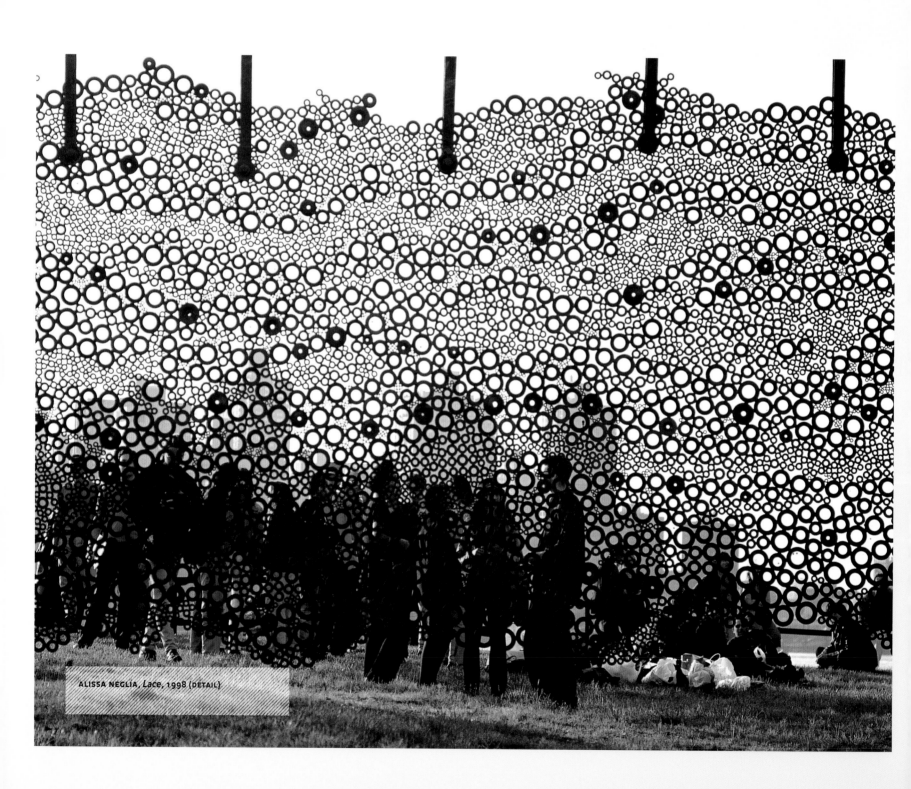

ALISSA NEGLIA, *Lace*, 1998 (DETAIL)

Introduction

Twenty years ago, Mark di Suvero looked at a rubble-strewn waterfront lot in Long Island City and had a unique vision that few could have anticipated but many came to adopt. In a derelict but beautiful site, he saw an opportunity to create a place where art could make a lasting contribution to the urban landscape. Among the refuse, he gleaned the potential to transform a neighborhood suffering from postindustrial blight into a thriving epicenter of culture shared by artists and community members alike.

For an endeavor such as this to take wing, and to be strong and unwavering after two decades, it had to be a galvanizing and enduring vision. The participation and collaboration of thousands of dedicated people have allowed this vision not simply to survive but to thrive. We are proud and honored to be able to acknowledge many of them in the following pages.

Socrates Sculpture Park now operates in concert with the New York City Department of Parks and Recreation to manage, program, maintain, and improve this site, which currently attracts more than sixty-five thousand visitors annually. Since 1986, the Park has been an outdoor studio to over five hundred artists, an exhibition venue presenting more than fifty exhibitions of large-scale sculpture, and a vital park attracting an international audience to a small parcel of Long Island City's East River waterfront.

With this book, we hope to convey the Park's spirit of creativity and collaboration, to present both its physical and psychological environment, and to show the diversity of experiences that occur in this remarkable space.

We dedicate this book to all who have labored, created, performed, and played here. We devote these pages to those who have generously contributed their time, money, and expertise, and to those who made their way here from all over the city and around the world.

ALYSON BAKER
Executive Director

STUART MATCH SUNA
Chairman

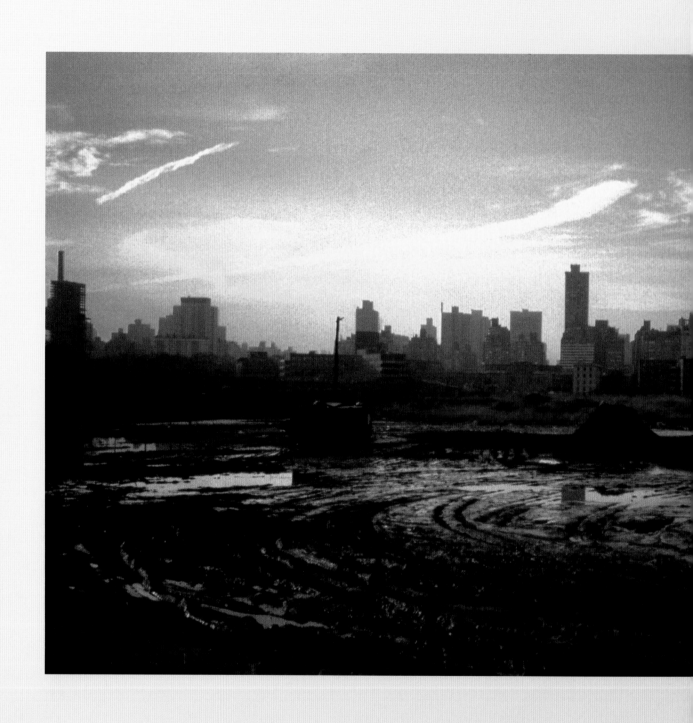

Site preparation, 1986

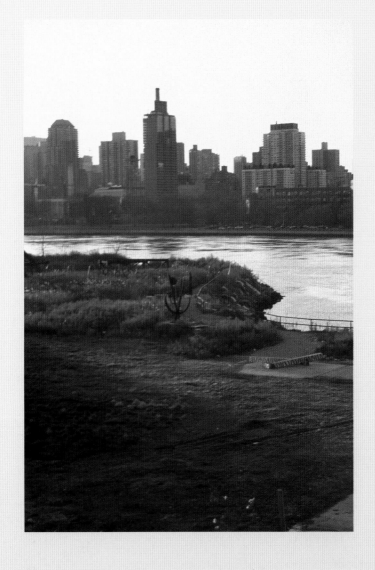

Park overview, 1986

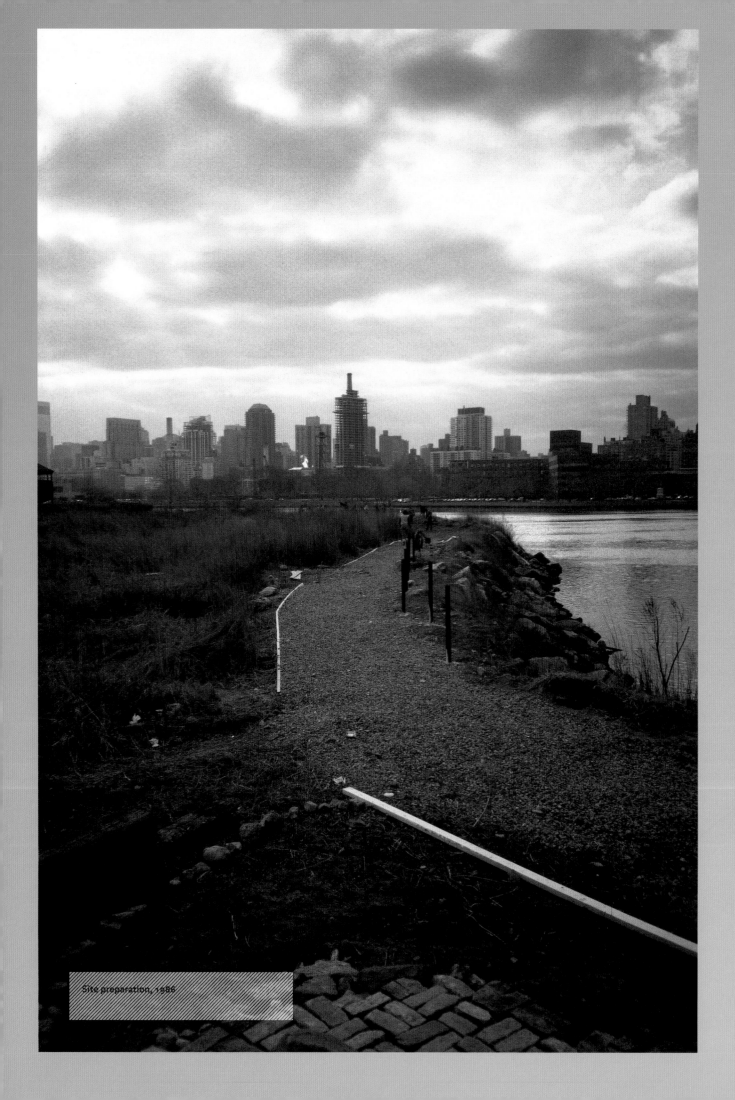

Site preparation, 1986

And that, just as one might have to turn
the whole body round in order that the eye
should see light instead of darkness...
until its eyes can bear to contemplate reality and that supreme
splendour which we have called the Good.
Hence there may well be an art
whose aim would be to effect this very thing...
not to put the power of sight into the soul's eye,
which already has it, but to ensure that,
instead of looking in the wrong direction,
it is turned the way it ought to be.
—Socrates, *The Republic of Plato*[1]

Socrates Sculpture Park, a triangular plot of reclaimed land along the East River in Long Island City, New York, is an unusual place to effect the kind of radical changes to society imagined in utopian projects. But it is a utopian project nonetheless, and one that is an astonishing success. It has also achieved something once considered impossible: it has taken Manhattan, with its traditionally inward focus on artistic achievement, and "turned it round," bringing the eyes of the city—and the entire art world—to bear on four-and-a-half acres of waterfront park in Queens.

How did Socrates Sculpture Park succeed where so many other similar projects have failed? The previous century certainly saw its share of idealistic plans fall short of their aims. Architects, planners, and urban designers imagined new cities emerging from the dense fabric of nineteenth-century metropolises, and many of these projects were realized with unintended consequences. The nearby Astoria Houses, for example—repetitive apartment blocks with scattered and indistinct public spaces—were designed on the principles of twenti- # Urban Space eth-century "ideal city" planning. The goal was to form a new kind of "city," where social concentration and open space would give rise to a new and enlightened community freed ## as Work of from the constraints of traditional urban development. But these aims were unrealistic. The community did not embrace the # Art

THOMAS HANRAHAN

public spaces, and the anonymous buildings often hardened, rather than softened, social pathologies.

In the face of these dashed hopes, the principles of the "ideal city" have been replaced by a new, less ambitious design paradigm that is transforming the remaining waterfront of Long Island City, to the south of Socrates Sculpture Park. The new model is a mixture of private residential towers set alongside thin strips of park facing the water's edge. This fragmented, commercially viable form of public space abandons the pretense of promoting an enlightened or improved society; it is instead an amenity that speeds the consumption of private, luxury apartments. Gone is the idealists' ambition of a new city where art, space, and social experimentation would give rise to new kinds of public space and artistic expression. Contemporary cities are now increasingly stratified, with pockets of luxury and restricted common areas.

Meanwhile, as the idealistic projects of the midcentury faded into commercial propositions at the century's close, in 1985 a group of artists and community leaders began an unusual experiment at Hallets Cove in Queens. There were no trained "urbanists" among them, and organizer Mark di Suvero was a sculptor, not a planner or architect. The designers of the Park were neighborhood residents and fellow artists, as well as young people whom di Suvero mobilized from the nearby Astoria Houses and the surrounding community. The plan was never a formal drawing, but rather an opportunistic and organic process that employed the talents and energy of the people who would be using the Park for recreation and making art. The idea for Socrates Sculpture Park, while modest in resources, was grand in its ambition: to create a new urban space dedicated to learning and artistic production, one that was egalitarian in spirit and open to everyone regardless of class, education, or race. This idea, compressed into a rough and abandoned site, took hold and flourished.

The organizing principles of the Park that were laid out in the founding year continue to this day: Socrates Sculpture Park is open to everyone and stages two rigorously curated exhibitions of public sculpture each year. Much of the work for

the shows is produced on-site in the weeks before the openings, drawing young artists and people from the community into the production cycle. Why do the production and exhibition of these large-scale works energize both contributing artists and the surrounding community in such a special way? Perhaps the answer lies in the unique characteristics of outdoor sculpture, and in the changes in the perception and production of art that it has fostered.

Before establishing Socrates Sculpture Park and his Long Island City studio, di Suvero was part of a radical expansion and transformation of the term *sculptural*. In the 1960s and '70s, sculpture broke through its conventional boundaries, expanding in size and subject matter to include characteristics of both landscape and architecture. This new kind of art making shifted the traditional emphasis of sculpture from the object to the viewer, who now had to walk through space to engage and understand the work. In di Suvero's case, the work itself often moves as well, creating an even more complex relationship with the space around it. This increase in scale brought with it a commensurate change in the materials and methods of artistic production. Large-scale sculpture utilizes the products of industry and construction, such as massive wide flange steel beams and steel plates. The basic elements of the work require machinery such as cranes and tractors, so that the "workshop" often looks more like a building construction site.

Both the new means of producing sculpture and the perceptual shift in art have engendered the special qualities of Socrates Sculpture Park. On the most basic level, di Suvero's machinery served as the initial implements to clear the land; the tools of the artist became the tools of the community that had mobilized to form the Park. These tools still remain in the Park, now serving the artists who are invited each year to exhibit their work. This sharing of tools, a kind of physical manifestation of knowledge, is the basis from which artistic sharing and learning develop at Socrates.

The perceptual dimension is a more complex phenomenon, as learning and sharing are extended to the casual viewer, the everyday user of the Park. The visitor knows that something at Socrates is different, that it is not just a landscaped

park on the water. Something always seems to be "going on" at the Park, whether it is preparation for one of the shows, the exhibitions themselves, or one of the many events that are staged there regularly. It is an outdoor platform for artistic production and exhibition, and in the same way that large-scale and site-specific sculpture transforms the viewer into active participant, the urban space of Socrates connects the city dwellers to a community of artists every time they visit the Park. No other place in New York so seamlessly merges artistic programming with public space the way Socrates does.

This is Socrates Sculpture Park's great secret: that the processes of producing and viewing public art in turn lead to an even larger scale of civic engagement and perception, creating a public space of learning and aesthetic appreciation. It is no surprise to notice that there is little vandalism or destruction in the Park, or the pride and goodwill surrounding it, or the resolute progress toward organizational stabilization and the growth of its mission. Socrates succeeds where others have failed because it has created a way of seeing and making that has both ethical and aesthetic dimensions, merging these into a visible, public space. By any standard, the Park itself is the art that directs our eyes to where they ought to be, turning visitors toward the creative actions of artists and their audiences. This is the gift of Socrates Sculpture Park and its creators.

1 Socrates, *The Republic of Plato*, trans. Francis MacDonald Cornfield (1941; repr., London: Oxford University Press, 1975), 232.

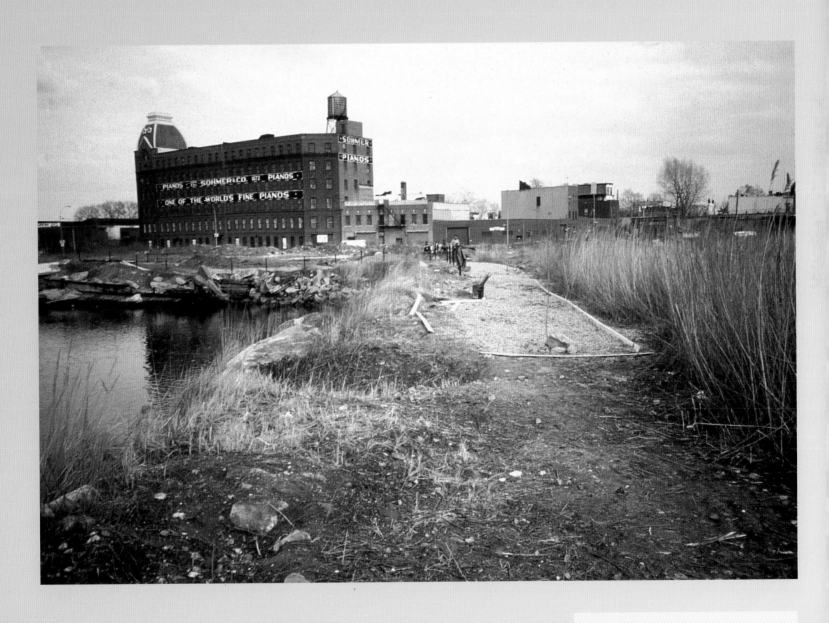

Site preparation, 1986

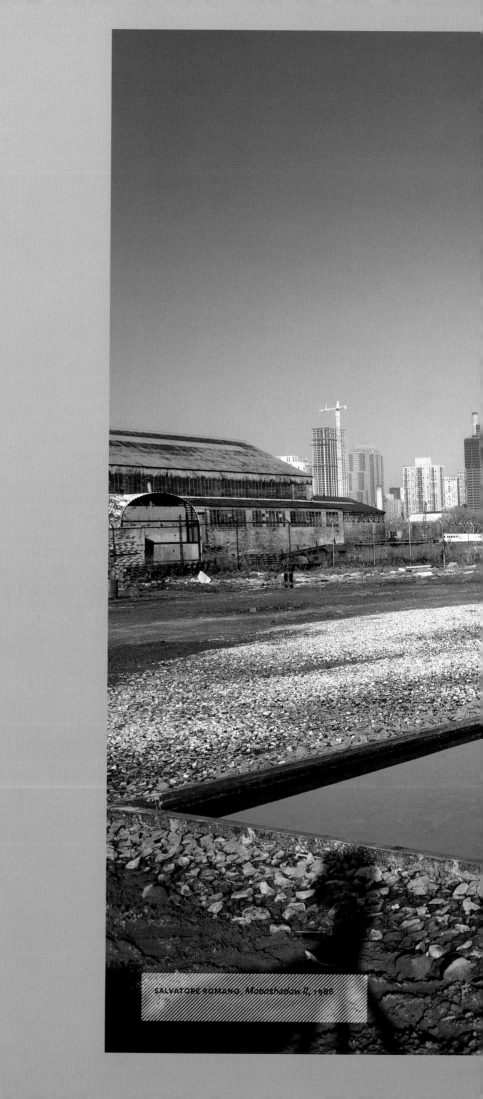

SALVATORE ROMANO, *Moonshadow II, 1986*

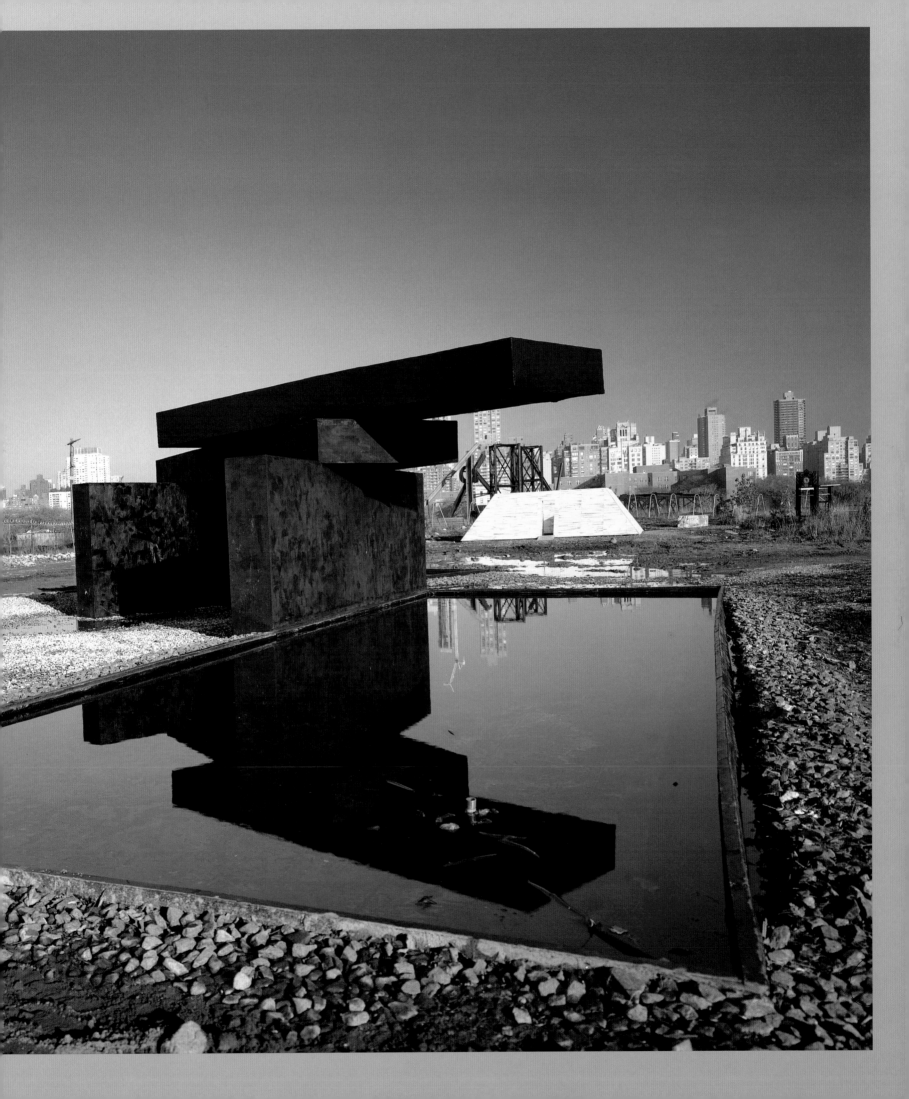

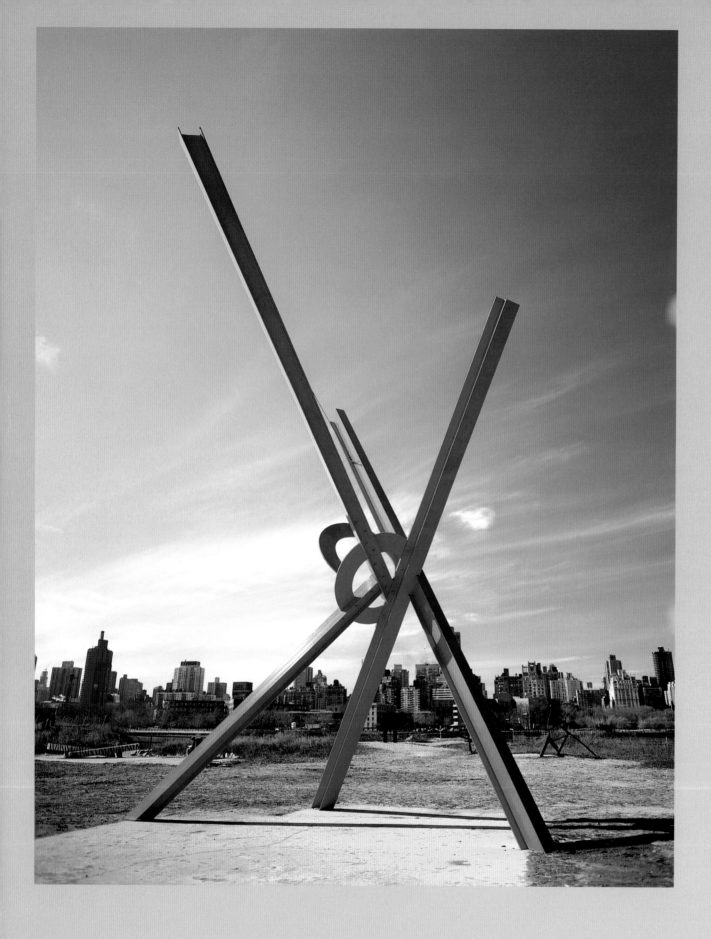

MARK DI SUVERO, *Old Glory,* 1986

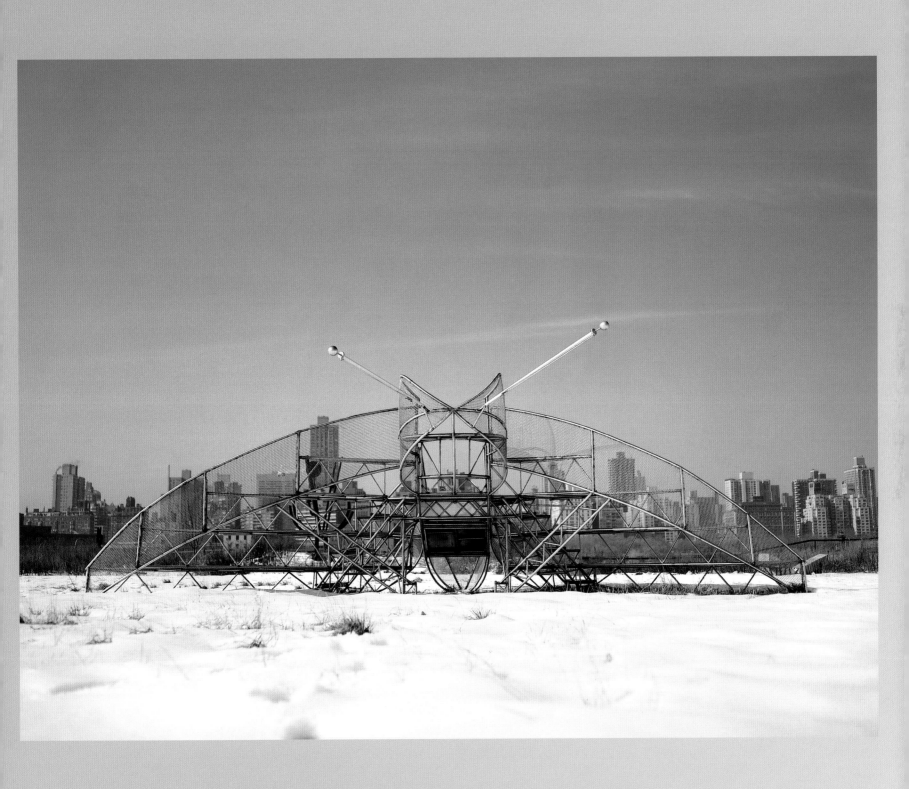

VITO ACCONCI, *Bughouse*, 1985

"Socrates started as a plot
of unloved land on the East River,
full of derelict cars, tires, scrap
metal, used needles, and
broken bottles. It was in a tough
neighborhood full of guns,
drugs, and crime—you wouldn't
think of bringing your family
to the place. The site was as bad
as it gets. But Mark di Suvero,
who had a studio nearby, had a
vision of artists working with
the neighborhood to renew the
land and bring it to life. Soon,
the first exhibition was held, and
out of this wasteland art
bloomed and was nourished.
Socrates Sculpture Park
is not urban renewal, it's an
urban miracle."

BILL BUCHEN, artist

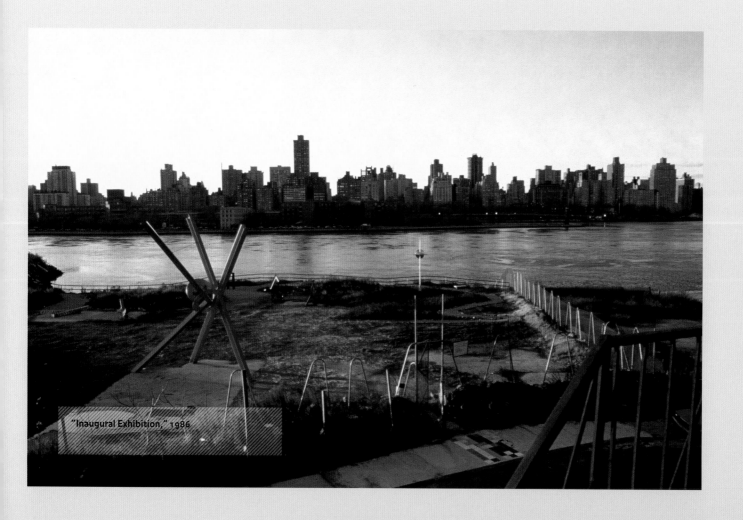

"Inaugural Exhibition," 1986

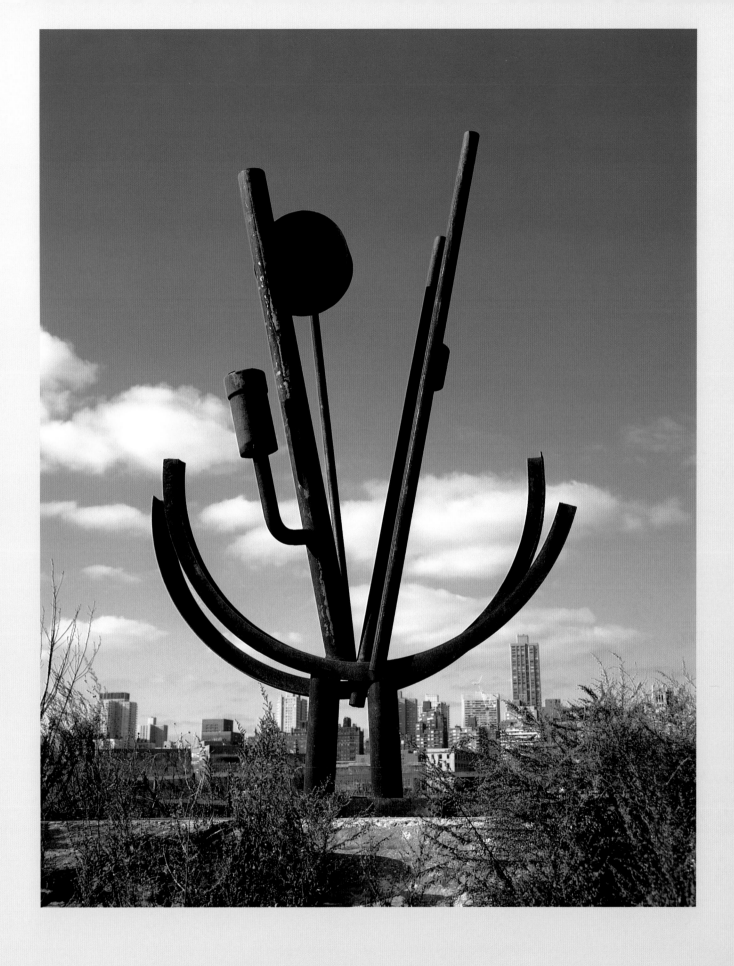

RICHARD STANKIEWICZ, *Grass*, C. 1978

Memories rise with the river's miasma: Long Island City, an unlikely Eden. Athena begat Socrates, born from the brain and the brawn of all.

We pick up trash, cars, weeds, and crack pipes. Melissa paints the boat, on the boat, the entire boat. Commuting on the East River, Enrico at the helm. Views from the water, of water, astounding. Tucker is working, charming, wheedling, traveling between the Park and the pier and the projects in his own community outreach.

Harmonic convergence: crews, neighbors, and artists rub together and are one. Acres of a new New York rise from the ooze. Every show gets better when steel jocks and conceptualists argue over the cow as sculpture. Learning the lessons of Socrates.

The place for art is everywhere. The work of artists is every thing.

HELEN LESSICK, artist

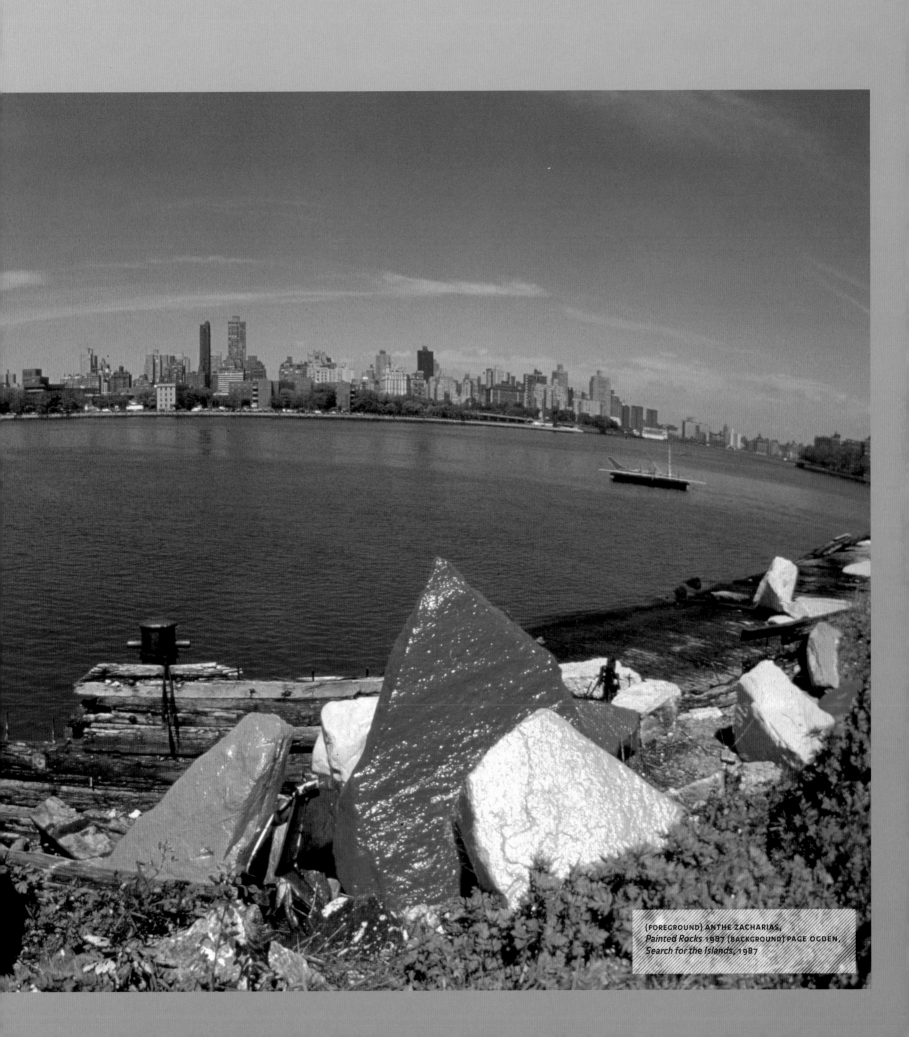

(FOREGROUND) ANTHE ZACHARIAS,
Painted Rocks 1987 (BACKGROUND) PAGE OGDEN,
Search for the Islands, 1987

RICHARD NONAS, *Agriculture (Gate to Gate)*, 1987

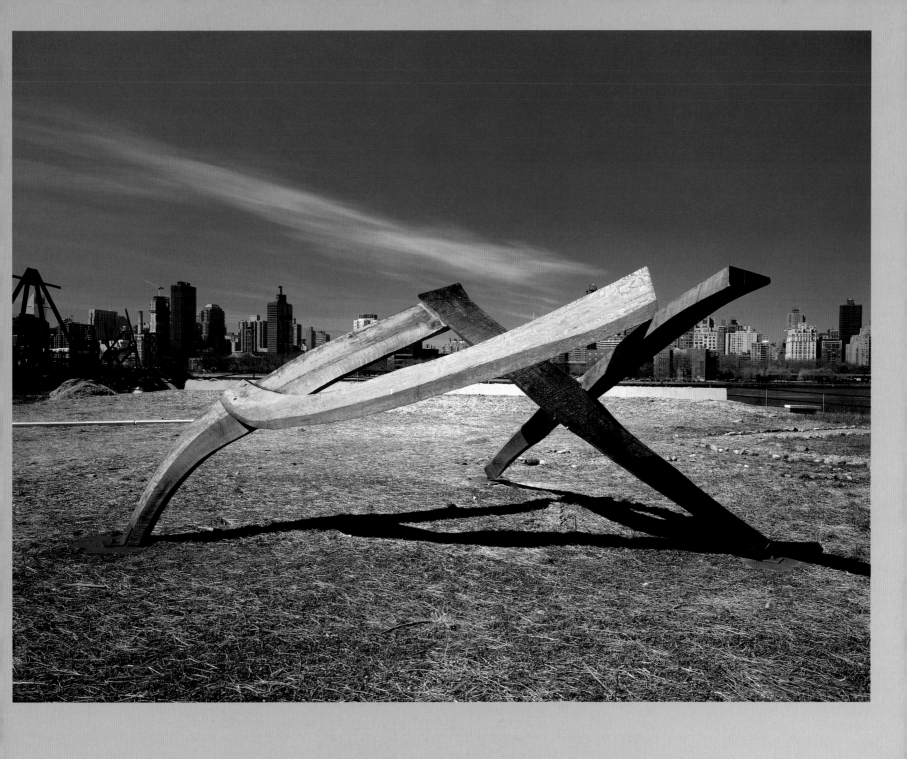

TOM DOYLE, *Wild Geese*, 1987

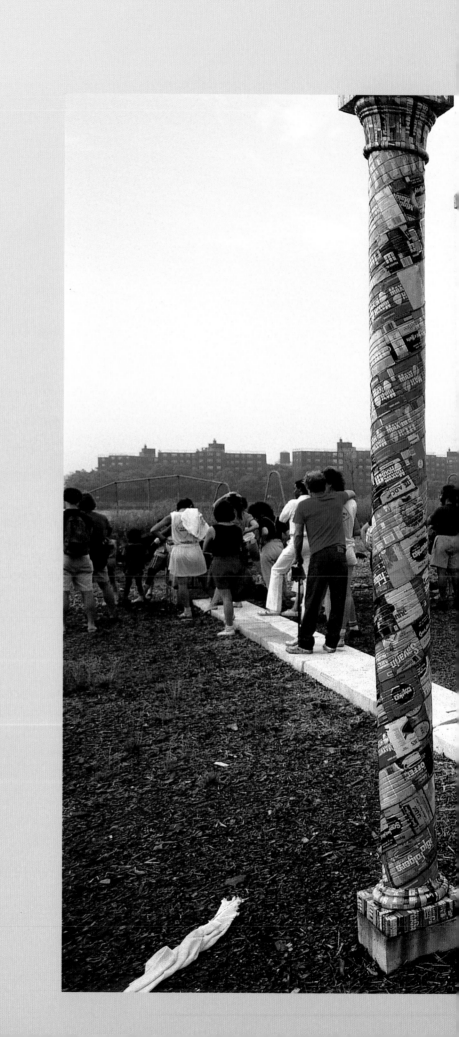

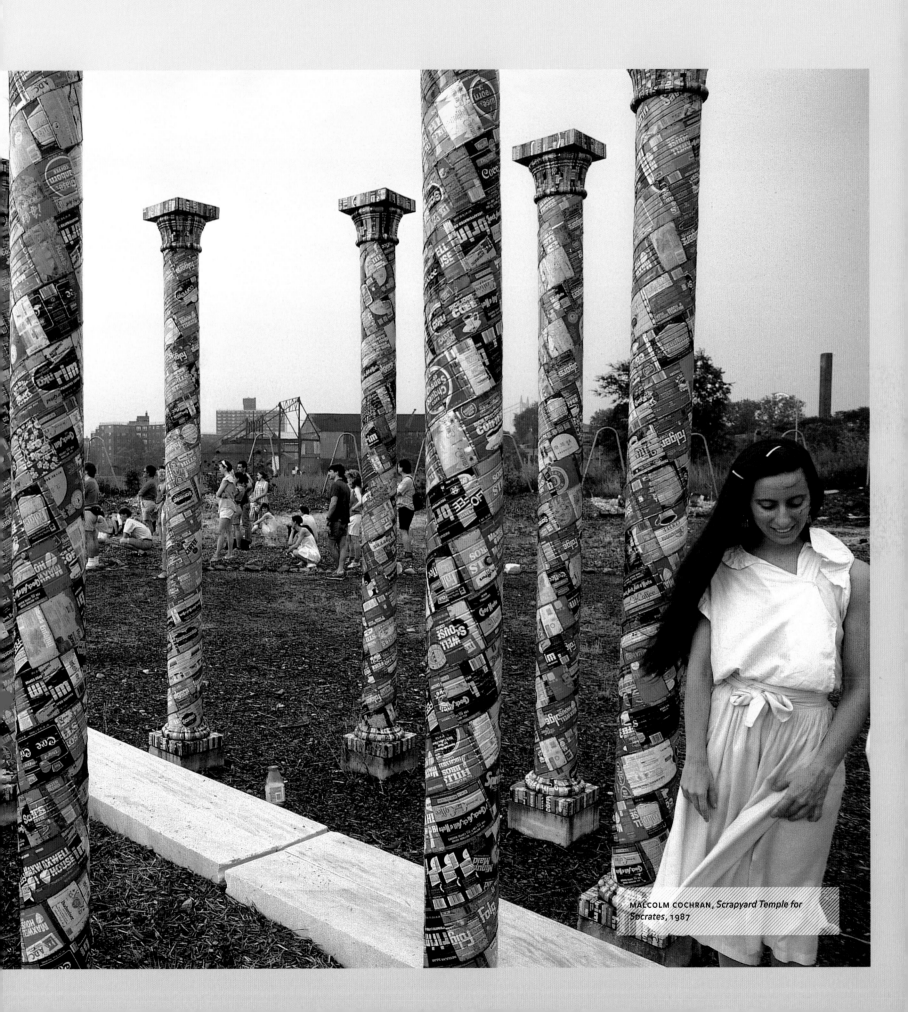

MALCOLM COCHRAN, *Scrapyard Temple for Socrates*, 1987

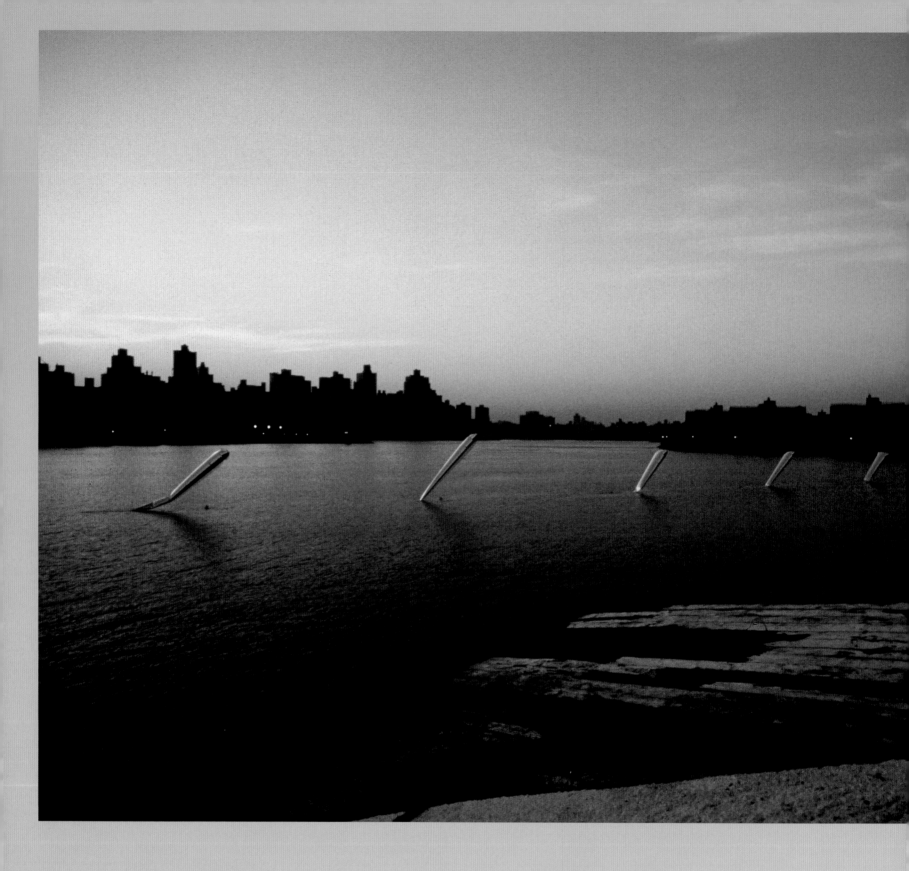

GENE THOMPSON, *Paradox*, 1987

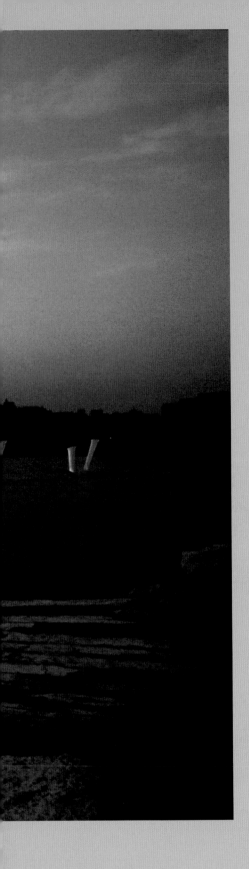

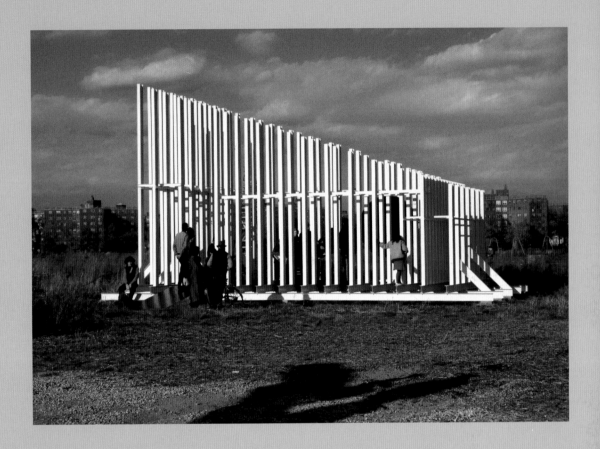

TERRY LEE DILL, *Trojan Sphere*, 1987

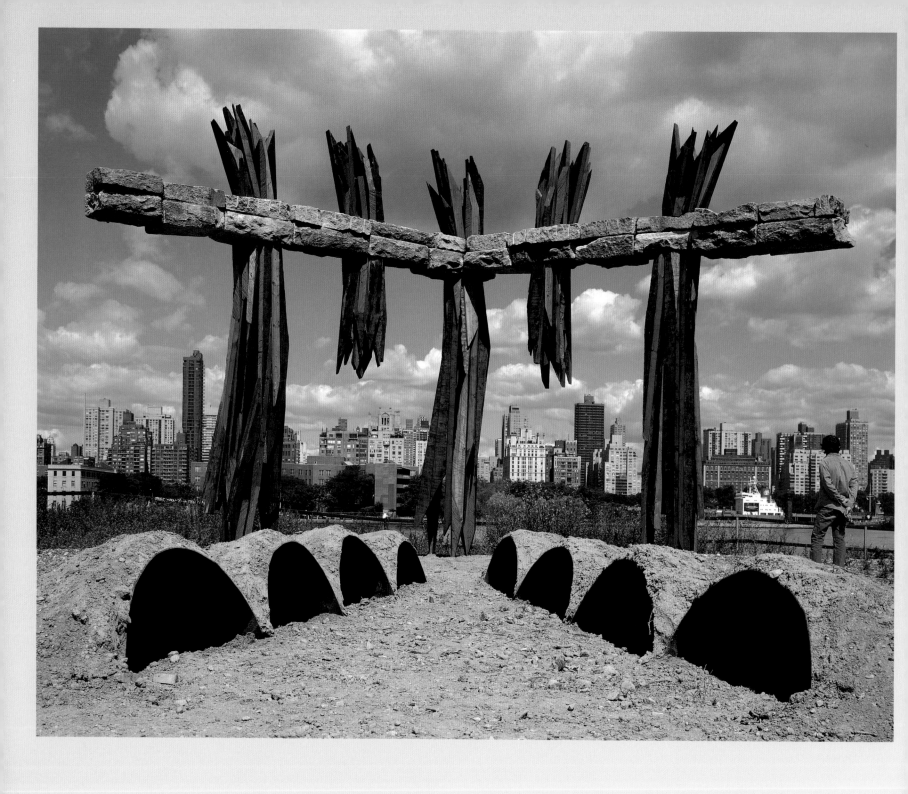

ILAN AVERBUCH, *Song of Love and Hate*, 1988

MAREN HASSINGER, *Three Bushes*, 1988 (DETAIL)

39

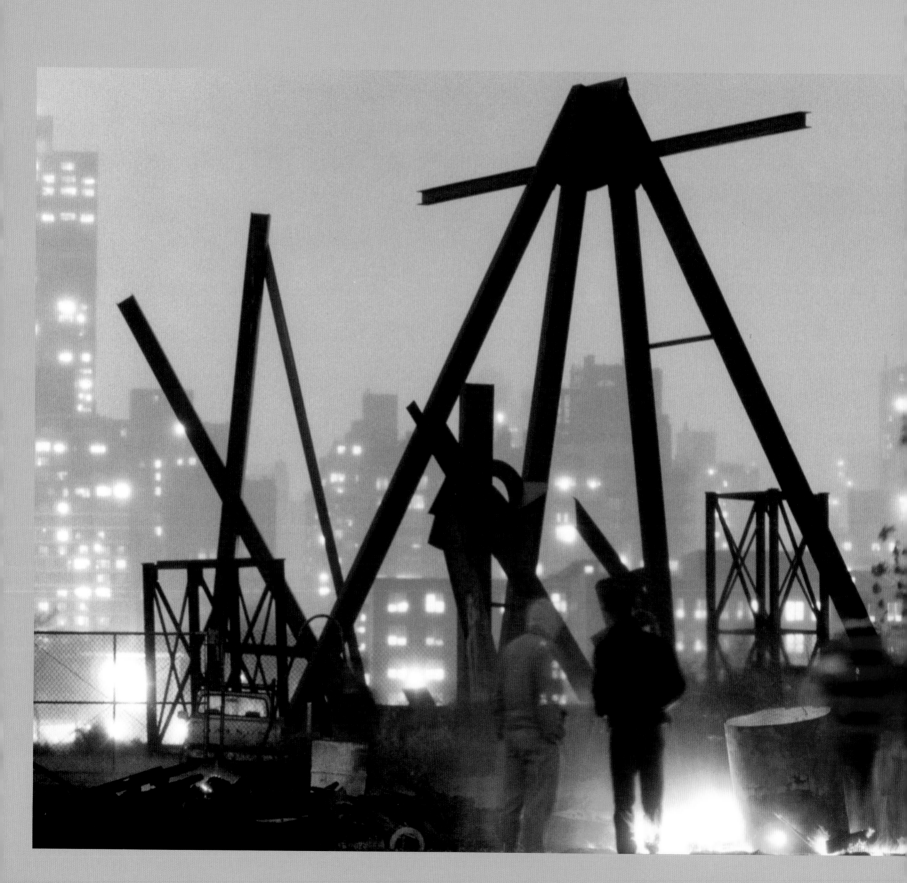

"Enrico Martignoni was
essential in the creation of Socrates
Sculpture Park, the largest
20th century sculpture park in
New York City. His joy, hard
work, multi-tasking and direction
of ideas, methods, political
acumen and capacity to organize
was unique and superb. We had
a common idea: turn the dump into
a living sculpture park.

We were a team, my studio
working and everything we could do
for the park we did. This idea was
so strong, "turning the desert into a
flowering fruitful land" that
we gave it all our energy. So many
helped, seeing this vision
turned into reality, inspired by
Enrico's generosity of spirit
and accomplishment. We had
Isamu Noguchi, a recognized great
American artist, at the beginning,
and I was the name, the
famous international artist, and
my checkbook too. Enrico's capacity
from zoning boards to economics
was brilliant. Seeing pieces arrive,
helping install, build, the joy of
art in the open with the magnificent
skyline as a backdrop, we were
dedicated to this idea. It was a case
of "taking from Peter to pay Paul"
economically between us. It
became a passion. We were a team,
and finally after great effort,
we were, one day put into the City
of New York's Parks Department."

MARK DI SUVERO,
artist and founder of Socrates Sculpture Park

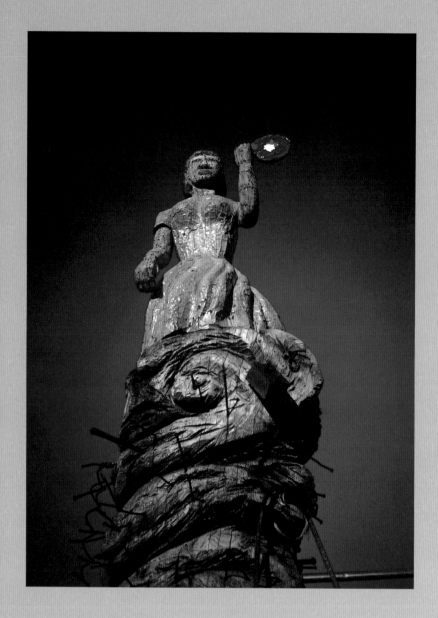

"I can still remember the first time I saw the land and metal buildings for the future Socrates Park. I was walking the site with Mark di Suvero, and it was completely filled with all kinds of debris, including many abandoned vehicles. Mark only saw the opportunity, and before long, listening to him talk about a dream, I began to see it too, and so did many of his friends—and now look what has happened. This is a great park, and it only happened because Mark saw what it could be and acted upon it. He saw the art, and the artists coming from everywhere to create and build their works, the people walking, running, and enjoying the reclaimed land, the landscape with the trees, flowers, and pathways to the water, and the joy, the sounds of laughter and people meeting for the first time, the picnics, dances, and music, sunsets and sunrises, and the views at the river's edge. This was Mark's vision, and this is what the Park has become."

ANITA CONTINI,
Senior Vice President, Director, Corporate and
Public Affairs, CIT

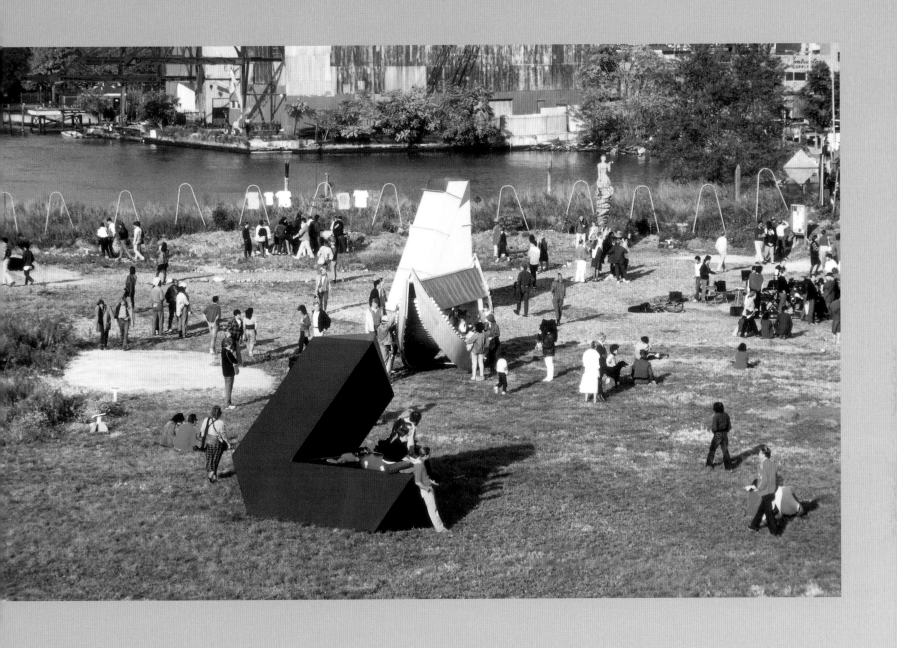

Opening of "Sculptors Working," 1988
(FOREGROUND) TONY SMITH, *Duck*, 1963

43

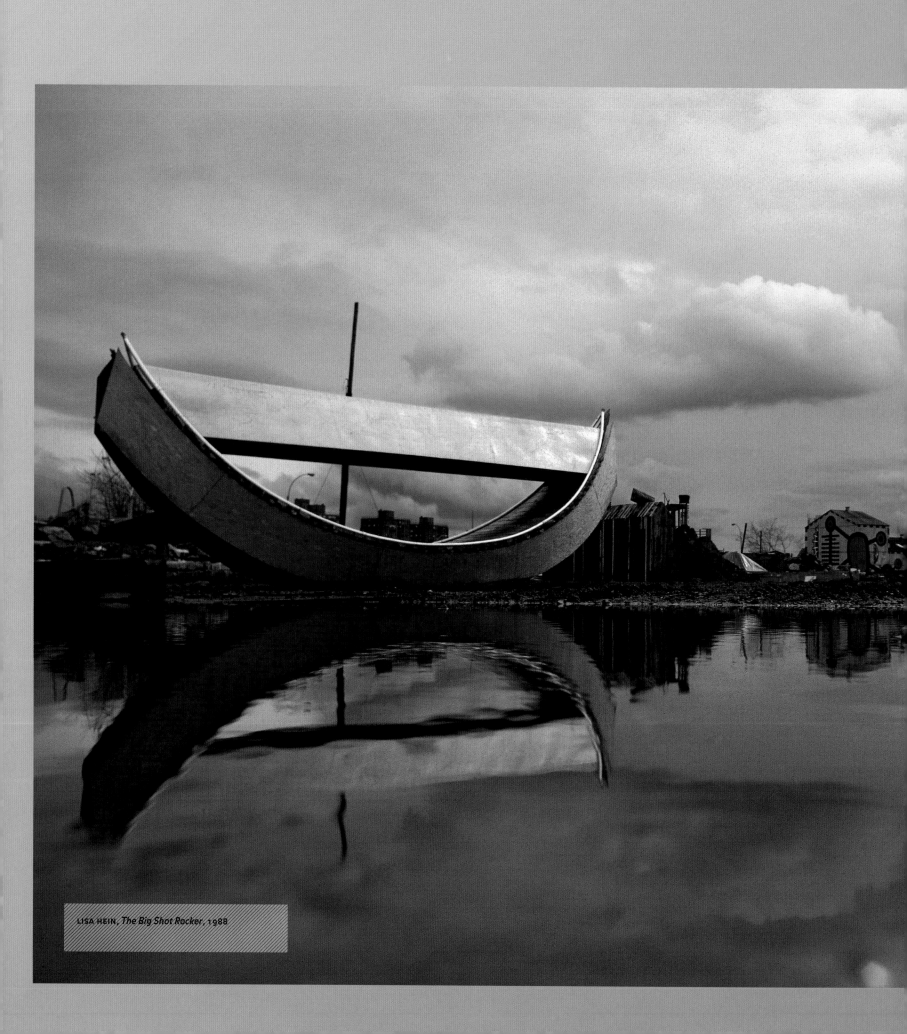

LISA HEIN, *The Big Shot Rocker*, 1988

"It's a wonder sometimes how sculptors manage to build the things they do. The projects usually involve aspects of engineering, business, construction, fund-raising, public relations, and just about every other field from the mundane to the most complex, at times forcing the artists to function in roles usually thought to require expertise. The artists and workers I met while at Socrates finished projects that under the best of circumstances would be extremely difficult and, driven by their own initiative, completed works which truly reflect a commitment to sculpture."

TOM BILLS, artist

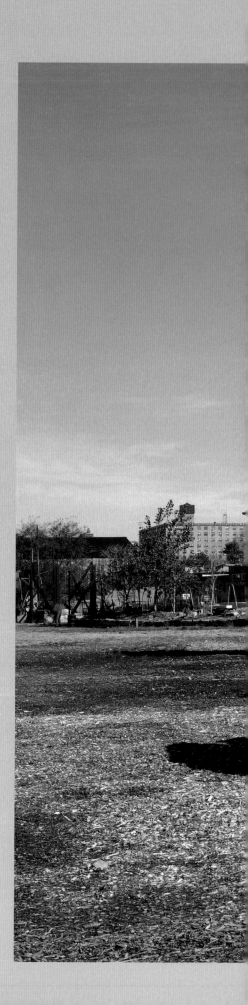

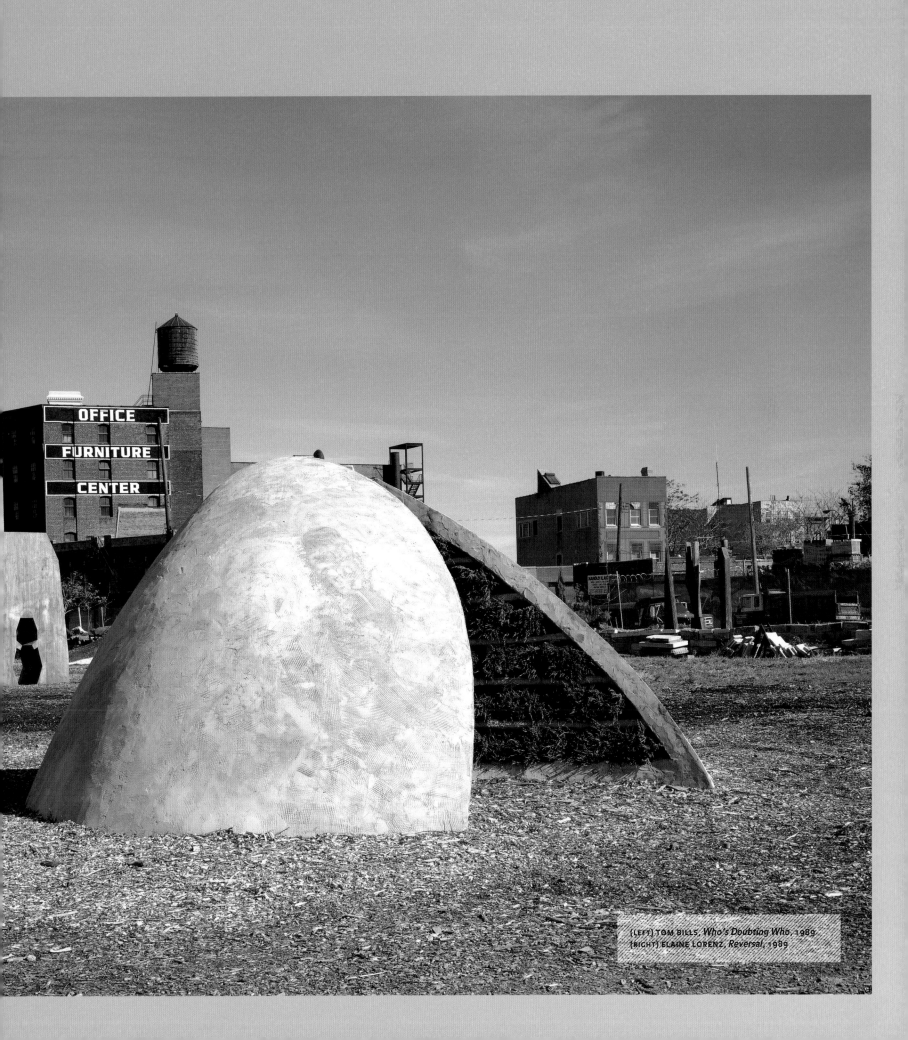

(LEFT) TOM BILLS, *Who's Doubting Who*, 1989.
(RIGHT) ELAINE LORENZ, *Reversal*, 1989

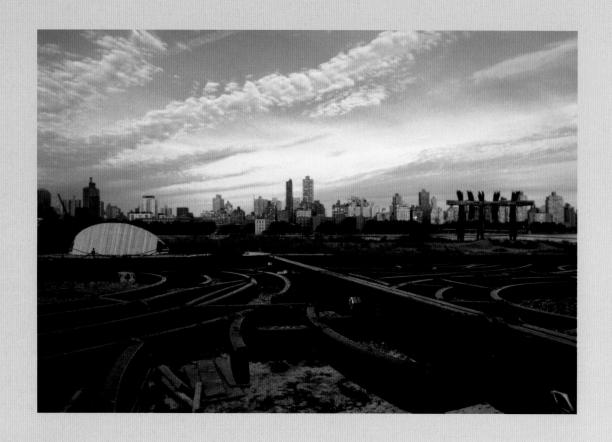

Park overview, 1988

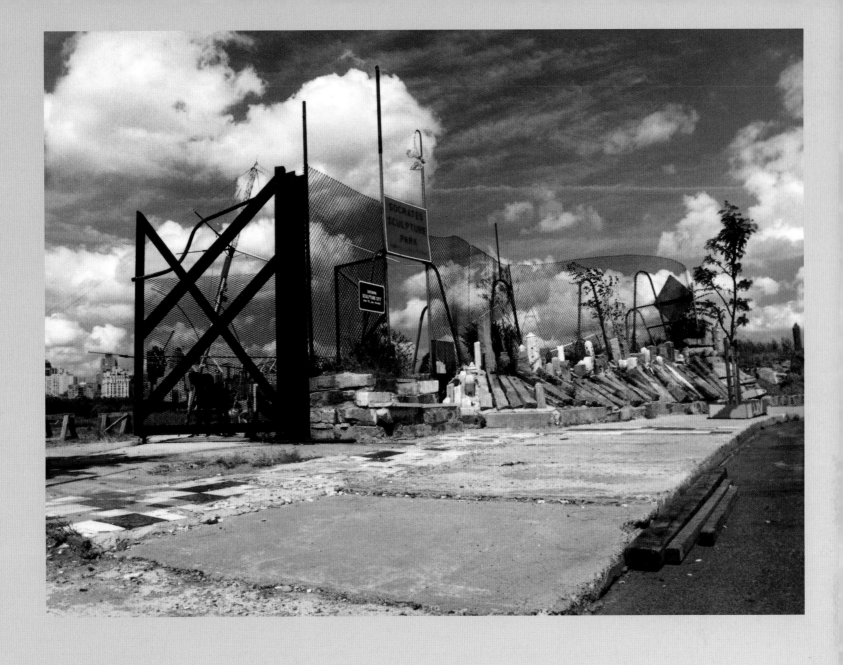

The north gate, 1989

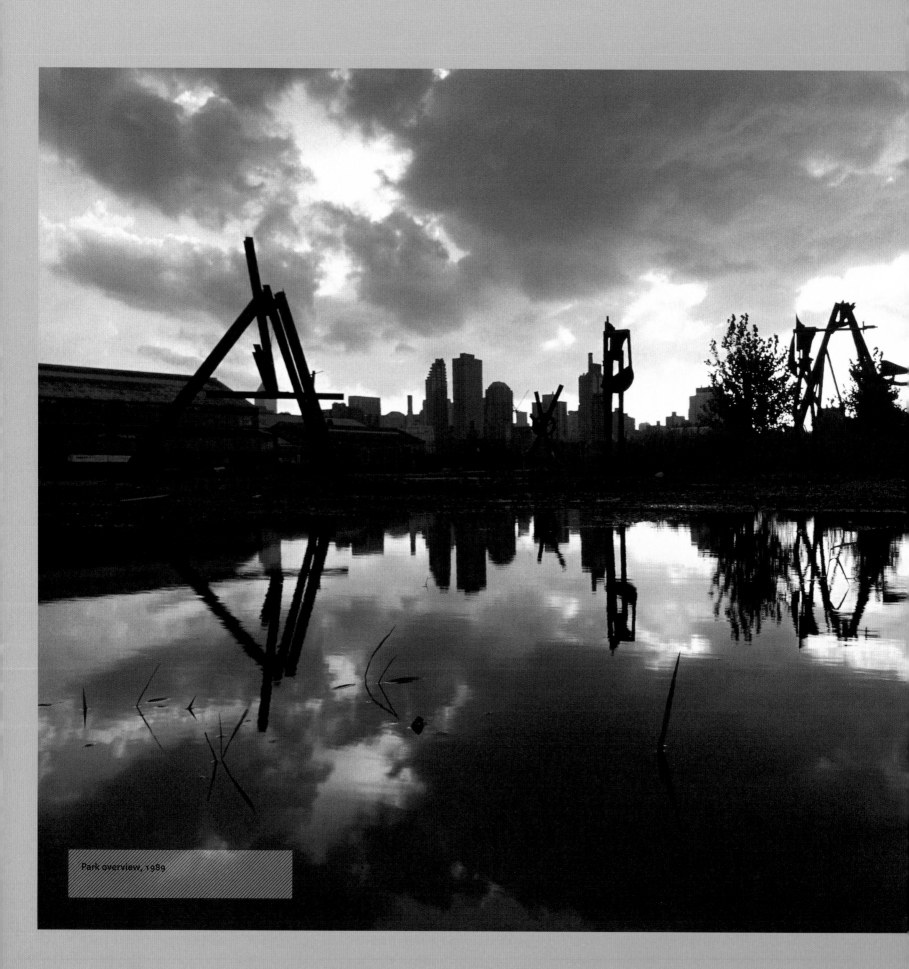

Park overview, 1989

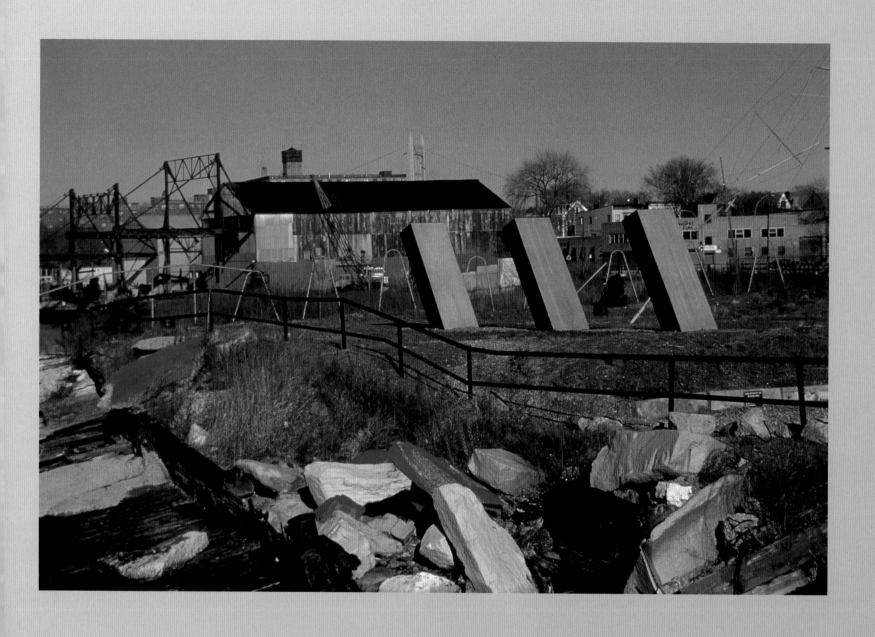

RONALD BLADEN, *Three Elements*, 1965

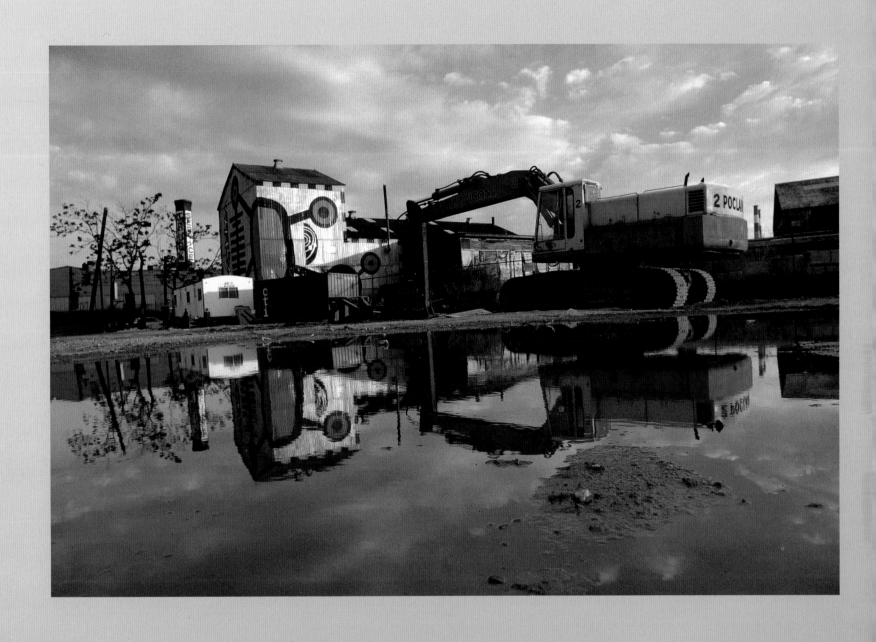

Park overview, 1989 (LEFT) RICHARD MOCK,
Perceiving Space, 1986

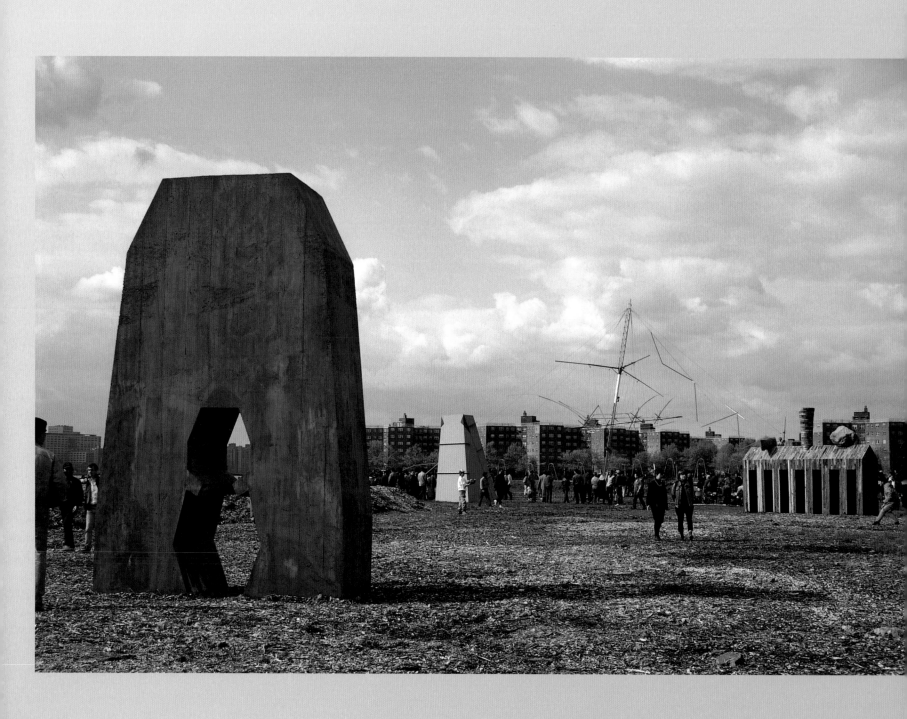

Opening of "Sculpture City," 1989
(LEFT) TOM BILLS, *Who's Doubting Who*, 1989

"What makes Socrates so unique in the cultural realm is the fact that at any given time, one can see works by world-renowned artists, lesser-known artists, and completely unknown artists. These works are presented in a completely egalitarian manner. What also makes the Park distinctive is that the process of creating the works for each exhibition is largely open to the public. There is always a delightful period when a new exhibition is emerging and one can see the beginnings of activity, which proceeds to get downright hectic until finally it crescendos on the opening day."

KENNY GREENBERG, artist

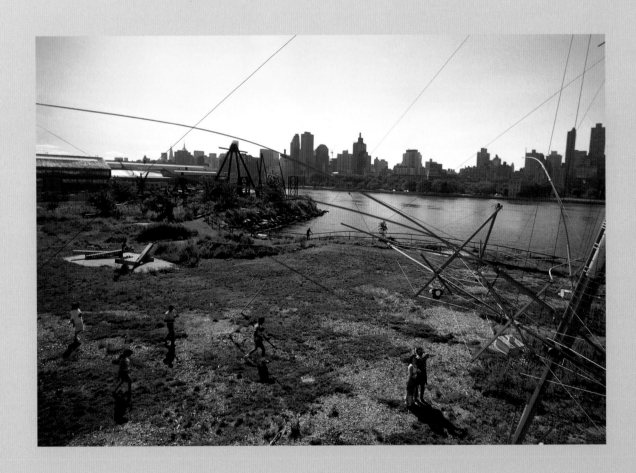

SCOTT GILLIAM with DICK ROBINSON, *BIG JU-JU (Big Spirit)*, 1989 (DETAIL)

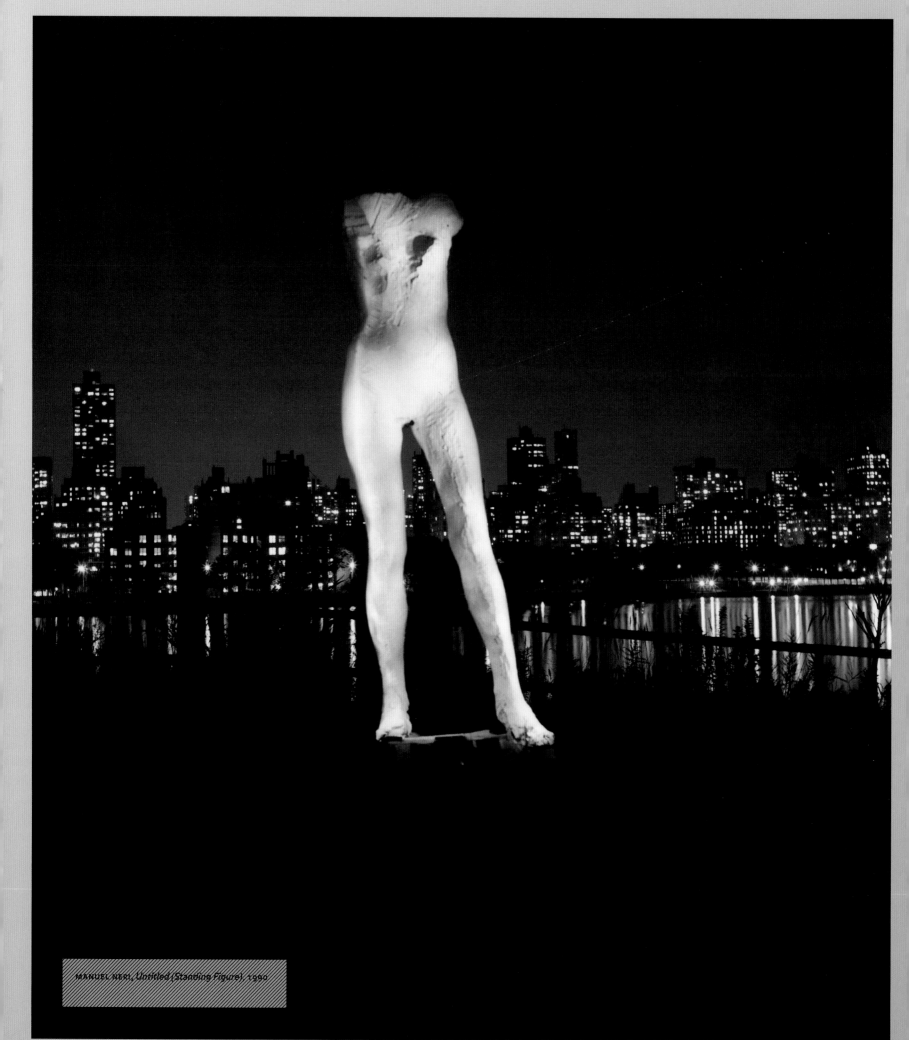

MANUEL NERI, Untitled (Standing Figure), 1990

JOHN MORSE

Let's Go!

Openings in
the early years of Socrates Sculpture Park
were always thrilling—
a thousand people milling among
the art, children finger painting beneath
a tarp, volunteers selling hand-
painted T-shirts to raise a bit of money—
and extremely happy.

On one of those gloriously
sunny Sundays, attendees included
people with severe physical
challenges from a nearby facility
gamely navigating the Park's rough
terrain in wheelchairs and on
crutches. One broadly smiling young
man was on a gurney—not on his
back, but stomach, arms stretched out
in front of him à la Superman—
piloted by Mark di Suvero. In his
typically frisky fashion, Mark practically
raced his charge from sculpture
to sculpture with the frenetic glee
of a contestant on a supermarket
shopping spree. From a distance, the
young man appeared to be flying.

I've often thought of Mark's
sculptures as the earth standing up, not
so much gravity defied as the sky
acknowledged—*it's up there, let's go!*
And so it is with Socrates: not so much
a garbage dump denied as a waterfront
embraced, less a pitiless city
bureaucracy and more the urban idyll,
not a wretched corner of housing
projects, rather a community that
wanted love and wanted to love,
not a man nailed immobile by paralysis
but, instead, soaring.

"This project took a
literal garbage dump and
developed it into a place of
beauty. It made the Queens side
of the East River an important
part of the city's waterfront and
introduced to the community
an art form that they never would
have enjoyed had Socrates
not existed."

CLAIRE SHULMAN,
former Queens Borough President

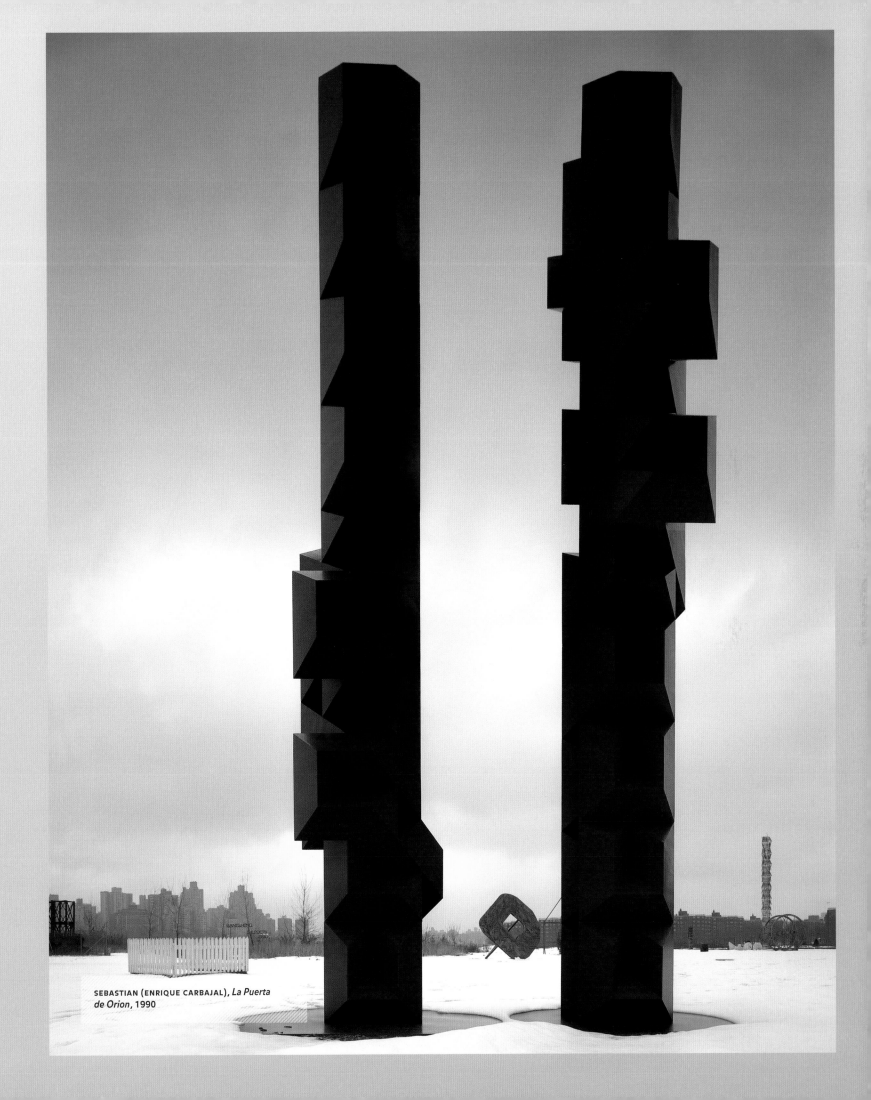

SEBASTIAN (ENRIQUE CARBAJAL), *La Puerta de Orion*, 1990

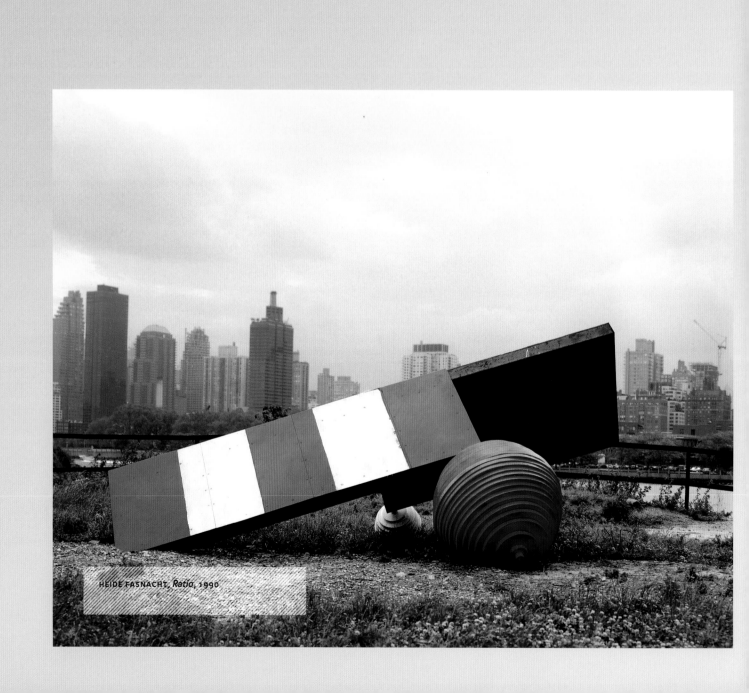

HEIDE FASNACHT, *Ratio*, 1990

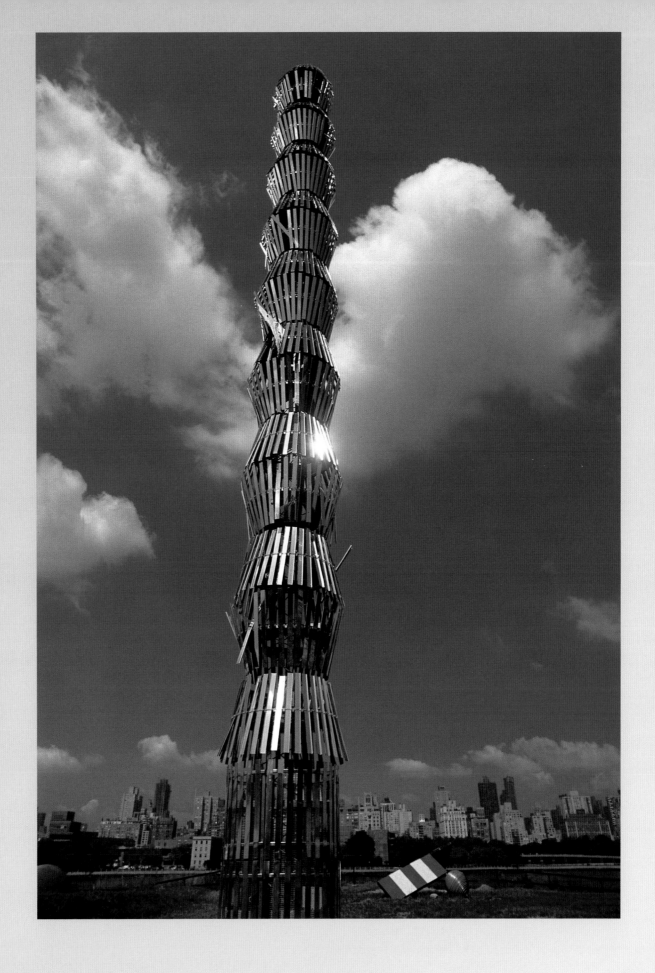

ED ANDREWS, *Neonemometer*, 1988

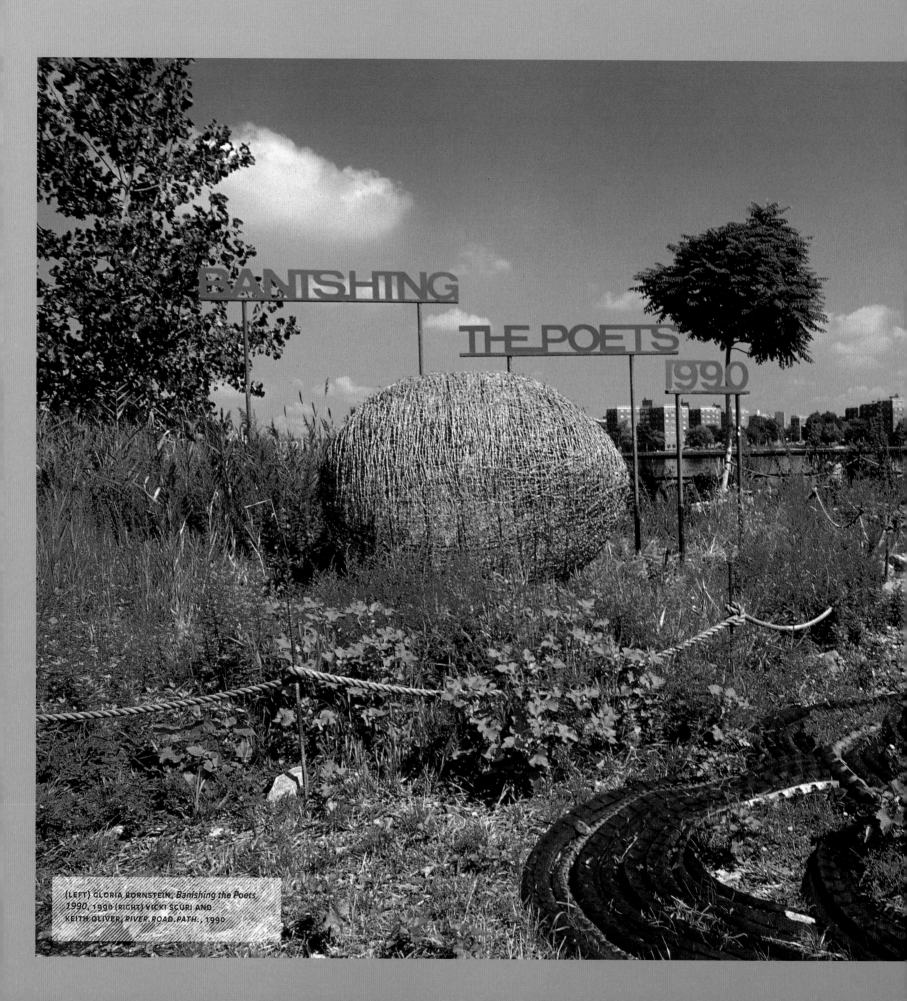

(LEFT) GLORIA BORNSTEIN, *Banishing the Poets*
1990, 1990 (RIGHT) VICKI SCURI AND
KEITH OLIVER, RIVER.ROAD.PATH., 1990

"As a laboratory, Socrates has been a provocative presence in New York's cultural scene for the past twenty years, continuously reframing its waterfront setting against the widest range of emerging art.

As architects passionately interested in the intersection of art, architecture, and landscape, we continue to regard Socrates as a model in our own work for what an urban sculpture park should be: lively, experimental, at times gritty, and always surprising."

MICHAEL A. MANFREDI,
Partner, Weiss/Manfredi Architects

"My first visit to Socrates
Sculpture Park was in 1990,
a huge sculpture by Charles
Ginnever was on view, and
I started to walk around it, to get
the measure of it. My family
was cold and wanted to go home,
so I began running around it.
I was fascinated by the fact that
the piece didn't have any right
angles, and as I moved around it,
it changed constantly. I realized
the piece that Ginnever con-
ceived did not exist without the
viewer. Then and there,
I made the decision to begin
collecting sculpture.
Socrates is one of the
world's best places for exploring
the world of sculpture as a
dynamic model. While it
shows works of the established
masters, it also provides
abundant space for newer artists
to receive exposure, which
might otherwise not be possible.
To this extent, it is an enabler,
in the grandest traditions
of patronage."

LEONARD RIGGIO,
Chairman, Barnes & Noble, Inc.

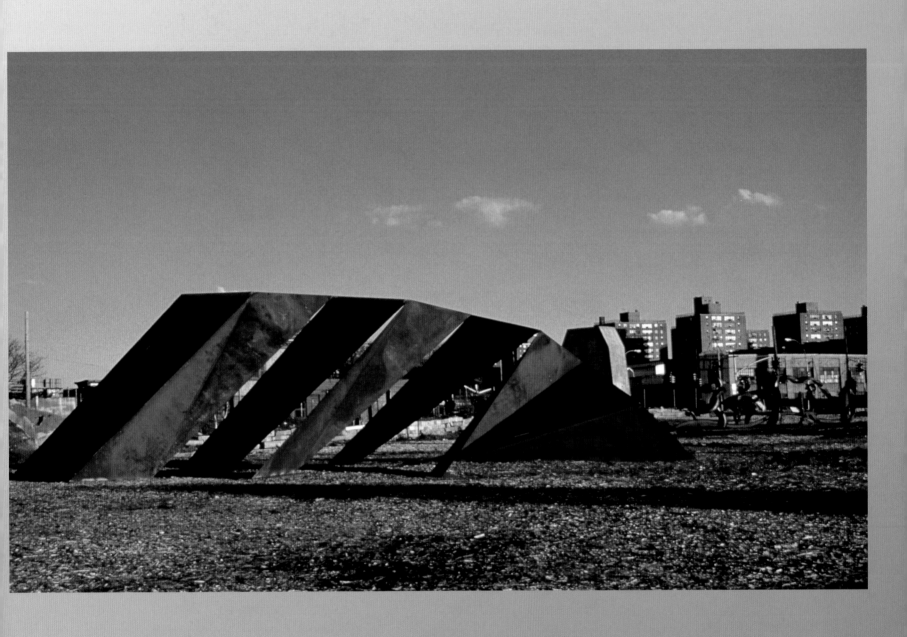

CHARLES GINNEVER, *Knossos*, 1990

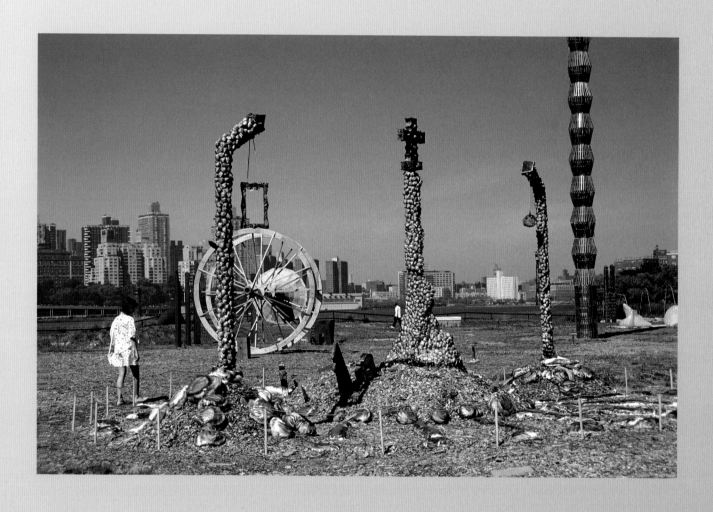

(FOREGROUND) JONAS DOS SANTOS, *Shrine to the Immigrant*, 1990 (BACKGROUND, LEFT) JESSE MOORE, *Calling to Evangeline*, 1990

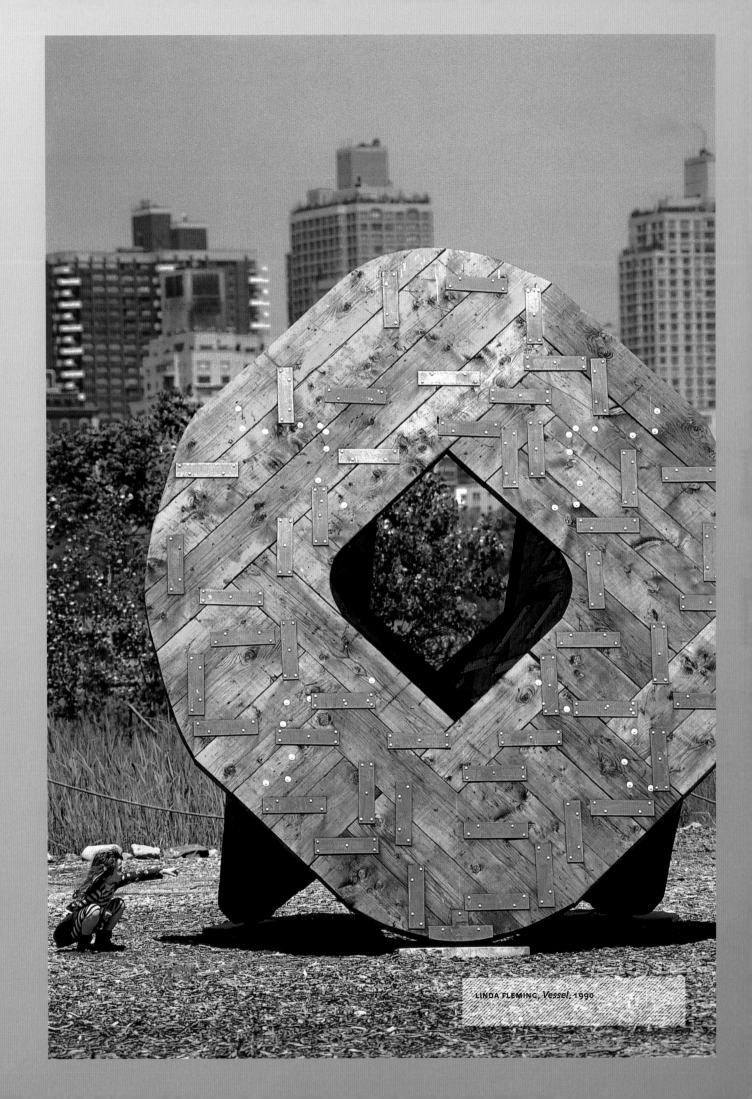

LINDA FLEMING, *Vessel*, 1990

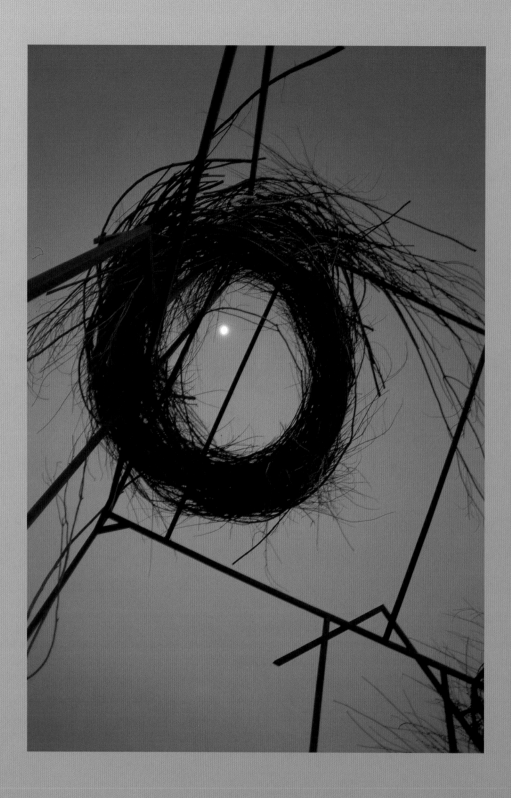

PATRICK DOUGHERTY, *Homebound*, 1990
(DETAIL)

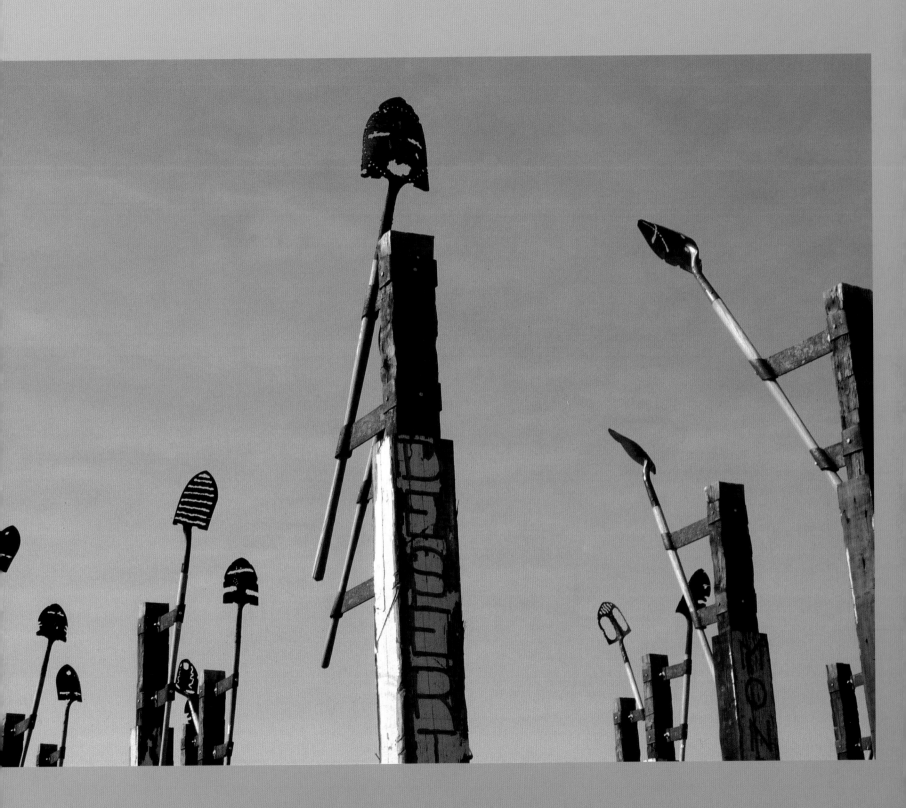

GAIL ROTHSCHILD, *Ploughshares into Swords*, 1991 (DETAIL)

"Socrates is a model
that brings recreation, major artworks,
and open space together
to embrace art forms, urban
design, and contemporary
sculpture in one of the most
culturally diverse communities
in the country."

GAIL HARRIS, Director of
Community Development, Goodwill
Industries of Greater New York and Northern
New Jersey

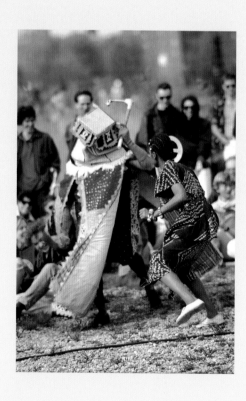 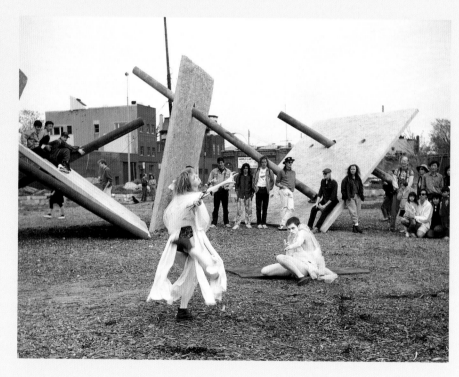

(LEFT) Opening of "Grass Roots Art Energy,"
1991 (RIGHT) Performance by Patti Bradshaw and
Jason Childers at the opening of "Grass Roots
Art Energy," 1991

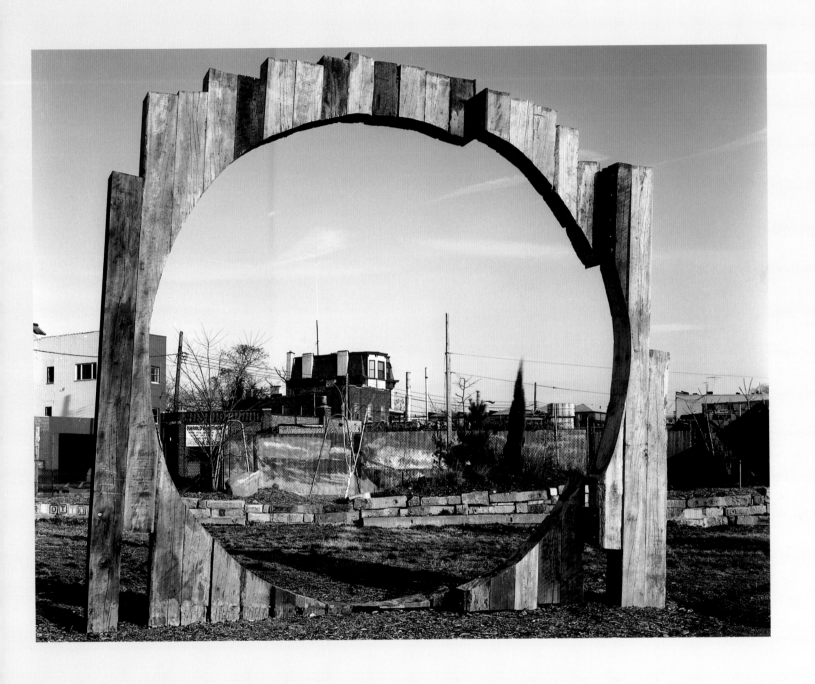

TADASHI HASHIMOTO, *Silver Horses with Wings*, 1991

71

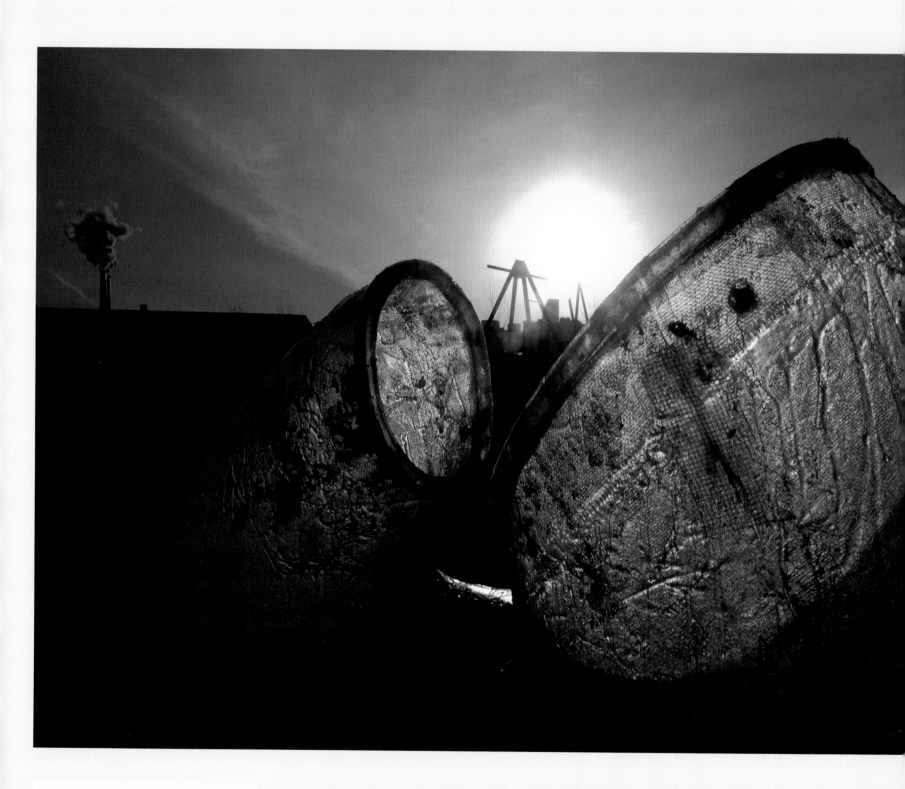

ROBIN HILL, *Replacement Valves*, 1990 (DETAIL)

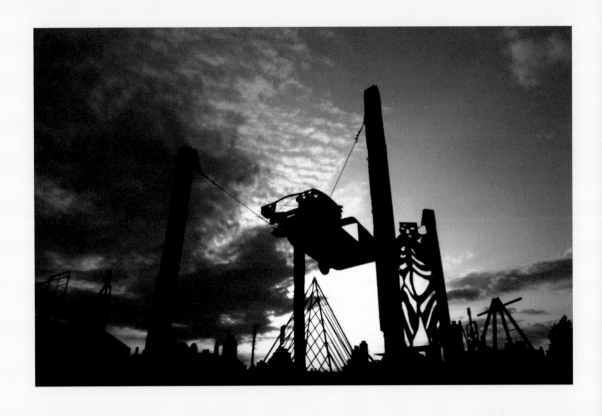

EMILIO CRUZ, *Cargo Cult for Lewis Mumford
A.K.A. Resurrection of Dry Bones, and the Union
of Two Sticks*, 1991

73

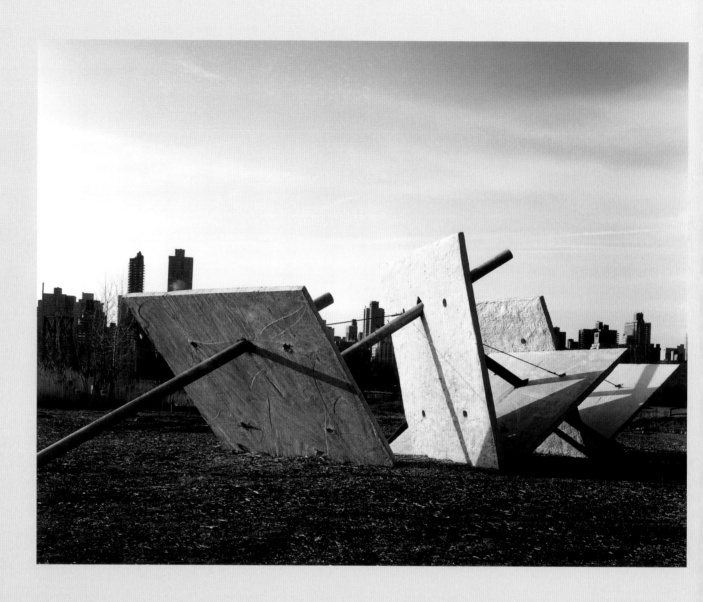

"Often, working at
Socrates Sculpture Park
marks the first time that
an artist has built a sculpture
outdoors. With the divine
backdrop of the East River and
the Manhattan skyline, the
Park has served many artists
as a place of exploration
and visual adventure."

**URSULA
VON RYDINGSVARD**, artist

GUY DILL, *Huron*, 1991

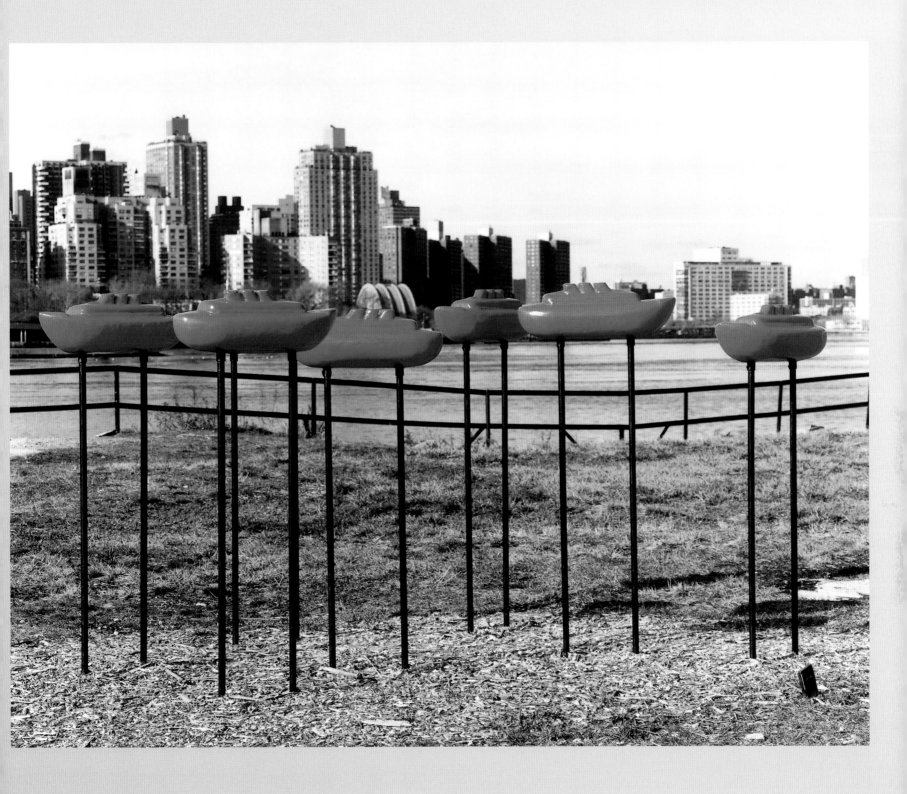

PETER TILGNER, *Liners*, 1991

Shoreline, facing south, 1991

"Socrates Sculpture Park
is one of the great breakthrough
waterfront projects in New York.
Like the celebrated 'Art on
the Beach' project on the site of
Battery Park City, it gave an
entire generation a new vision of
what the waterfront could be.
'Art on the Beach,' however, was
obliged by its location to be a
temporary operation, while
Socrates Sculpture Park has not
only survived, but it has become
a city park."

RAYMOND W. GASTIL,
Founding Director, Van Alen Institute

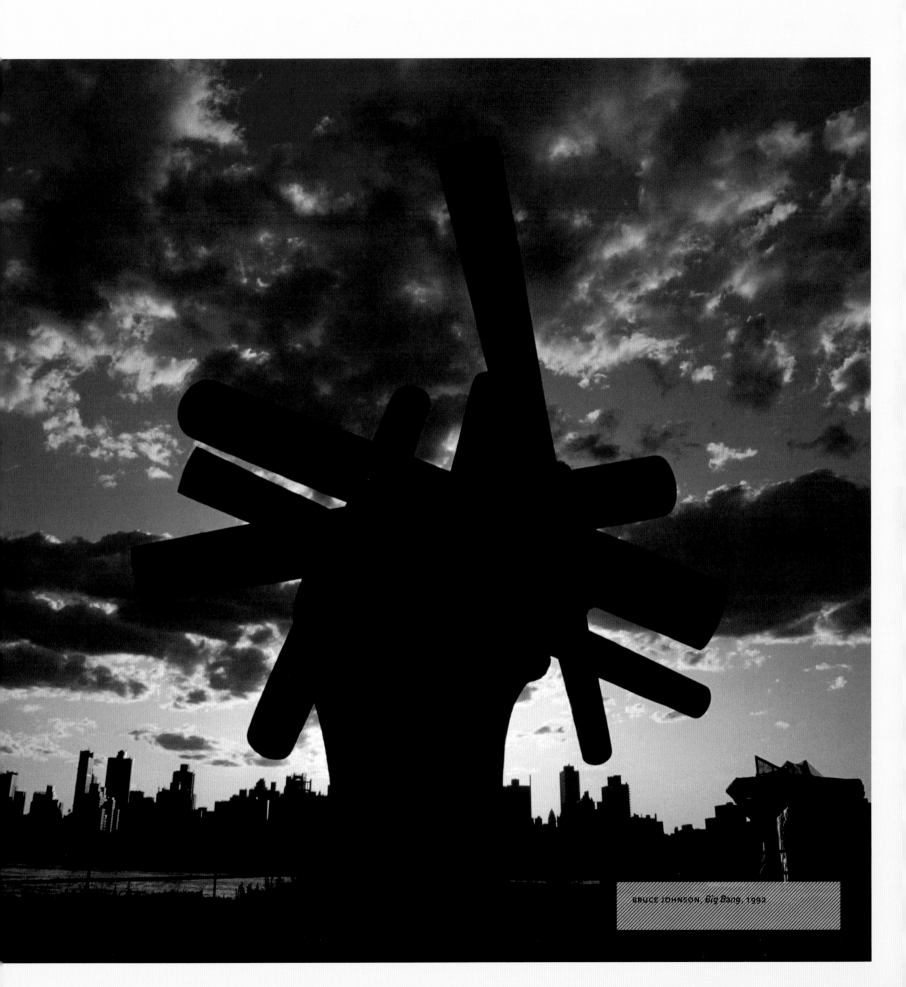

BRUCE JOHNSON, *Big Bang*, 1992

Park overview, 1992

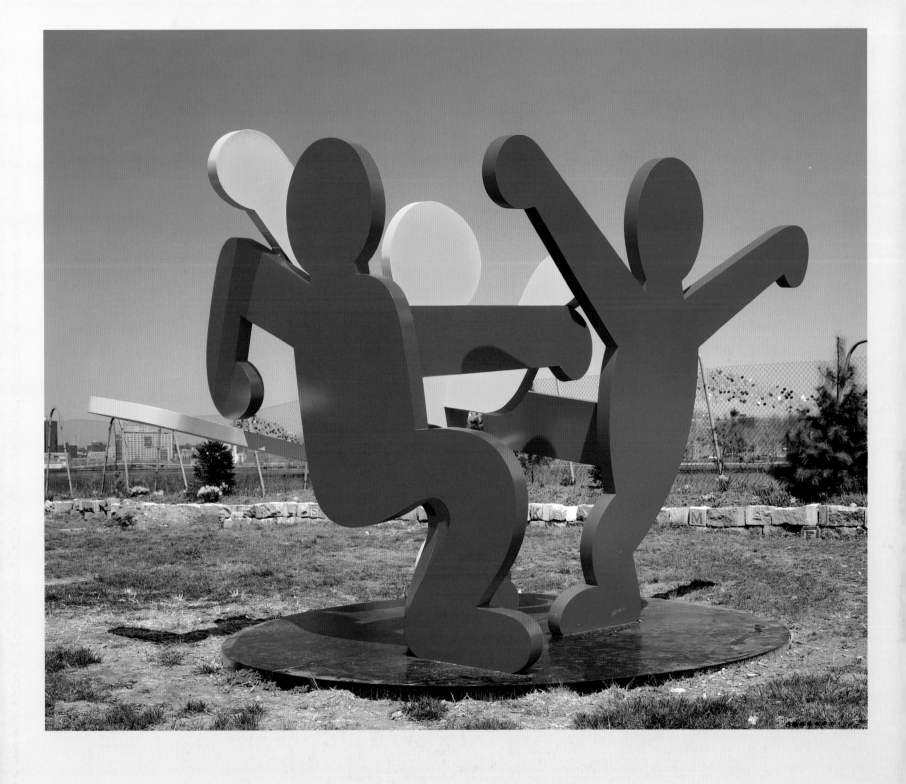

KEITH HARING, *Untitled*, 1989

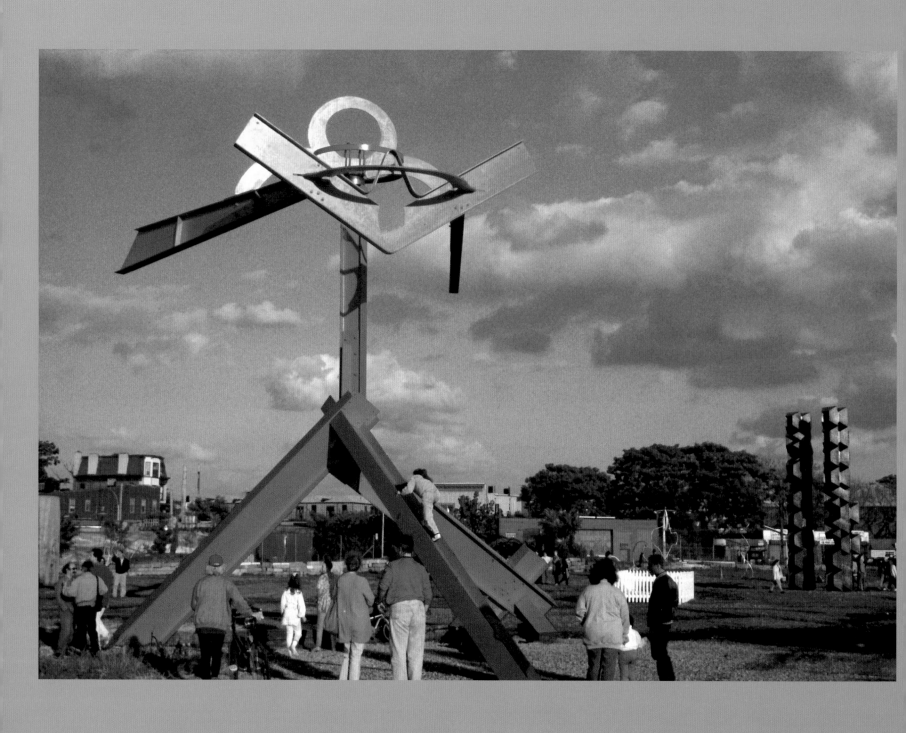

MARK DI SUVERO, *For Gerard Manley Hopkins*,
1983–89

Any account of Socrates Sculpture Park must begin with its founder, Mark di Suvero, and the question of why he would want to found a public sculpture park. Although he has achieved international acclaim as an artist, Mark identifies with the working class. In a recent memoir, I summed up Mark the artist as a "romantic hero." In response, he protested my designation during a phone call, declaring that he was a "worker." I answered that in my opinion what made his construction-sculpture marvelous was his vision, not his labor, but I knew exactly what he meant.

As for Mark's conception of his artistic mission, on a wall of his studio in Petaluma, California, he tacked a quotation from George Bernard Shaw that reads in part: "I am of the opinion that my life belongs to the whole community, and as long as I live it is my privilege to do for it whatever I can." Mark himself has said that art is a gift that we give to others. It follows that many of his sculptures are meant to be placed in public spaces and that creating them has always been an intrinsic part of a wide range of civic activities.

For Mark, the idea of "the people" is not an abstraction. It means hands-on interaction with the public. In 1977, he and Anita Contini started the not-for-profit Athena Foundation, which, as Mark wrote in his founder's statement, "is dedicated to the arts for the people." He meant for the foundation to bring art and the community together in a celebration of joy—and as a consequence, to show the way to the revitalization of culture and communal life. As part of its purpose, Athena would establish a public sculpture park and, according to the founding statement, "search out artists (thru [sic] the recommendation of other artists, on the basis that artists know art best) and shall provide materials/time/space . . . as required."

I once asked Mark: "Why did you call your foundation Athena? Why Socrates?" He responded that the name Athena was an acknowledgment of the woman warrior as well as the nearby Greek American community, then reputed to be the largest of Greek heritage outside of Athens, and that Socrates was chosen in recognition of the philosopher's search for truth.

Art for the People

The First Decade of Socrates Sculpture Park

IRVING SANDLER

83

Mark invited me to be on Athena's board,[1] although I am not sure why. It may have been because of my participation in organizations that served artists. I ran the Abstract Expressionists' club in the 1950s, and I cofounded the not-for-profit Artists Space in the early 1970s. I happily agreed to his request, especially as the foundation's programs would be shaped by artists. But in truth I had no choice: I find it impossible to say no to Mark, and I am not alone in this. He seems incapable of pessimism, and his enthusiasm and broad smile preclude any nay-saying on the part of everyone he encounters.

///////

In 1980, Mark acquired two large sheds on the Astoria waterfront in Long Island City. In them he housed his studio and living quarters, as well as the Spacetime Construct Studio that he established as part of the Athena Foundation. The mission of Spacetime, which sponsored the Outdoor Studio and the Emerging Artist Fellowship programs, was to provide artists with studio space and the wherewithal plus a small honorarium to create large-scale works in a noncompetitive communal setting. Mark hoped this would foster the creative process and a climate of experimentation, which indeed it did.

Spacetime—and later, Socrates Sculpture Park—met a desire on the part of a growing number of sculptors to make large-scale works without bases. Sculptures are usually placed on pedestals to raise them so that they are easy to see. The base is supposed to be ignored. But in our time, artists have perceived these pedestals, which often are bigger than the works they support, as sculpturally meaningless forms. In reaction, many contemporary artists have simply removed these supports and placed their sculptures directly on the floor or ground. To raise them to eye level or above, however, they have had to enlarge their works, often to proportions that cause them to seem cramped in gallery, house, or even museum rooms, and are suitable primarily to outdoor sites.

The Athena awards have turned out to be of critical importance to artists exploring large-scale projects. One of the participants, Ursula von Rydingsvard, summed up the sentiments of her fellow artists: "The Athena Foundation has

enabled me to build several pieces, the largest of which required the use of a hoist (my first). It was a pleasure to work on a spacious pier with lunches overlooking the East River, with handsome men working about and enough space to the sides and above to give me courage to face and negotiate the more difficult problems in my work. The Athena Foundation is a generous conception, having given me generous quantities of space at a time I needed it."[2]

<center>///////</center>

Adjacent to Mark's working space and the Spacetime Construct Studio was a four-and-a-half acre abandoned lot owned by the City of New York that was being used illegally as a dump site. It was on this garbage-littered parcel of riverside landfill that the Athena Foundation proposed to locate Socrates Sculpture Park. In 1985, New York's Board of Estimate granted the foundation a five-year lease on the lot at one dollar a year. In return, Athena agreed to clear and landscape the site, put in a walkway and railing at the water's edge, erect a sign, install sculpture, and open the park to the public free of charge. At the time, the Park was underwritten by the Athena Foundation for four hundred thousand dollars, with funds provided by local businesses, private patrons, the city, and most generously, by Mark himself. It got a big boost from Mayor Ed Koch, who was an enthusiastic supporter. In a press release at the time, he said: "The Socrates Sculpture Space…will transform a vacant lot into a cultural facility, improve the waterfront, and create an opportunity for artists and young people to work and learn together." He should have said "all the people."

The rubble-strewn eyesore that the Athena Foundation leased had spectacular views. It looked out over the East River and the northern end of Roosevelt Island onto the Manhattan skyline beyond. The attractiveness of the setting was enhanced by glimpses of Mark's soaring constructions. The beauty of the prospect notwithstanding, the lot itself was "garbage-land," as Mark termed it. I recall how discouraged I was when I first saw it. My initial thought was: How will we ever get rid of this junk pile? But Mark was not at all put off. He hired some hundred unemployed neighborhood youths (mainly from low-income housing projects nearby) who worked for a year to clean up the polluted wasteland. This provided them with

employment, instilled in them pride in *their* community and its sculpture park, and created a sense of protective loyalty to it. (Happily, the Park has been relatively free of vandalism and graffiti.)

The Park was built under the direction of Enrico Martignoni. Although its development has been piecemeal and ongoing, within a few years of its inception Socrates had already won prizes for its design—despite "an endearing scrabbliness."[3] It also has received commendation as an urban-renewal project and has garnered considerable coverage in art and architectural publications. In 1995, Socrates Sculpture Park was selected from among two hundred nominated sites as one of the "Great American Public Places" by a panel of architects, designers, writers, and developers. Among the other sixty-three winners of the yearlong search to identify outstanding models of the built environment, sponsored by the Lyndhurst Foundation of Chattanooga, were Central Park in Manhattan, the Brooklyn Bridge, and New York's Grand Central Terminal.[4] In 1988, Socrates received the Albert Bard Award in Architecture and Design from the City Club of New York.

The Park immediately attracted large numbers of people both from the international art world and from the surrounding Greek, African American, and Hispanic neighborhoods. They came not only to experience the sculpture but also to relax in an informal and convivial atmosphere. Children played on the grassy areas and shinnied up the sculptures, families picnicked, and visitors sunbathed, fished, and strolled, walked their dogs, or jogged through its meandering pathways, and otherwise unwound. And the scene remains much the same today.

Having built the Park, the next problem was holding on to the land and protecting it from the threat of developers who eyed the site greedily once it had been cleared. One developer offered to build three hundred upscale co-ops, a marina, a boardwalk, and a row of stores. Fortunately, art-for-the-many won out over profit-for-the-few. The enthusiastic support of the community was of crucial help in maintaining the Park.

Mark's egalitarianism, however, occasionally presented difficulties, for example, at the Socrates board meetings, where attendees included Richard Bellamy,

Mark's friend and dealer; Anita Contini; Socrates employees; moneyed "suits"; artists; neighborhood folk; including teenagers and seniors; and, it seemed, just about anyone who happened to be around that day. I recall one meeting at which fund-raising was the main topic of discussion. The "suits" and I began to talk with long faces about approaching private patrons, not-for-profit organizations, and corporate sponsors who might contribute to the heavy costs of running the Park. Then a young person who could not have been much older than sixteen proposed baking cookies, and an earnest discussion ensued as to what kind of cookies, how much to charge, and where to sell them. It was utterly delightful. Luckily, larger grants also were obtained.

///////

The exhibitions at the Park are diverse, invariably inventive and surprising, and feature works by young artists. Thus far, some five hundred artists have shown their work at Socrates. These exhibitions, which change twice a year, are too numerous to list in this essay, but I would like to recall the shows of the first few years, which remain etched in my memory. The "Inaugural Exhibition," consisting of fifteen large-scale works and multimedia installations, opened in September 1986. Sculptures by artists including Bill and Mary Buchen, Rosemarie Castoro, Lauren Ewing, Linda Fleming, Paul Pappas, and Salvatore Romano and a mural painting by Richard Mock were made in situ, transforming the Park into a kind of open studio, workshop, and laboratory. These and subsequent works exhibited at Socrates have raised critical questions about the nature of art in public places, namely, the relation of the work to the site, the kind of work that is most effective in its public setting, and why, and, more generally, how art can rejuvenate public life and art.

The "Inaugural Exhibition" was followed in May 1987 by "Sculpture: Walk On/Sit Down/Go Through," consisting of site-specific works that called for viewer participation. The sculptural installations in "Artists Choose Artists," which opened in November 1987, were chosen by artists who had previously shown at the Park, and in the following spring Socrates mounted "Sculptors Working." In July 1988, building on the popularity of the exhibition openings, which featured

music, dance, film, and theater performances, the Park expanded its scope to present "Socrates Live," a festival of dance, theater, and music.

As if Socrates did not have enough to do—maintaining the Park, supporting the Outdoor Studio and Emerging Artist Fellowship programs, organizing two major shows each year, and hosting upward of sixty thousand visitors—on top of all this, they also conduct an education program for young people. Since its inception in 1990, this series of in-school, after-school, and summer workshops has involved more than 1,300 children a year enrolled in local schools and organizations in all five New York boroughs. There is also a Community Works Initiative program that trains and employs residents from the neighboring housing projects.

Not surprisingly, Mark and Socrates Sculpture Park have received art-world and public recognition. Among its many honors, in 1987 Mayor Koch presented Mark with the Doris Freedman Award for "contributions to the people of the City of New York that greatly enrich the public environment." In 1998, in confirmation of the growing role that Socrates Sculpture Park plays in the lives of residents in the surrounding neighborhoods, the New York City Department of Parks and Recreation incorporated Socrates as a city park. At a dedication ceremony, which drew artists, people from the community, and prominent local politicians, Mark summed up Socrates Sculpture Park's achievement: "The true art of this age is all around you. We have shown great international artists here: Ronnie Bladen, Eduardo Chillida, Beverly Pepper, Tony Smith, Richard Stankiewicz, and younger artists have come here and become nationally recognized." He ended his remarks by saying: "So on this glorious day I ask you to give to the Great Spirit, the Earth Mother, and the flowing river three yippees! Yippee! Yippee! Yippee!"

1 The other board members were Anita Contini, President, Director of Programming for the World Financial Center at Battery Park, New York; Barbara Haskell, Curator at the Whitney Museum of American Art, New York; and Ruth Cummings, documentary film producer. The board advisors were Mark di Suvero, Isamu Noguchi, and Susan K. Freedman, President of the Public Art Fund in New York.

2 Ursula von Rydingsvard, "Artists' Statements," *Athena Foundation 1977–1986* (New York: The Athena Foundation Inc., n.d.)

3 Alfred Sturtevant, "Socrates Sculpture Park: An Open-Air Studio Across the River," *Stroll* (October 1987): 58–61.

4 John Toscano, "Socrates: Local Park with International Outreach Educates, Entertains," *The Western Queens Gazette*, September 3, 1997, 1, 31.

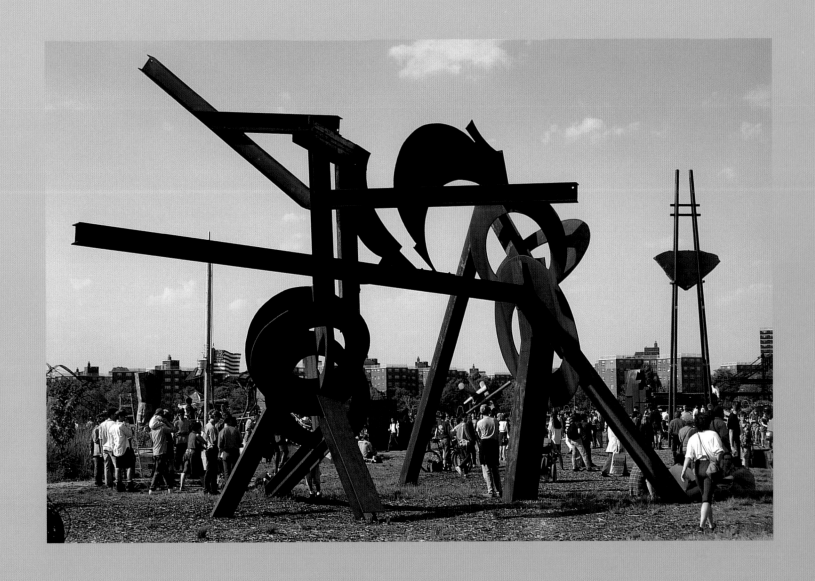

MARK DI SUVERO, *Lao Tzu*, 1992

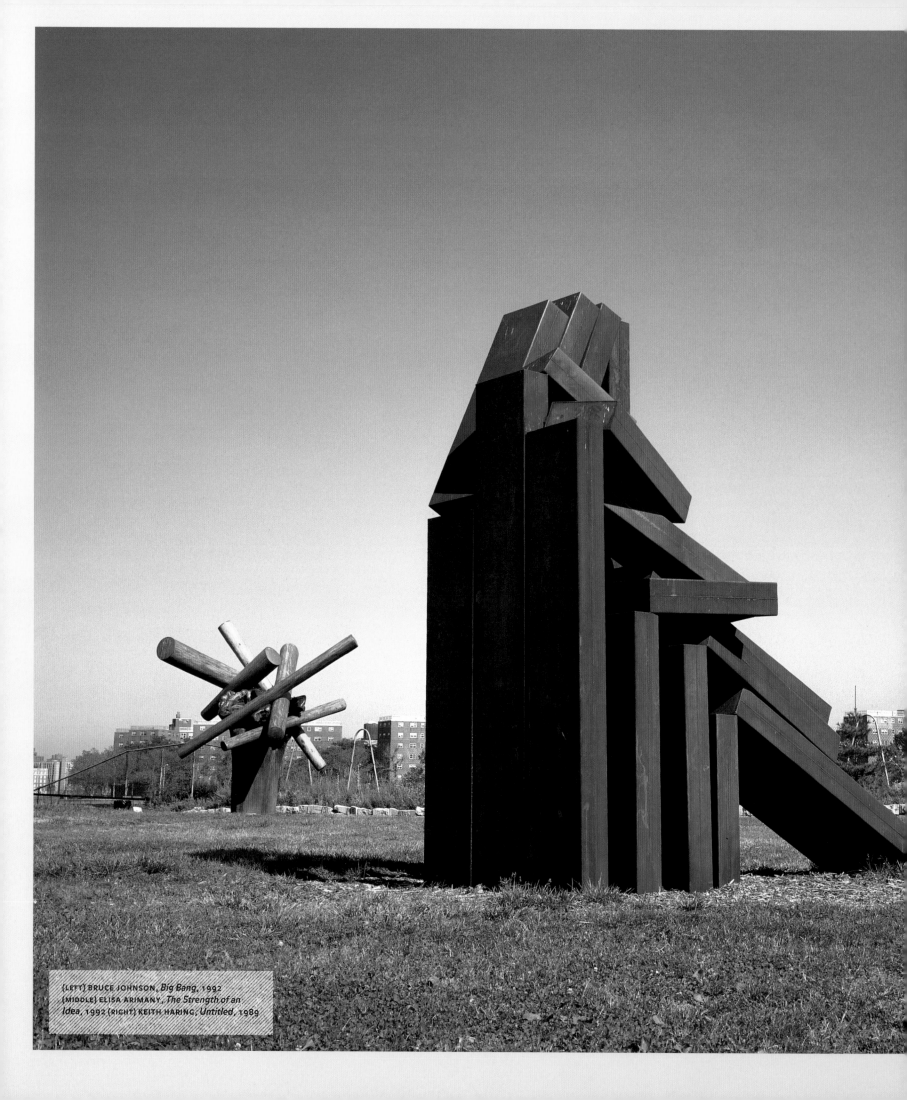

"Socrates is a unique place. I've never encountered anything else like it. As an institution, Socrates is committed to supporting and showing new and experimental outdoor works and to creating a real connection to its own interesting and diverse neighborhood. The people I met there while working on my project felt a real ownership in Socrates, which is uncommon for most of the art centers I've encountered."

HARRELL FLETCHER, artist

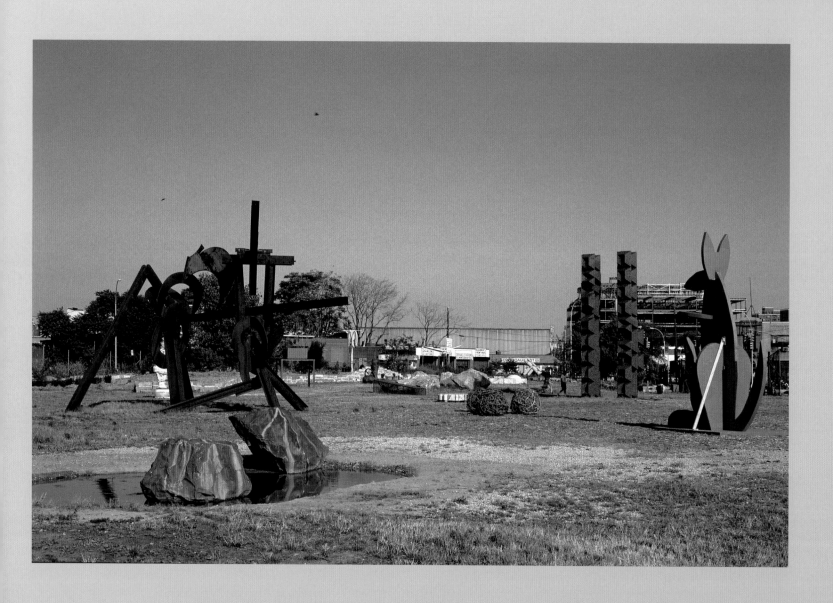

Park overview, 1992

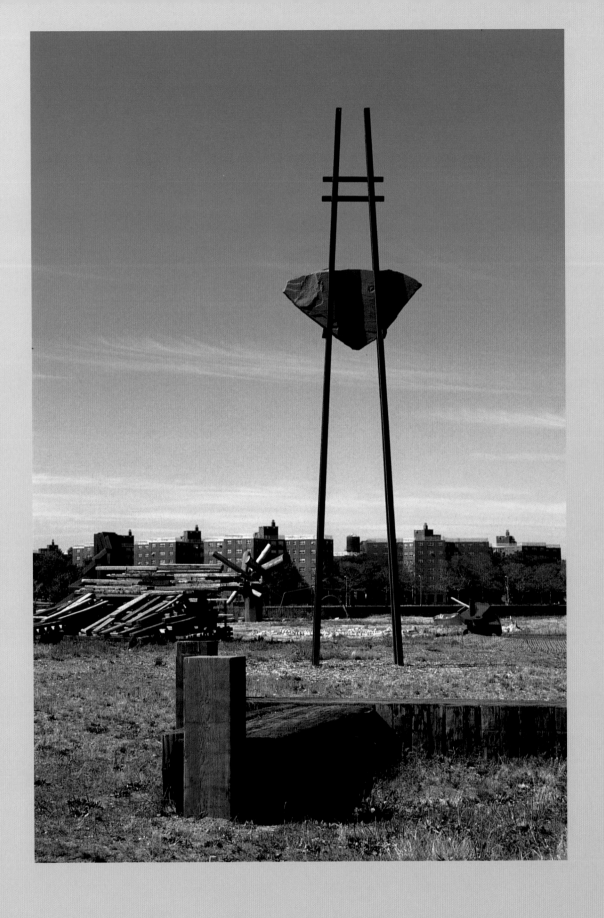

DEL GEIST, *Clavis Tower*, 1993

BARBARA EDELSTEIN AND JIAN-JUN ZHANG,
Water Rocks, 1993

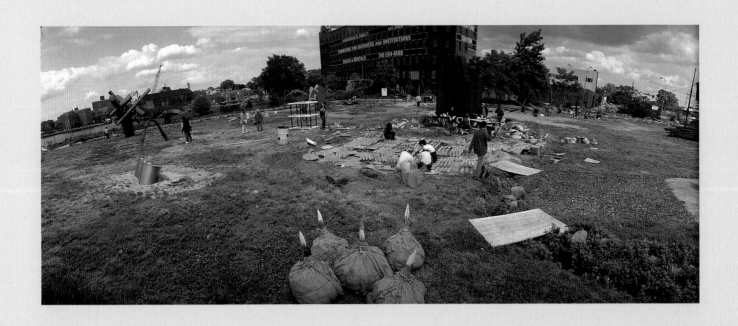

(TOP) Installing "50NY93," 1993 (BOTTOM)
Installing Itty Neuhaus's *Bag of Night*, 1993

"Socrates Sculpture Park,
with its unique location overlooking
Manhattan, provides important
support for emerging artists
in today's art world. The Park's
program allows artists the
invaluable opportunity to
experiment with creating new
works and is a great place to see
the vitality and energy so
present in today's art world."

GLENN D. LOWRY,
Director, The Museum of Modern Art,
New York

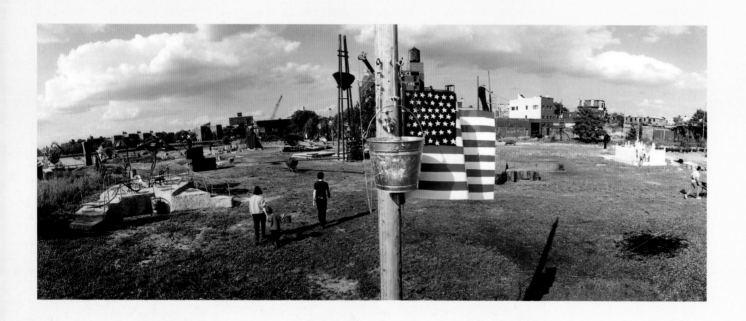

GEORGE MANSFIELD AND KAZUMI TANAKA,
Half Mast, 1993 (DETAIL)

ANTOINETTE AYRES, *From Here to There*, 1993

EVE SUSSMAN

A Mirage Upriver

...sometime in the mid-1980s, not long after moving to New York I came across a mirage. It was a strange inexplicable vision. Throngs of people milling in a vacant lot on the edge of the river; there was loud music, beer; across the field there were lots of colors, reflective shiny things, and unusually large objects—anomalies. A pagan celebration of a tribe just landed— I squinted to try to make out who the crazy people were in the distance— the whole scene a non sequitur in an otherwise desolate landscape.

I saw this mirage while passing a vacant lot in an industrial neighborhood in Queens. As quickly as it appeared it disappeared. Illogical, it was soon forgotten, or rather delegated to that part of brain where one puts things that make no sense.

Seven years later, in the summer of 1993, the vision would come back to me. In a flash of recognition when the brain dislodges a lost memory, the illogical becomes logical, something that meant nothing suddenly means a lot, like falling in love with someone whom you've passed on the street everyday for years.

When I opened my first show as director of Socrates Sculpture Park in 1993 I had a strange déjà vu feeling. I was sure I had been there before. The fleeting memory became clear—what I had passed coincidently seven years earlier on my way somewhere else was the first Socrates Sculpture Park opening. I had no way of knowing the inexplicable event I saw fleetingly in 1986 was a ritual in which I would become seriously involved. I met those crazy people in the distance and joined them.

Socrates then was a microcosm of the Wild West and a circus. In those early days it was a law unto itself. The place was exciting, explosive, it buzzed. Art got made and within and around it every day was another saga. Freight containers were the architecture of choice. My assistant director, Maria Mingalone, and I worked in one. Artists camped out in them. They made work, threw fits, got hurt, got better, celebrated, built bonfires; hearts got broken, people got married, films got shot, work went up, shows opened, work came down, the ground flooded, dried out again, and a new crop of sculptors appeared. It was not an institution, not a venue, not a non-profit space. It was an art farm.

These days when I pass the Park I am reassured that the same inexplicable mirage upriver that I happened upon twenty years ago is still there—an illogical-logical place, full of new anomalies that sprout every year—a non sequitur in the landscape.

ZACHARY COFFIN, *Fly*, 1993 (DETAIL)

DAVID KRAMER, *Harvest*, 1993

BOB HAOZOUS, *Border Crossing*, 1991 (DETAIL)

Park overview, 1994

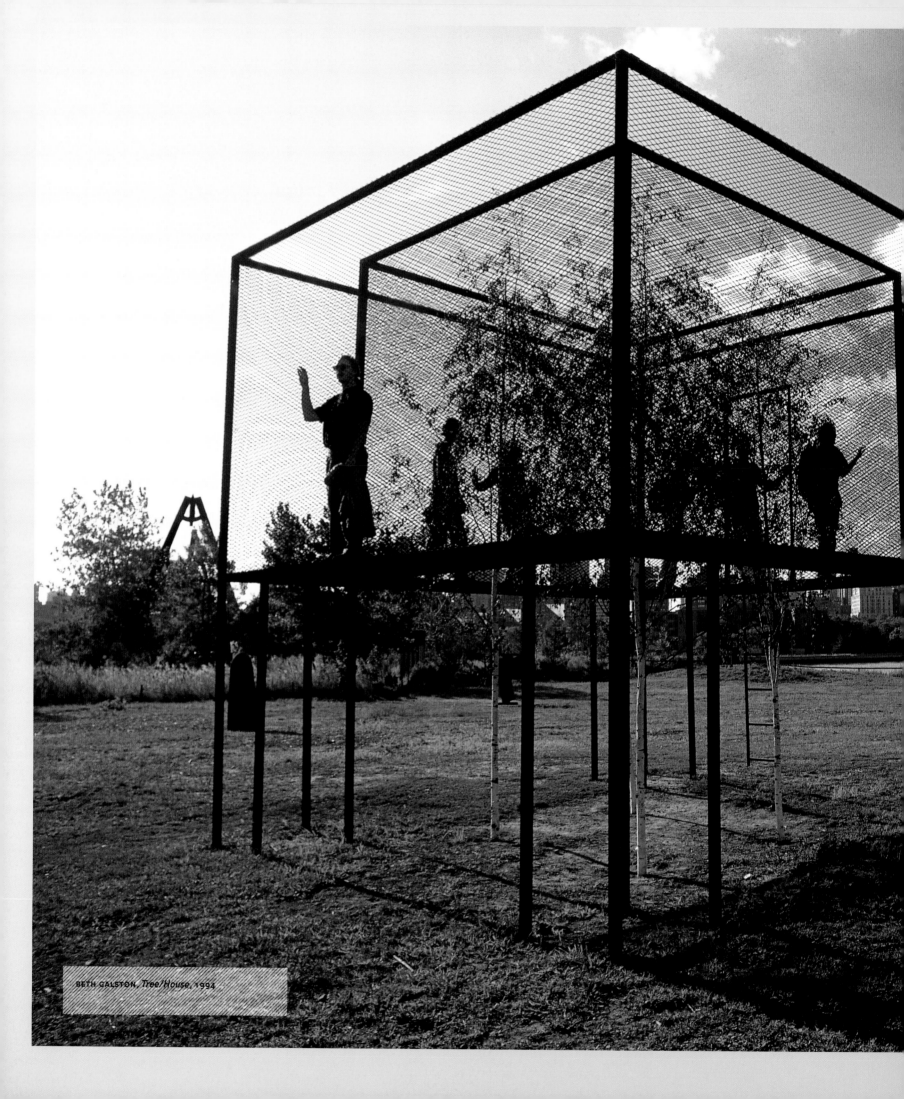

BETH GALSTON, *Tree/House*, 1994

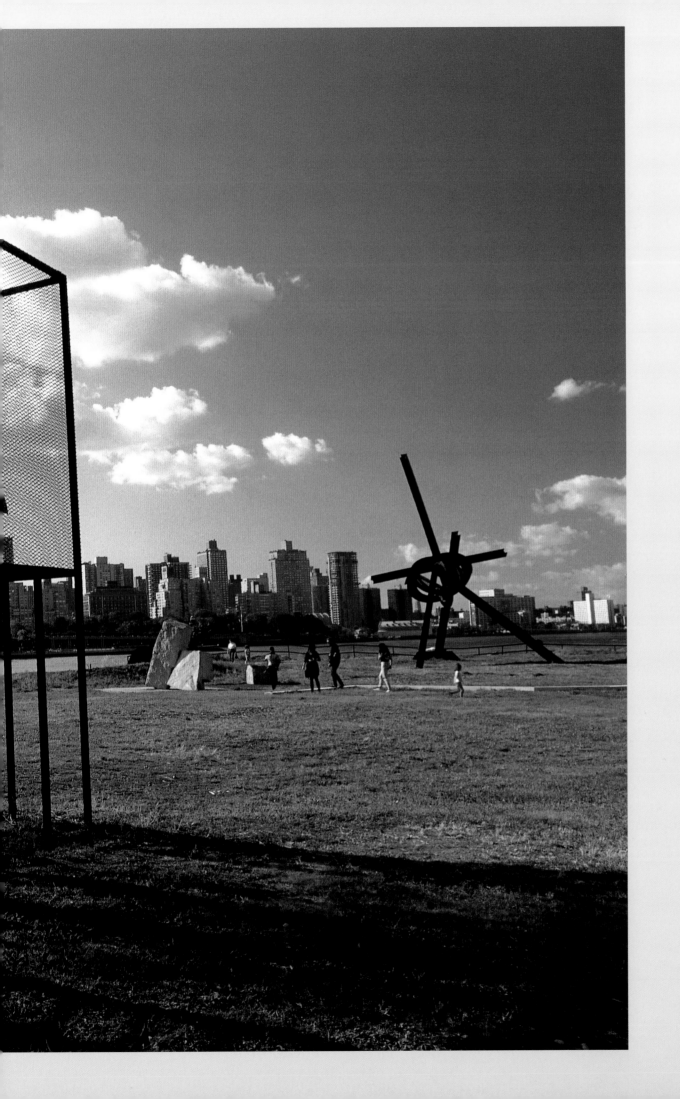

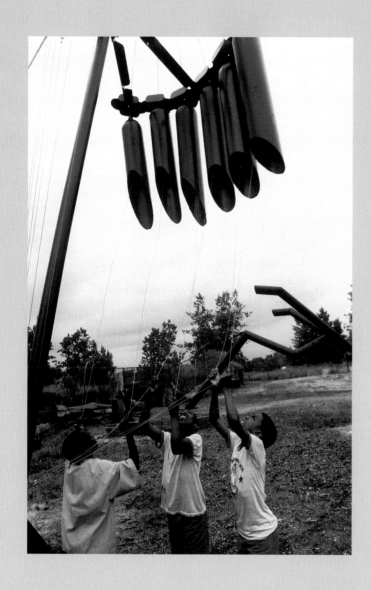

"Socrates was an unlikely
idea in an unlikely place and yet
I've seen it transformed from a
vaguely threatening corner
lot to a welcoming public park.
The artworks and the audience
who mingle with them go
perfectly together.
 The success of this Park
demonstrates how people who
care about the larger picture can
make a huge difference."

JENE HIGHSTEIN, artist

ZACHARY COFFIN, *Belltower*, 1994 (DETAIL)

NANCY RUBINS, *Veins, Connections and Points of Departure: Memorial for Peter Kunz,* 1990

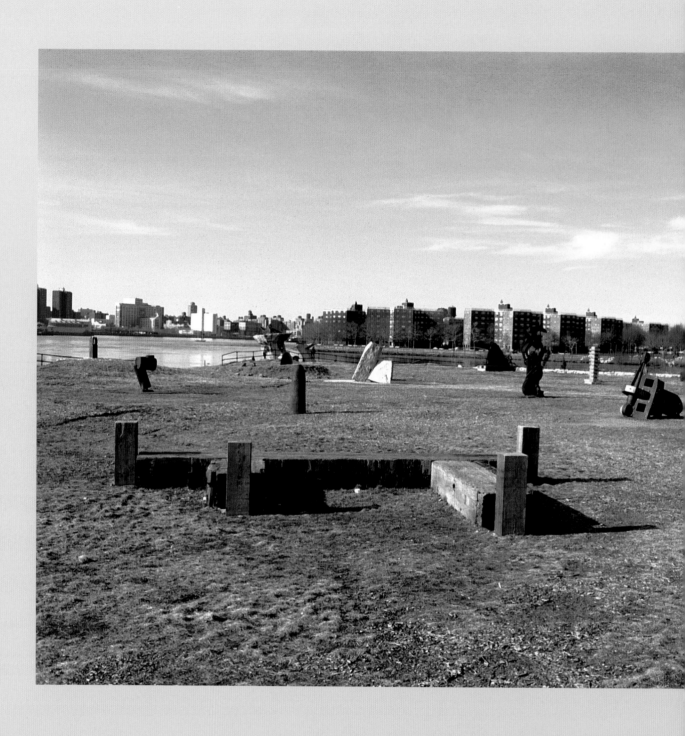

Park overview, 1994

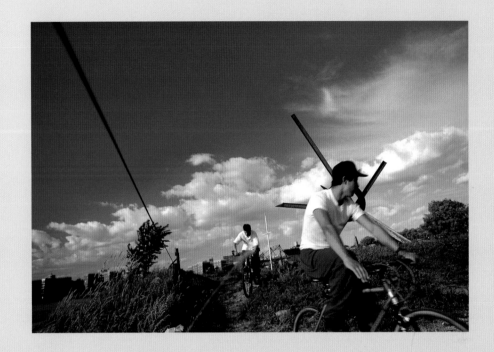

"From the outset, Socrates has played a community role. It employs young people from the neighborhood and the local schools in a variety of capacities. On another level, it is a positive force in this urban environment....Socrates occupies a special place in the greater New York park system as an invaluable venue for the presentation of art activities in the region. It is the only such open, public-owned space in the greater New York area, and in fact the only one in the Northeast metropolitan areas."

MARTIN FRIEDMAN,
Director Emeritus, Walker Art Center,
Minneapolis

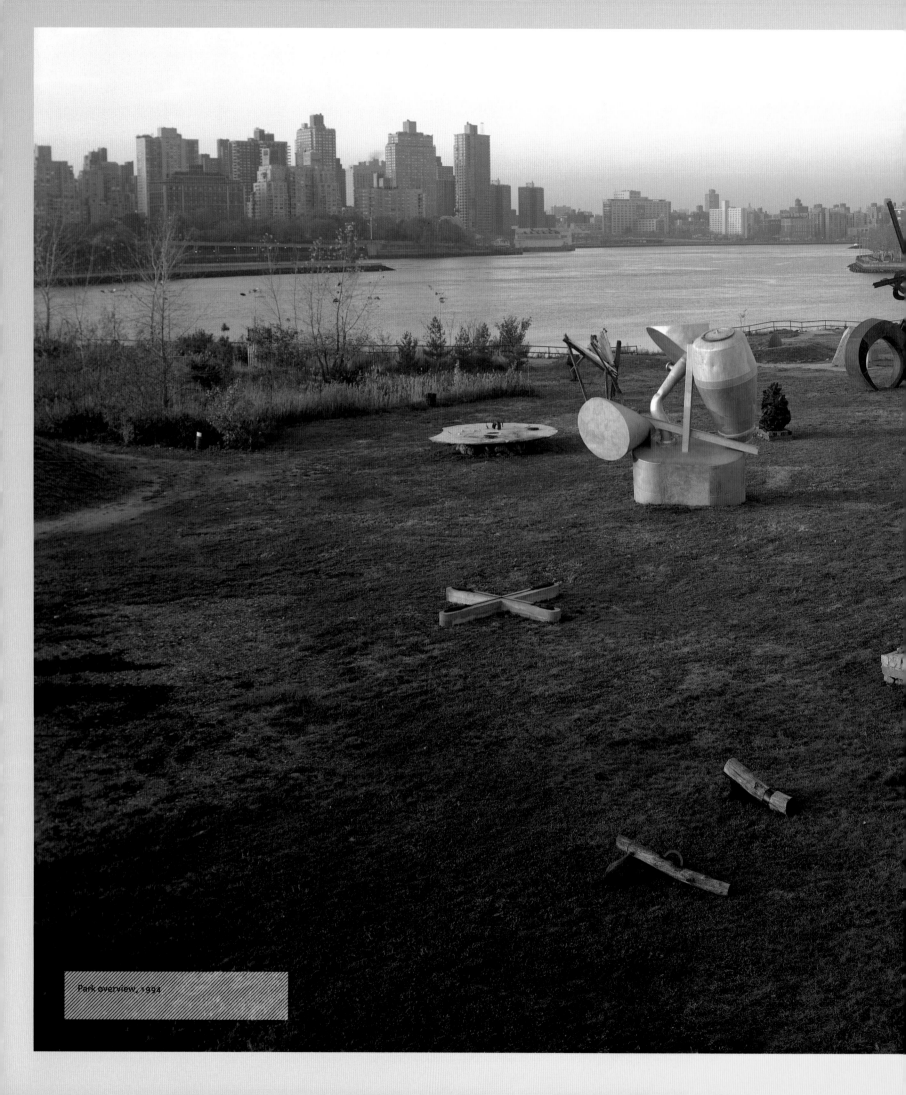

Park overview, 1994

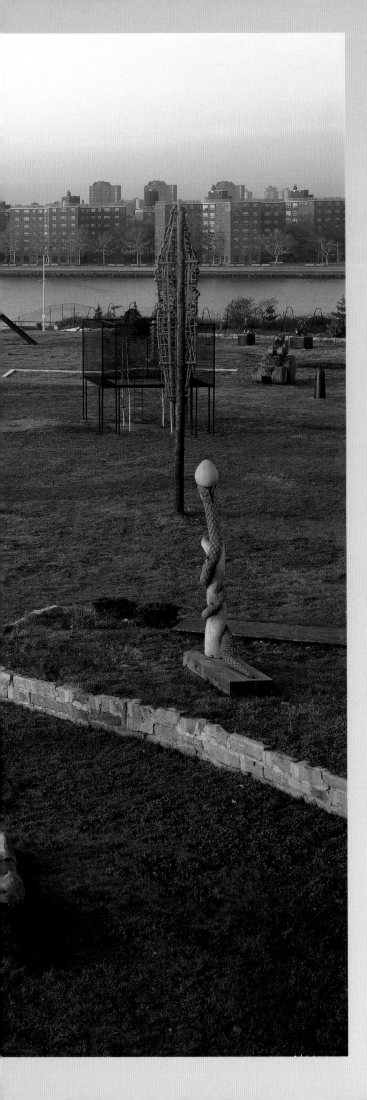

"I believe Socrates Sculpture Park successfully illustrates why it is so important to preserve open spaces, places that can accommodate a large number of people. Everyone from all five New York boroughs can come and enjoy the different kinds of sculpture and landscaping. Many of the works also integrate with the water in unique ways. No other place in the city has sculpture in an open space so available to people, on such a magnificent site."

AGNES GUND, President Emerita, The Museum of Modern Art, New York

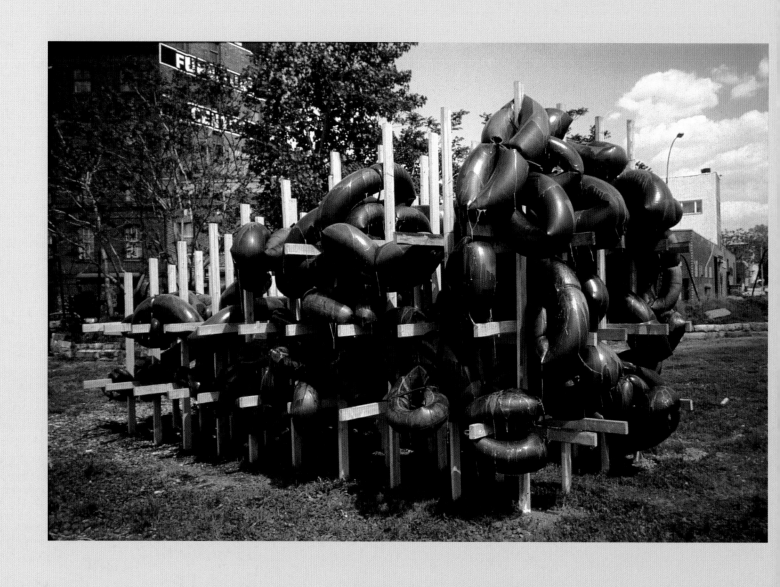

BRAD KAHLHAMER, *Corn Crib II*, 1995

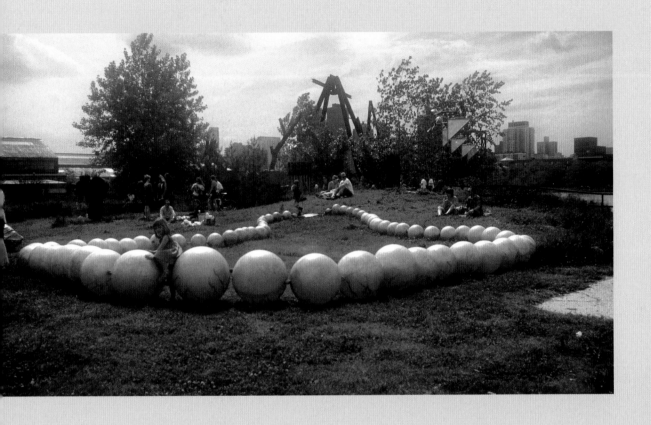

KARIN GIUSTI, *The World Is Your Oyster*, 1990
(DETAIL)

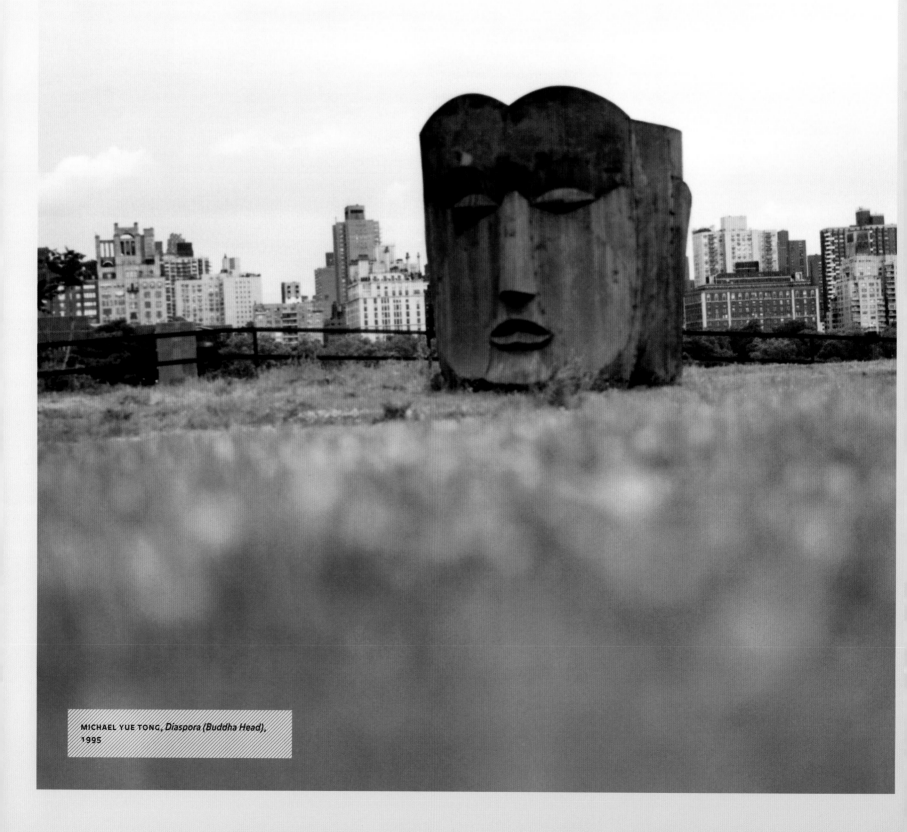

MICHAEL YUE TONG, *Diaspora (Buddha Head),*
1995

KATE D. LEVIN

'Round Art

At Socrates,
the viewer is always looking at
sculpture through other sculptures.
Looking at the City through the art;
looking at the art through the
City—and other visitors, and the
landscape, and random manifestations
of urban life like cars, boats, and
increasingly, blessedly, birds, ducks,
egrets, and one year, a swan.

There are so few places to see art
in the round like this, partly because
of the distinctions imposed by different
creative disciplines. Theater, dance
and music, even if they're done
outdoors, have a backstage of some
kind. And the rest of the visual art
world functions with an urgent and
often masterful regard for controlling
what the spectator sees through
lighting and design in museums and
galleries. Three-dimensional work
seen in a three-dimensional backdrop
(Socrates even smacks of four
dimensions on some days) is hugely
challenging. At the Park, however,
the visual jam session of things to look
at makes everyone a little bit of an
artist: you have to choose what
to see, how to focus, how to handle

the palate of forms competing
or collaborating for your attention.

This is not merely about
authorizing peripheral vision. The
entire process of making art happens,
in real time, at the Park. Artists tackle
technical problems, have setbacks,
succeed stupendously, get rained and
snowed on, get exhilarated, get into
conversations with other artists,
neighbors, visitors and their children:
the work gets installed, changed, taken
out, in full view of the community
that makes the Park by coming to it
over the 365 days a year it is open.

Socrates is singular in dignifying
the making and seeing of sculpture.
The practice seems obvious, even easy,
but it's not. The courage, generosity,
and inevitability with which the
Park shares the process are signs of
enormous pride in its artists and
respect for its visitors. The result is
the potential, so often fulfilled,
of an extraordinary reciprocity of
creativity, discovery, and joy.

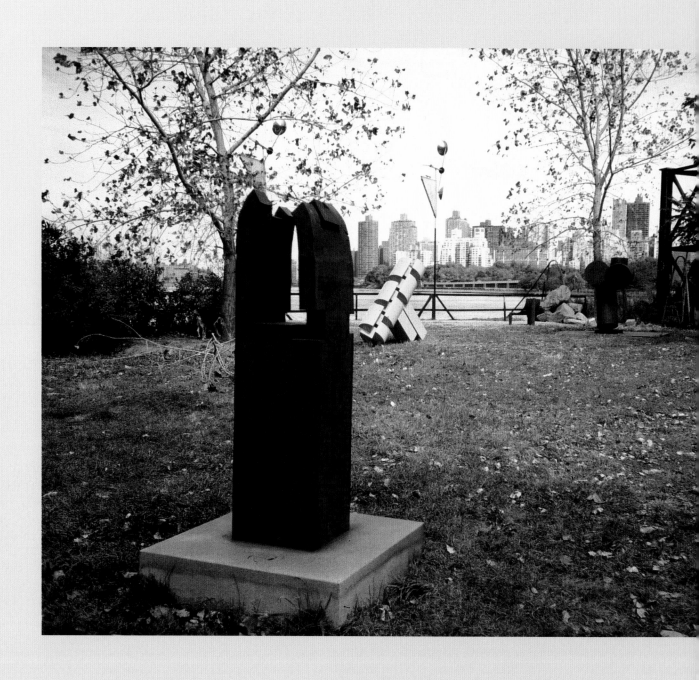

(LEFT) EDUARDO CHILLIDA, *Stele of Gernika III*, 1987 (MIDDLE) SEBASTIAN (ENRIQUE CARBAJAL), *Teponaxtli*, 1989 (RIGHT) RICHARD STANKIEWICZ, *#4*, 1973

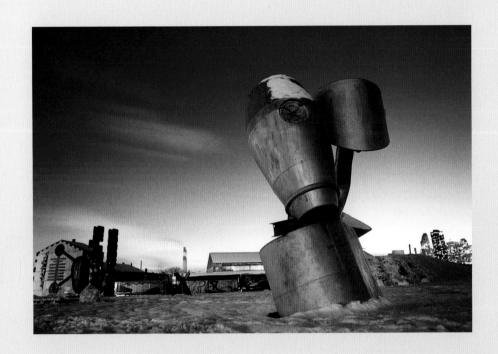

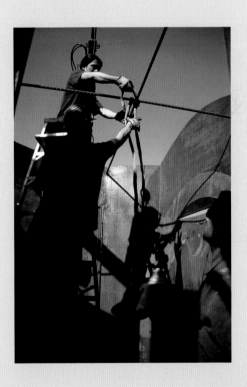

(TOP) JOHN HOCK, *Prometheus*, 1994
(BOTTOM) Installing Michael Yue Tong's *Diaspora (Buddha Head)*, 1995

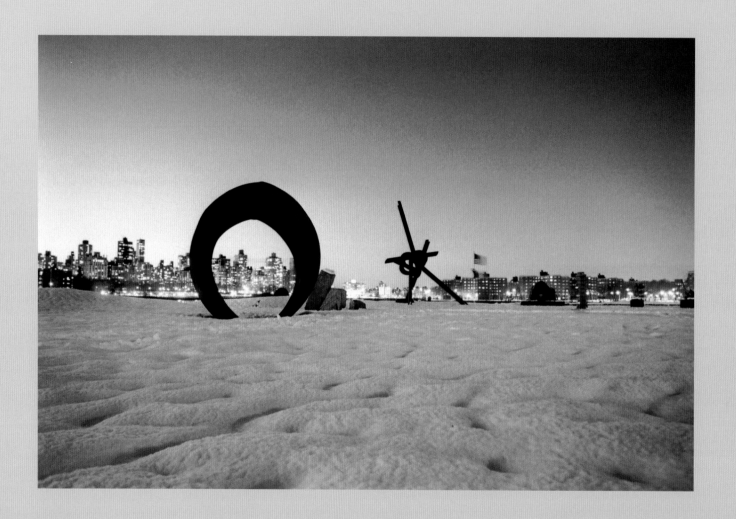

Park overview, 1995

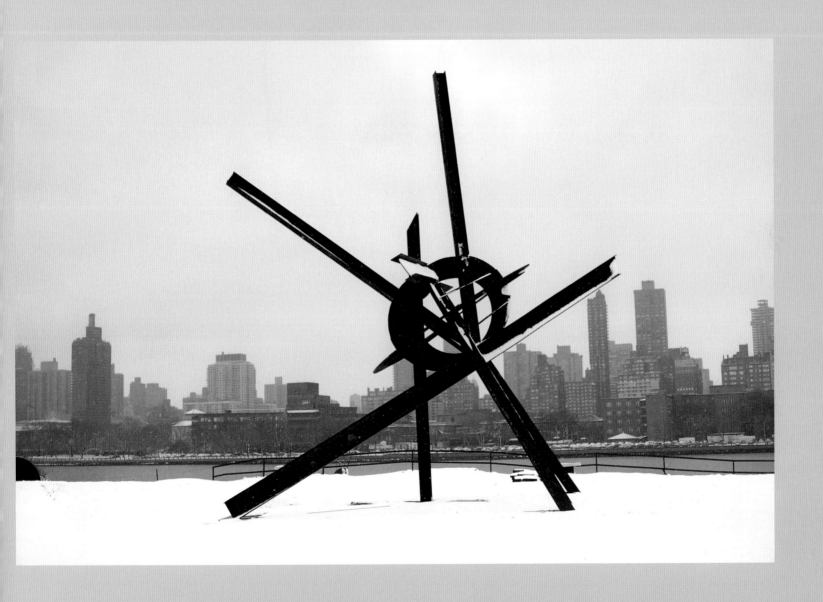

MARK DI SUVERO, *Galileo*, 1996

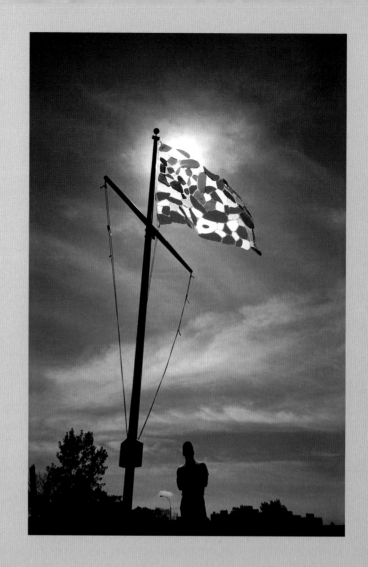

(TOP) JOHN MORSE, *Mosaic Flag*, 1996
(BOTTOM) John Clement, 1996

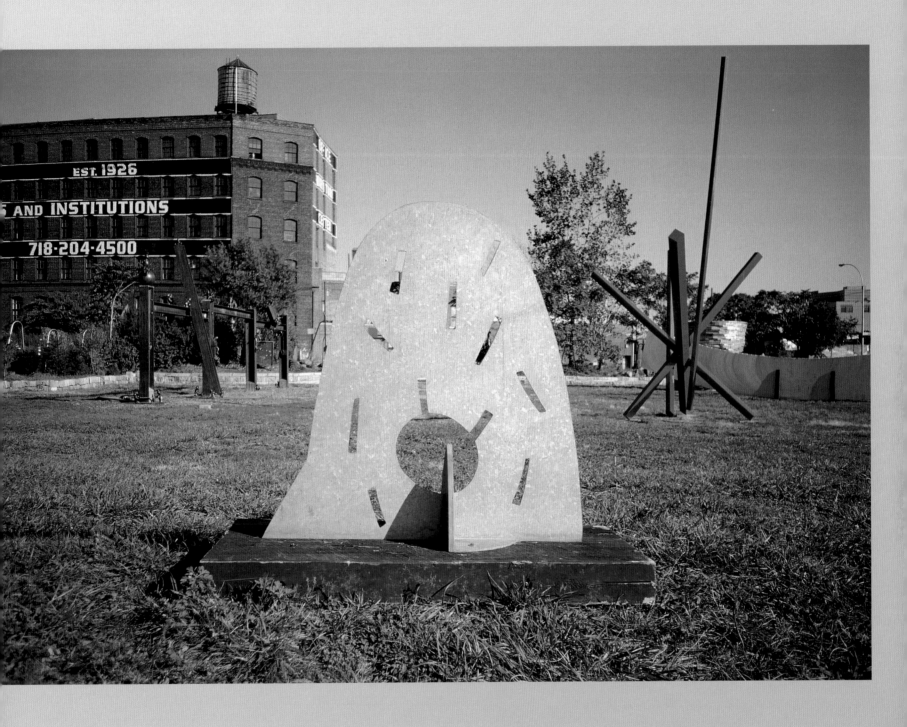

EST. 1926

AND INSTITUTIONS

718·204·4500

(LEFT) TOM OTTERNESS, *Life Underground*, 1995–96 (MIDDLE) ISAMU NOGUCHI, *Atomic Haystack*, 1982–83 (RIGHT) JOHN HENRY, *Santa Fe Moon*, 1996

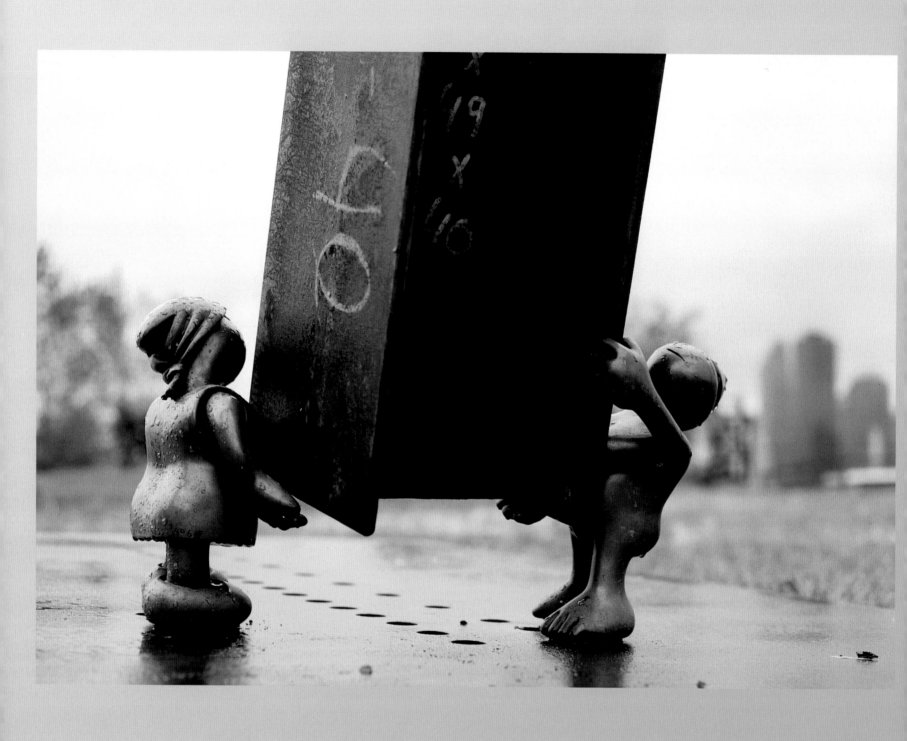

TOM OTTERNESS, *Life Underground*, 1995–96
(DETAIL)

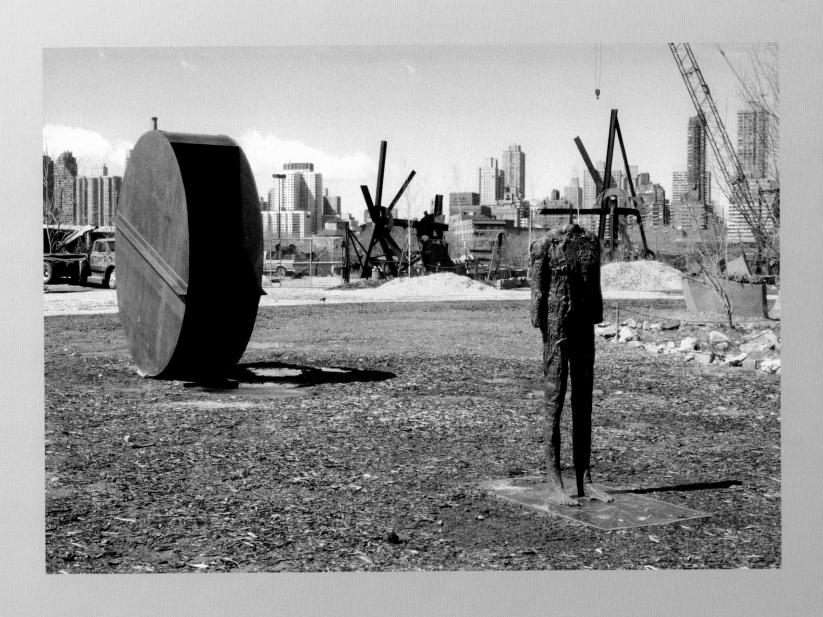

MAGDALENA ABAKANOWICZ, *Standing Figure with Wheel*, 1990–93

KATHLEEN GILRAIN, *Burial/Birth*, 1995

KATHLEEN GILRAIN

The Socrates Years

My introduction to Socrates Sculpture Park came in the spring of 1995, when I was invited to make a sculpture for the exhibition "Pop Up." Eve Sussman was the director at the time. I had a wonderful experience working alongside other artists in the outdoor studio space. The technical staff, including artists John Clement, Joel Graesser, and Peter Lundberg, were always there, rain or shine, working on their own projects. They were a great inspiration and set the bar for the invited artists to roll up their sleeves and get to work. In March it was cold, in April it rained, but we kept at it and managed to make our work. The show opened in May with nine new large-scale sculptures.

While I was working on my piece, I learned that Eve was planning to leave her position at Socrates. I was eager for the job, and my enthusiasm and tenacity won everyone over. Just before Eve left, she, Maria, and I all met with the program officer of the Edward and Sally Van Lier Fund at The New York Community Trust and took her on a tour through the Park. We wooed her with the Wild West of Queens, the open space, the cool breeze on a hot August day, and the surrealism of the place. I think she fell in love with the Park, just as we all did on our first visit. A few artists were there sweating it out, making new work for the September opening. Mark rode across the Park on his bicycle with his cane slung over the handlebars like a cowboy. There was a man fishing, and the guy who played his horn in one of Bill and Mary Buchen's sculptures. Stephanie, Anthony, and other neighborhood residents and members of the Socrates Community Works Initiative program were working on the garden beds, planting some rare and beautiful gifts from the company Plant Specialists, and children were climbing on Chakaia Booker's rubber tire sculpture and screaming with delight. Shortly after this tour, Socrates received a significant grant that greatly expanded its exhibition program by creating Emerging Artist Fellowships. This initiative has flourished, and for many artists, it provides their first opportunity to make a large-scale, outdoor public work of art and an experience they will never forget.

I had many valuable experiences in the five years I was at Socrates, but the most important lesson I learned was respect—respect for the efforts of the artists and my co-workers. The artists included all types, from emerging to famous, unskilled to highly skilled, well adjusted to socially challenged, modest to arrogant. The members of the Socrates staff had an even more diverse range of skills, experience, and education. They included members of the local Long Island City/Astoria community, who helped install the exhibitions and maintained the landscaping and gardens, and the technical and administrative staff were all artists themselves. This continues to be one of the unique strengths of the Park: everyone brings different gifts to the table at Socrates, and everyone comes together to make it work.

RENEE KILDOW, *Resurrection*, 1996

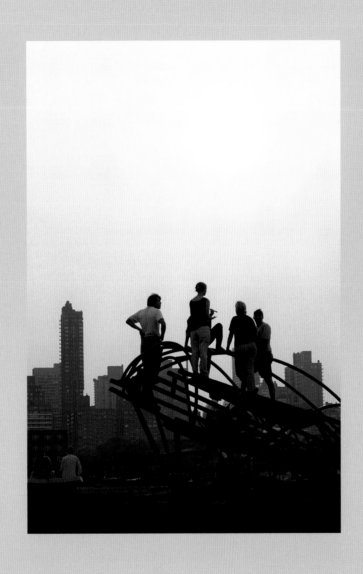

JOHN CLEMENT, *Kolmos Kosmos*, 1996 (DETAIL)

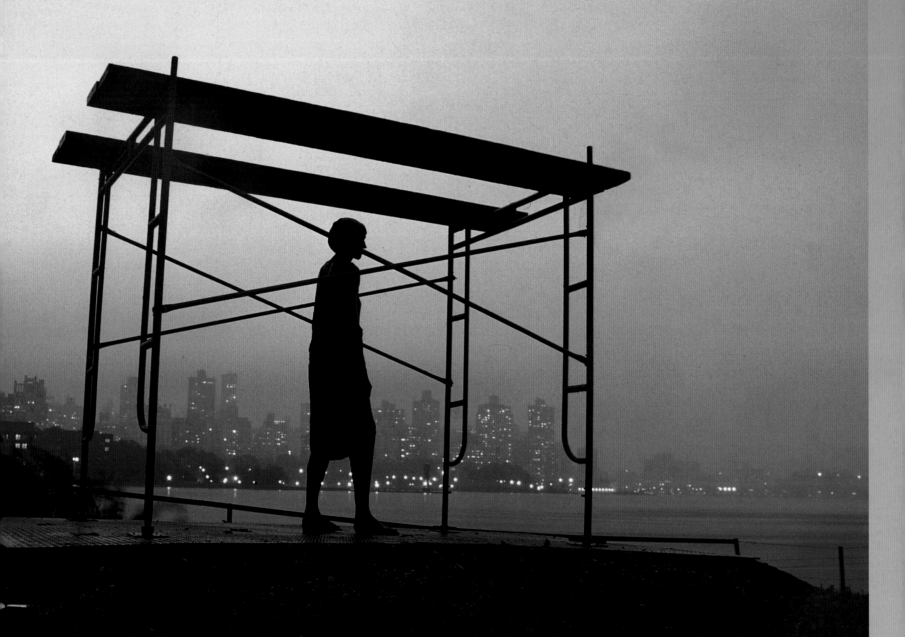

GEORGE SEGAL, *Woman Walking Under a Scaffold*, 1989

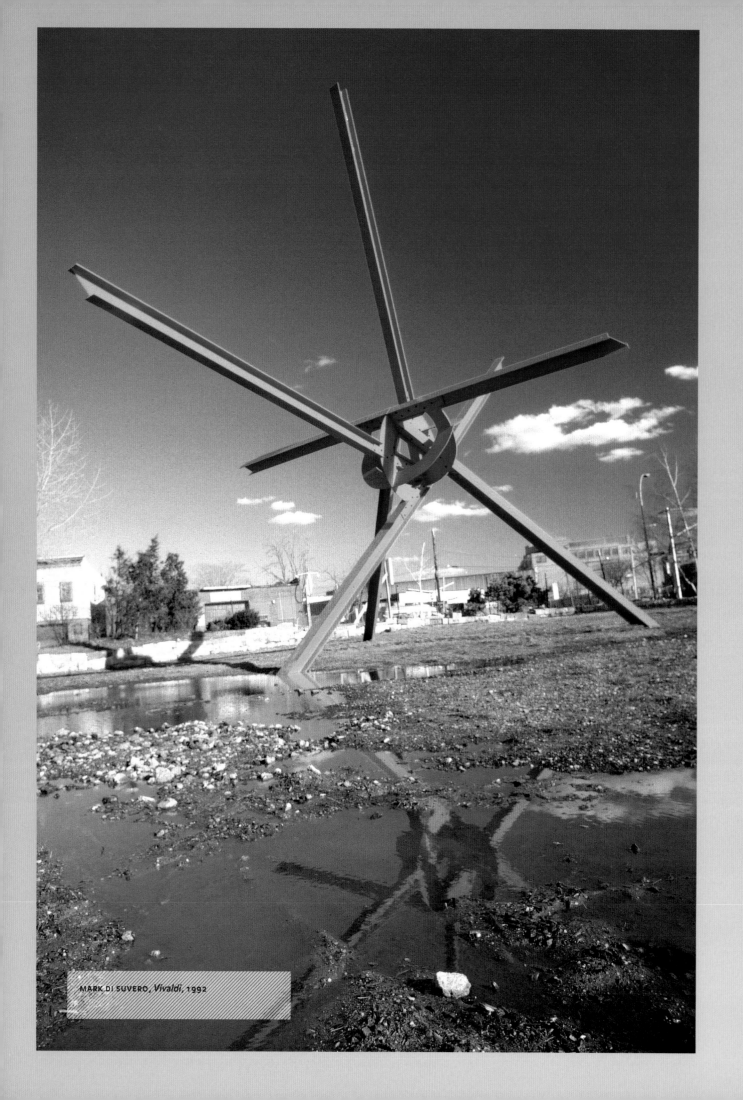

MARK DI SUVERO, *Vivaldi*, 1992

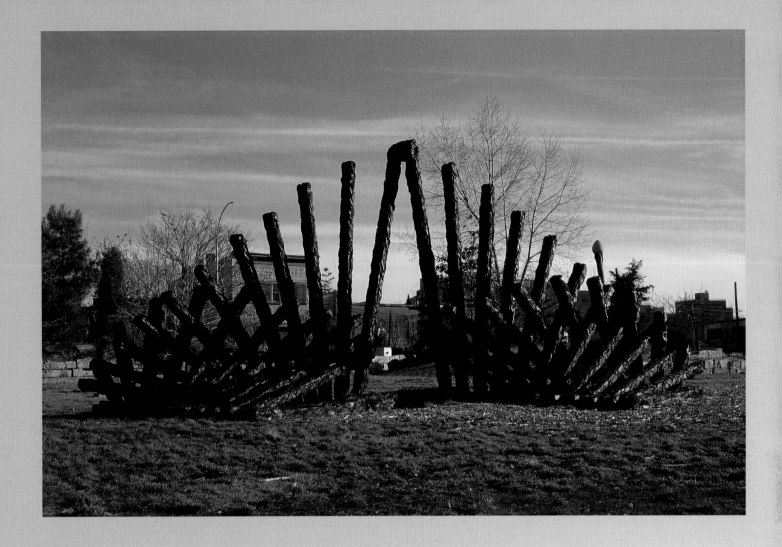

(TOP) CHAKAIA BOOKER, *The Conversationalist*, 1997 (BOTTOM) Chakaia Booker, 1997

"The most important social function of this Park lies in its ability to join the public's interest with the working spirit of artists. Curious about each new installation, people come to watch how the site is transformed by artworks, sometimes even participating in the effort. Unlike a museum, where the artist's work is displayed as complete, Socrates offers an opportunity to see how artists achieve their vision—often through accident and unanticipated events brought about by weather and the nature of being in the changing environment of the outdoors. In addition to being about art, Socrates is about having a good time in the open expanse of a remarkable place."

HUGH HARDY, FAIA,
Principal, H³ Hardy Collaboration
Architecture

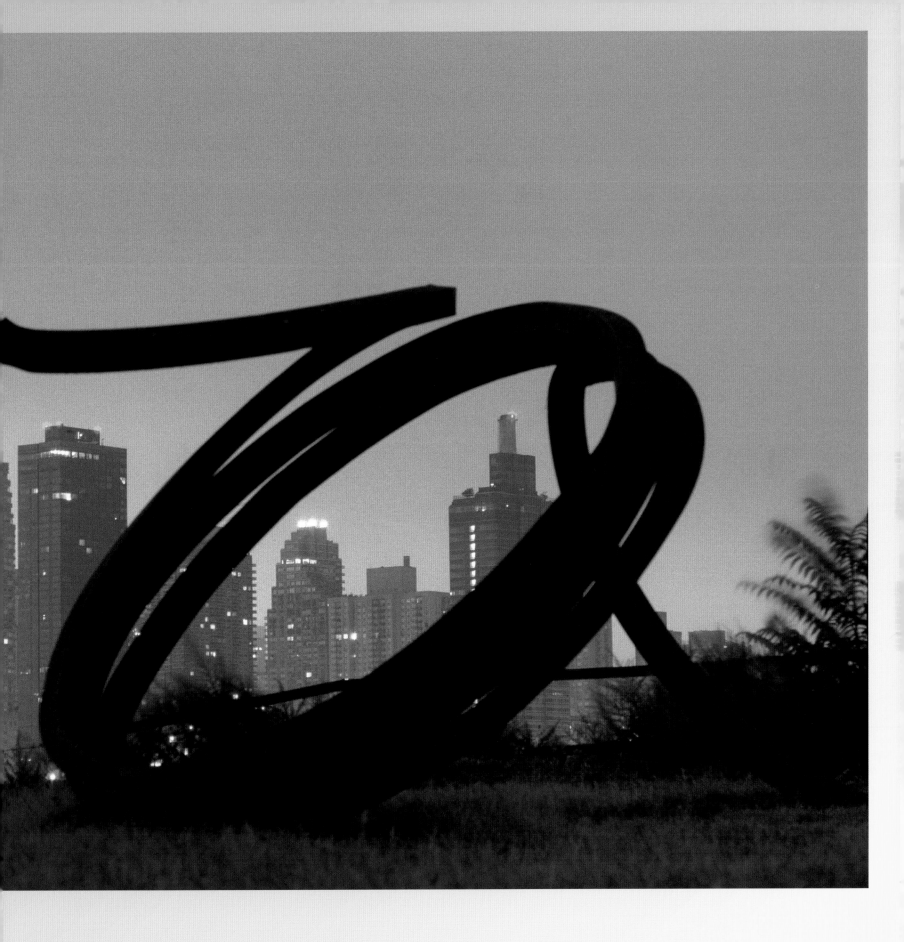

BERNAR VENET, *Indeterminate Line*, 1994

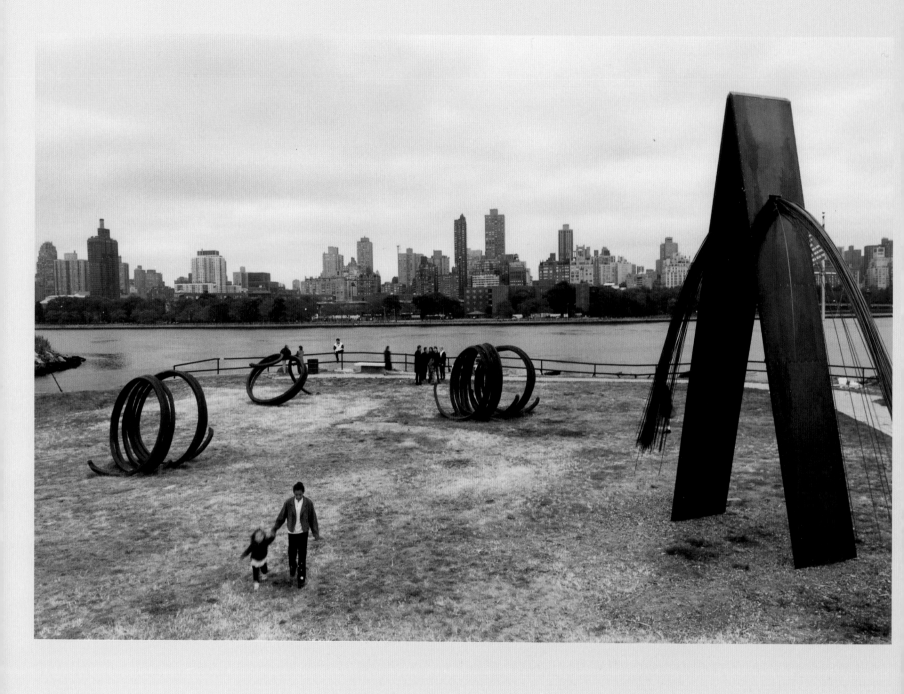

(LEFT) BERNAR VENET, *Two Indeterminate Lines*, 1992, *Indeterminate Line*, 1994, *Three Indeterminate Lines*, 1994 (RIGHT) ADĚLA MATASOVĂ, *Rain Wall*, 1997

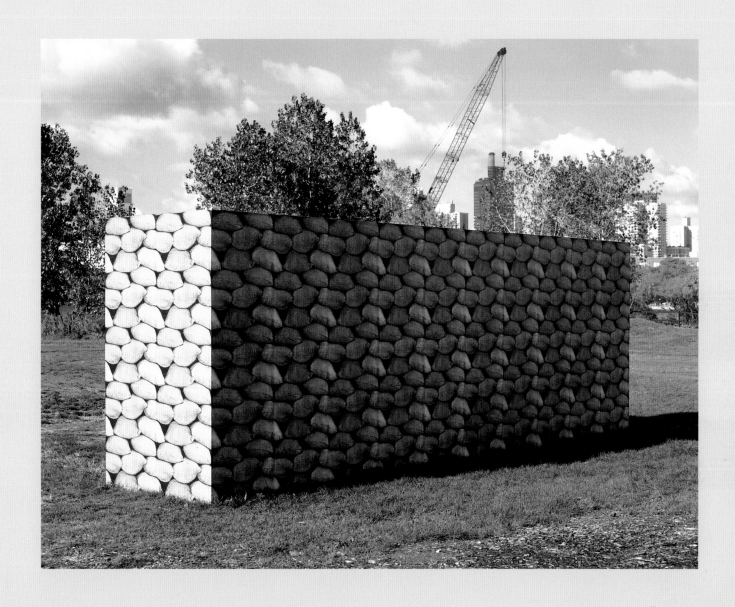

CHRISTINE TARKOWSKI, *Sandbag Box*, 1998

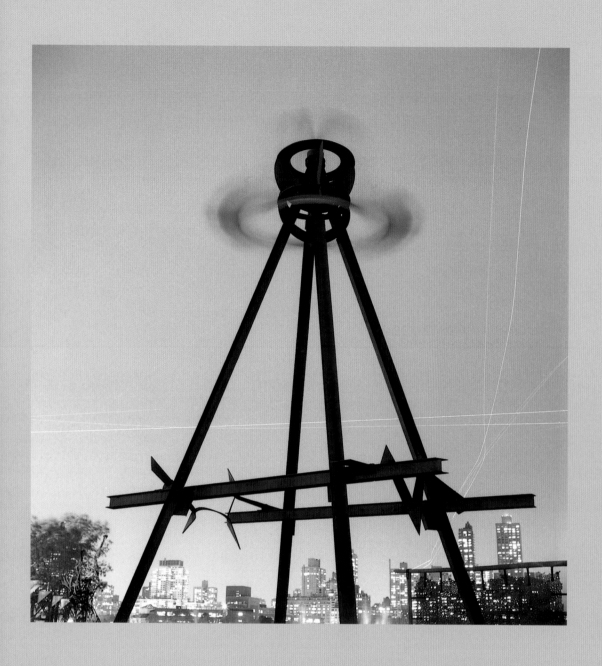

MARK DI SUVERO, *Grace à Toi (Homage à Michel Guy)*, 1992–97

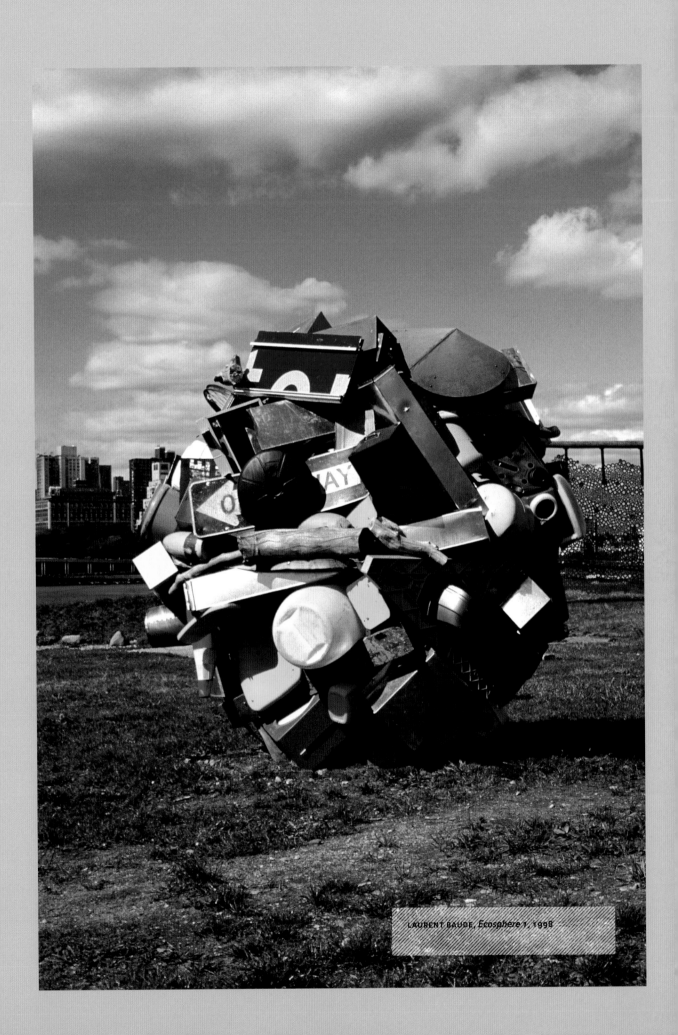

LAURENT BAUDE, *Ecosphere 1*, 1998

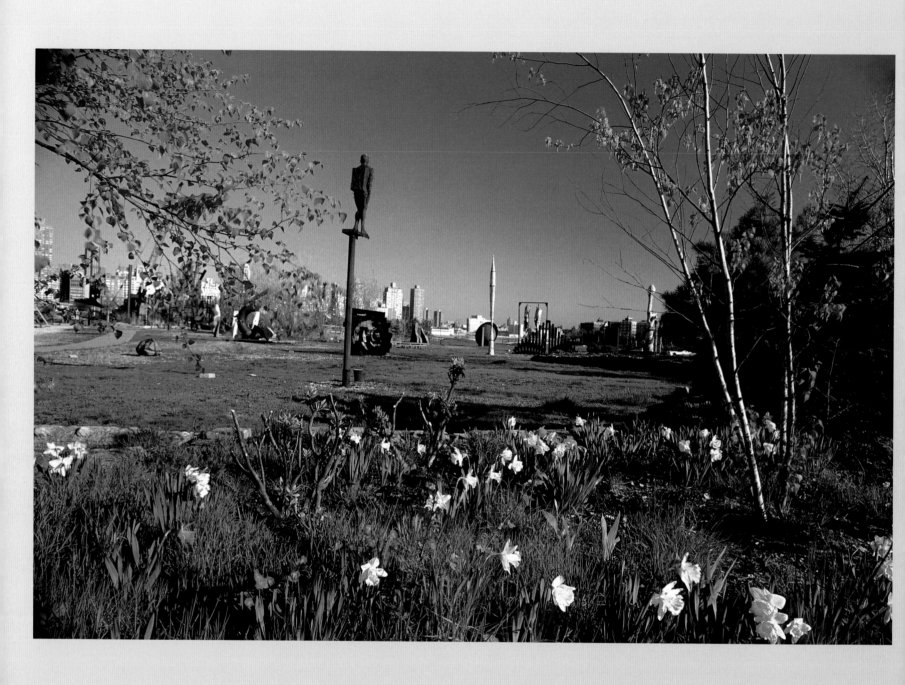

Park overview, 1998

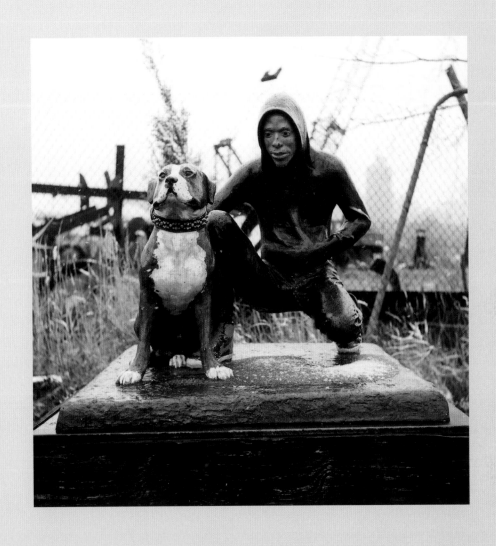

JOHN AHEARN, *Raymond and Toby*, 1990

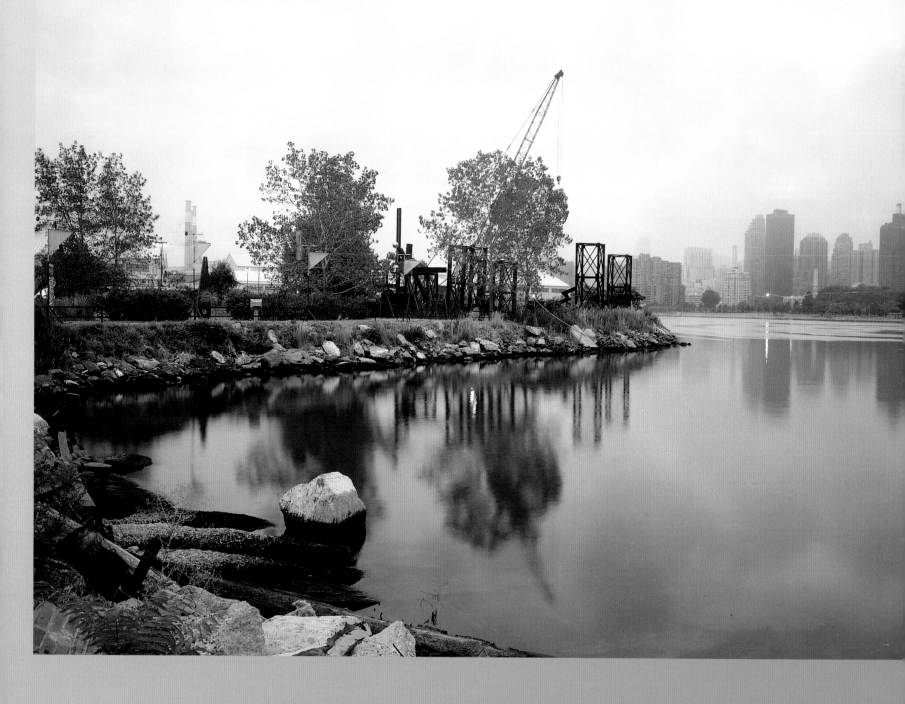

Shoreline, facing south, 1998

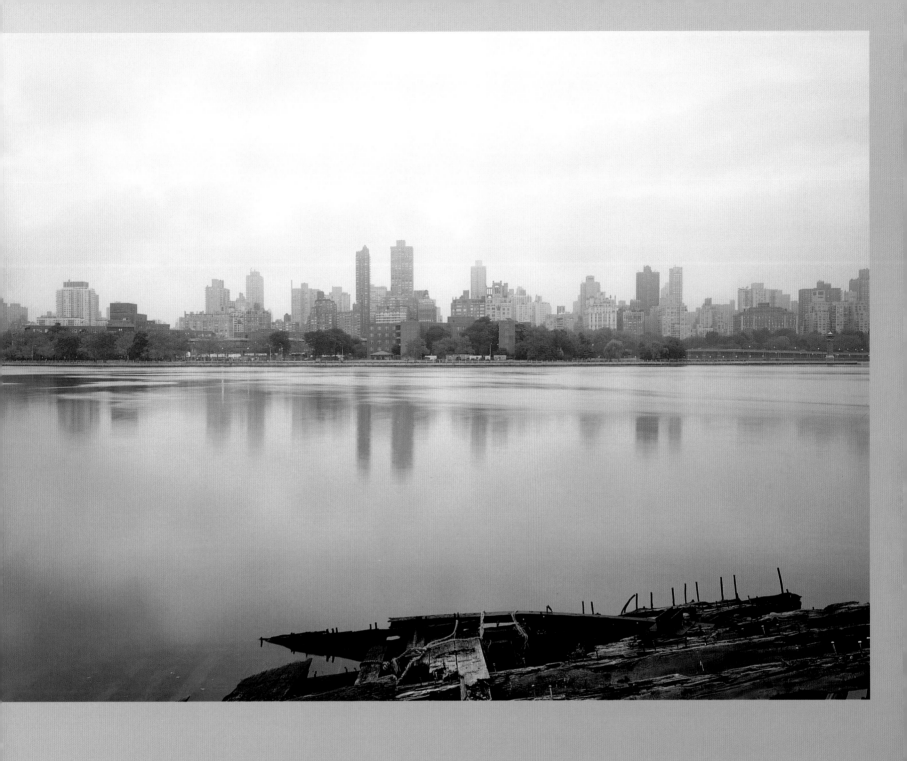

(LEFT) KNUT WOLD, *Peat Moss Sculpture*, 1999
(RIGHT) Installing Kellie Murphy's *The Gaelic Bloat*, 1999

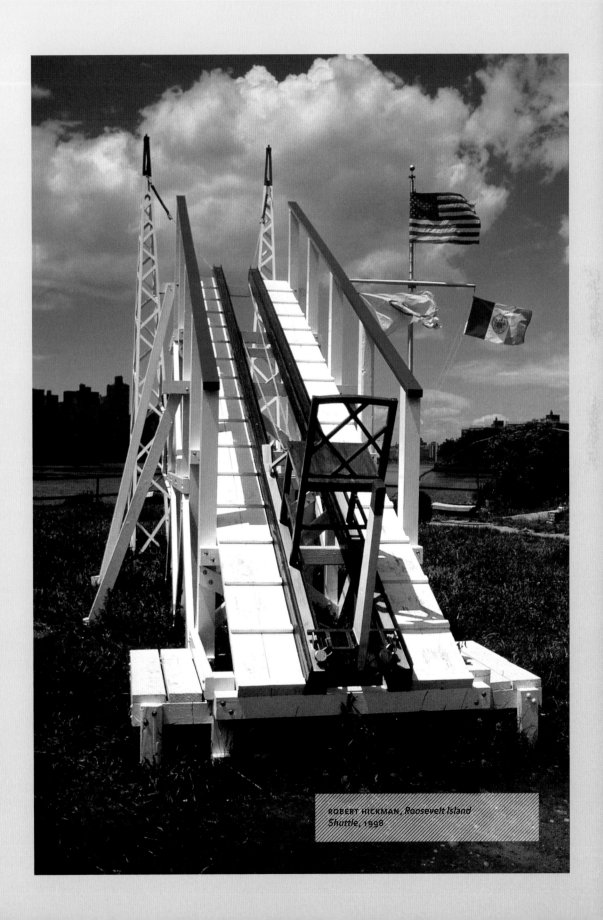

ROBERT HICKMAN, *Roosevelt Island Shuttle*, 1998

DAVID KREPFLE, *Flowers*, 1999

Being and circumstance, then, constitute the
operative frame of reference for an extended (phenomenal) art activity,
which becomes a process of reasoning between
our mediated culture (being) and our immediate presence (circumstance).
Being embodies in you the observer, participant, or user, your complete genetic,
cultural, and personal histories as "subsidiary" cues bearing on
your "focal" attending (experiencing) of your circumstances....
Circumstance, of course, encompasses all of the
conditions, qualities, and consequences making up
the real context of your being *in* the world. There is embedded
in any set of circumstances and your being in
them the dynamic of a past and future, what was, how it came to be,
what it is, and what it may come to be.
—Robert Irwin, *Being and Circumstance*[1]

The story goes that the old adage "it's all about the real estate" was first said apropos the commercial canyons of Manhattan. But on a little spit of land on the Queens side of the East River, near a place known for centuries as Hell Gate, this metropolitan axiom has found its own kind of idiosyncratic instantiation, both as practical reality and theoretical touchstone for what has, over the last two decades, become one of the New York art world's best-loved institutions.

As anyone who knows Socrates Sculpture Park even a little will attest, *institution* is a word that does not quite apply here. Indeed, the principles of openness, flexibility, and impermanence bound up in the story of how the Park came to be, and the reality of what it is today, seem rather dramatically at odds with most notions of how institutions typically function. This state of condition-ality, of constantly becoming rather than having already become—particularly within the social and physical con-text of a city that naturally gravitates toward finitude and closure—is precisely what marks the unique character of Socrates and differentiates it not only from other similar projects, but also from the general psychogeographic landscape within which it operates.

Being There

JEFFREY KASTNER

Real estate generally may be judged an artifact of commerce, but the realm of modern aesthetics has, of course, long had its own complicated relationship with place and process, and with the nature of the *real*. For decades discourses around these issues have informed the trajectory of contemporary artistic practice, both within and outside the confines of the gallery or museum, and particularly so in those interstitial zones between integral and contingent modes of creative activity in which public art functions. For all their conceptual vitality, what these often fascinating conceptual abstractions seem to boil down to is a series of questions about the individual's relationship to and experience of a given gesture in a given context, and the various ways that artists, curators, and commissioners might influence that experience. All of this only serves to confirm that what is finally most "real" about a place is the activity that occurs there—the "(social) product" that is "(social) space," in French philosopher Henri Lefebvre's celebrated formulation. In this framework, as a laboratory for creative practice, zone for contemplation, and interpenetrating network of abounding history and equally rich future potential, Socrates—while it may seem very much the exception to the totalizing rules governing commercial real estate in America's greatest metropolitan core—is arguably just as, if not more, "real" than many of the monumental, tangible structures in whose long shadows it lies.

The story of the Park's founding is no less inspirational, and it has become a well-known part of New York art-world lore. Reclaimed from disuse in the mid-1980s and built into dramatic utility from the ground up by its dedicated mothers and fathers—including sculptor Mark di Suvero, Enrico Martignoni, and the group organized around the Athena Foundation—the Park has always seemed a contingent, living sort of thing. It is a place where development (something with which Socrates has had much experience, both figurative and literal) does not foreclose on the meaning or future potential of the site, but instead augments and invigorates it in an ongoing, unpredictable way, where creative labor and its products are not ends but means, operating within a flexible system that from the beginning has privileged experimentation and risk taking.

Just as its tale of hardscrabble birth and early development in the face of bureaucratic and commercial challenges in many ways defined the first decade of Socrates, the story of the Park's trajectory into the maturity of its second decade began with a discussion over what it means to *develop*. The decision of Community Board 1 to grant the land for use by Socrates in 1986 was temporary and somewhat ad hoc. While this befitted the character of the place in its early years, it was also perhaps a sign of a certain (though not entirely unwelcome) kind of marginality, which by the mid-1990s was dissipating in the face of the organization's increasing prominence and the booming economic fortunes of a city that had begun to rediscover the charm and potential of its once-neglected boroughs.

This issue came to a head in 1997 when plans were drawn up for a large-scale commercial project to be located on Socrates land. After nearly two years of debate between supporters of the Park and local politicians and businesspeople advocating for the development of what was still a relatively unloved corner of Queens, the City of New York under Mayor Rudolph Giuliani stepped in and declared Socrates a permanent city park in December 1998. While clearly a victory for the Park in the real estate battle being waged over it, this also was conceptually serendipitous, a gesture on the part of the city that unexpectedly expressed a preference for flexibility over tangibility. By adding its imprimatur, the city granted institutional status to a project that was constitutionally opposed to conventional forms of institutionalization, of commercial development, and of functional fixity.

Despite the institutionalizing changes ushered in following the city's decision to officially sanction Socrates, the past ten years at the Park have been as richly variegated as the first. With its tradition of biannual group exhibitions augmented by a range of more modest shows, regular festivals, and events, and an ongoing commitment to community education and outreach, Socrates continues to thrive in the face of the contemporary art world's mercurial tastes. No small part of its success relies on the fact that it has remained at its core what might best be thought of as a proposition, in more than one sense of the word: both

as "something offered for consideration" and "a project or situation requiring some action." In its accessibility (Socrates is free and open to visitors every day of the year), the Park presents an offer to both artists and viewers—an opportunity to engage and act within a situation, and to do so in a context uniquely poised between the city and nature, between the organized and the self-determined, between the real and the ideal.

On a recent late winter morning, Socrates director Alyson Baker and exhibition coordinator Robyn Donohue gave a visitor an impromptu tour of the Park. Arrayed across its grassy expanse along the river, the show on view at the time (the 2005 installment of its annual "Emerging Artist Fellowship Exhibition") framed and was itself framed by its immediate surroundings: Manhattan across the water, at this place where the East and Harlem rivers flow together; to the rear, the factories and warehouses of Long Island City; and further up the shore of Hallets Cove, di Suvero's studio complex, separate yet in many respects the historical and emotional heart of the Park. Between the Park and di Suvero's pier, a new building had gone up—brand-new condos, it turns out—and other sites along this long-forlorn stretch of Queens are now being primed for reclamation as the area undergoes a process that has touched numerous other New York neighborhoods formerly thought beyond the reach of "development."

Does this new wave of development suggest that the wheel has turned once again, as Socrates begins its third decade? The pattern of symmetry it fulfills would seem, in fact, to be more than just serendipitous coincidence—it is rather precisely a function of the Park's position directly in the flow of the city's life, its historical identity as a real place amid other real places, and the conditions, qualities, and consequences of that identity. The circumstances that have produced the phenomenal project that is Socrates have everything to do with it so resolutely continuing to be where and what it is for these last two decades, and for remaining open, in both its attitudes and its practice, to what it may come to be in the years that lie ahead.

1 Robert Irwin, from "Being and Circumstance—Notes Toward a Confidential Art" in *Being and Circumstance* (Larkspur Landing, CA: Lapis Press, 1985). Excerpted in *Theories and Documents of Contemporary Art*, ed. Kristine Stiles and Peter Selz, (Berkeley, CA: University of California Press, 1996), 573.

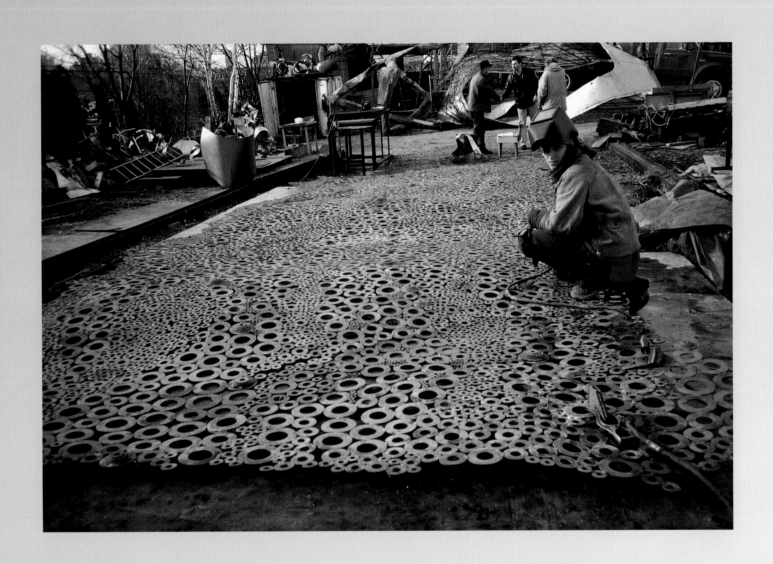

Alissa Neglia, 1998

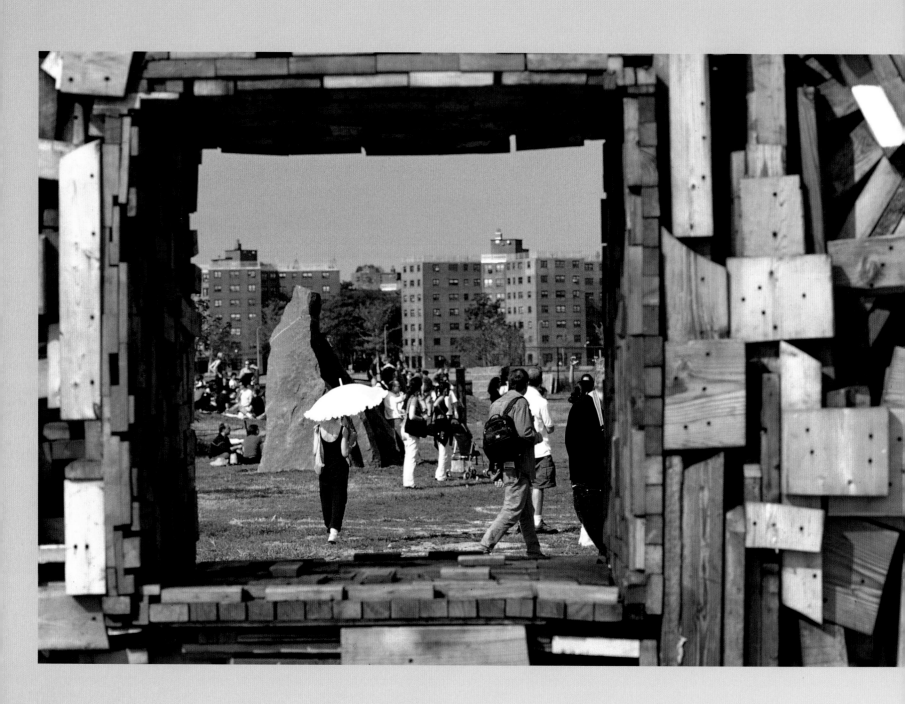

(FOREGROUND) SYLVIA BENITEZ, *China Money*, 1999 (DETAIL) (BACKGROUND) ELYN ZIMMERMAN, *Portal Lethe*, 1992

MATHIEU BORYSEVICZ, *Untitled (Location, Broadway at Vernon Blvd.)*, 1999

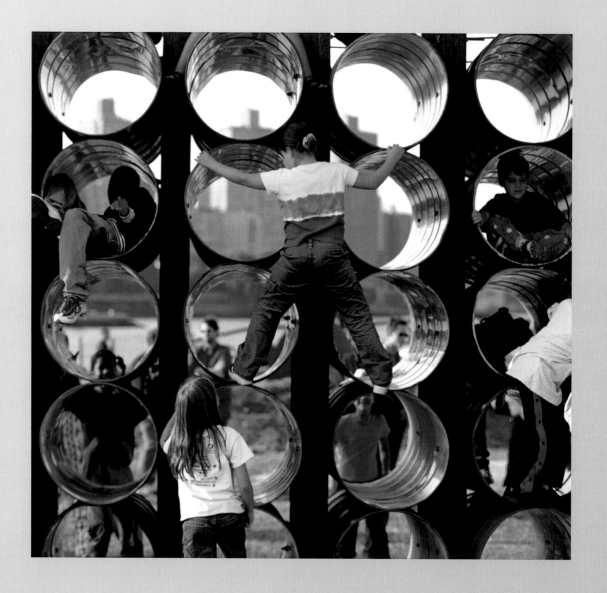

SOOK JIN JO, *Color of Life*, 1999 (DETAIL)

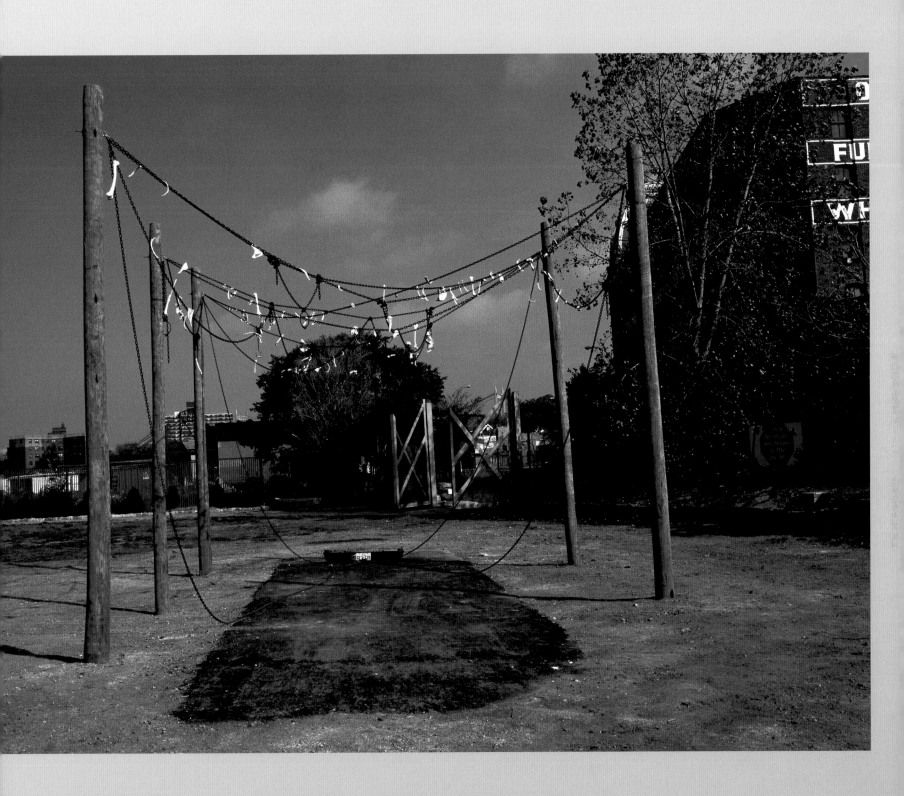

DREAD SCOTT, *Jasper the Ghost*, 1999

153

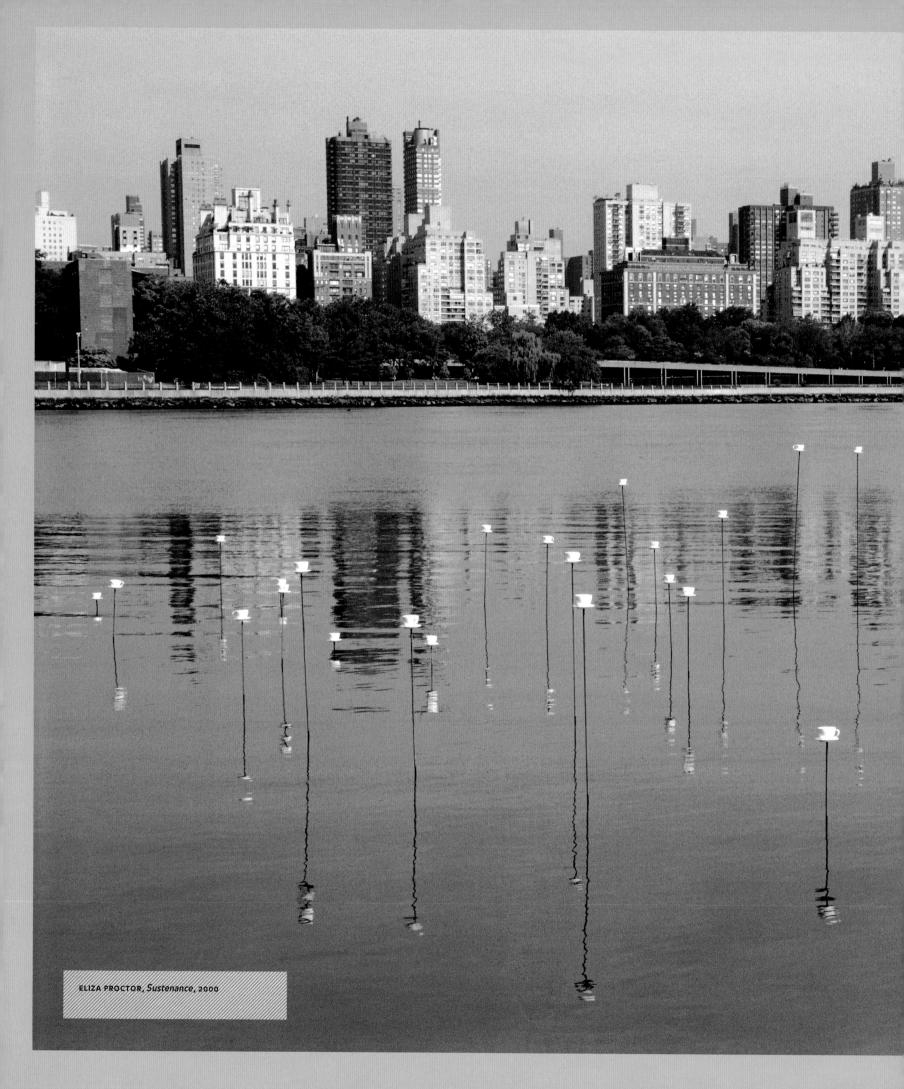

ELIZA PROCTOR, *Sustenance*, 2000

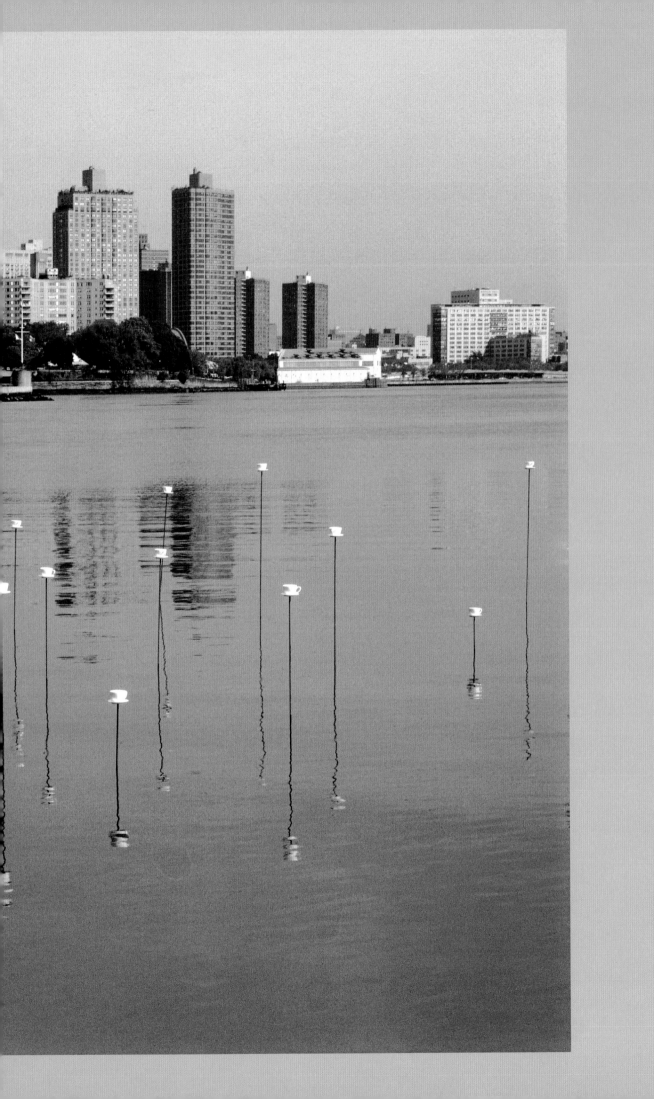

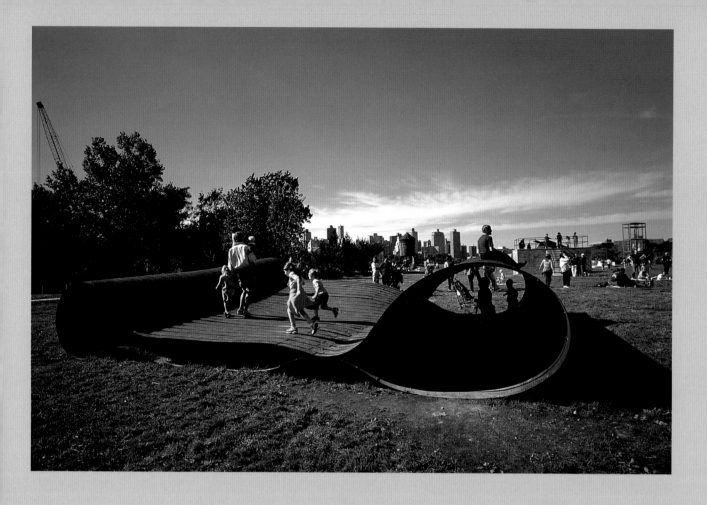

"The basic premise of meshing art of the highest level with an open public forum allows for both appreciation and education. The Park remains a city destination, yet maintains its feeling of community with its immediate surroundings. Socrates is able to boldly negotiate this set of different uses and ideas."

WENDY EVANS JOSEPH, FAIA,
Wendy Evans Joseph Architecture

(TOP) DEWITT GODFREY, *Socrates Sculpture 2000*, 2000 (BOTTOM) Installing Claire Lesteven's *Sometimes It's Windy*, 2000

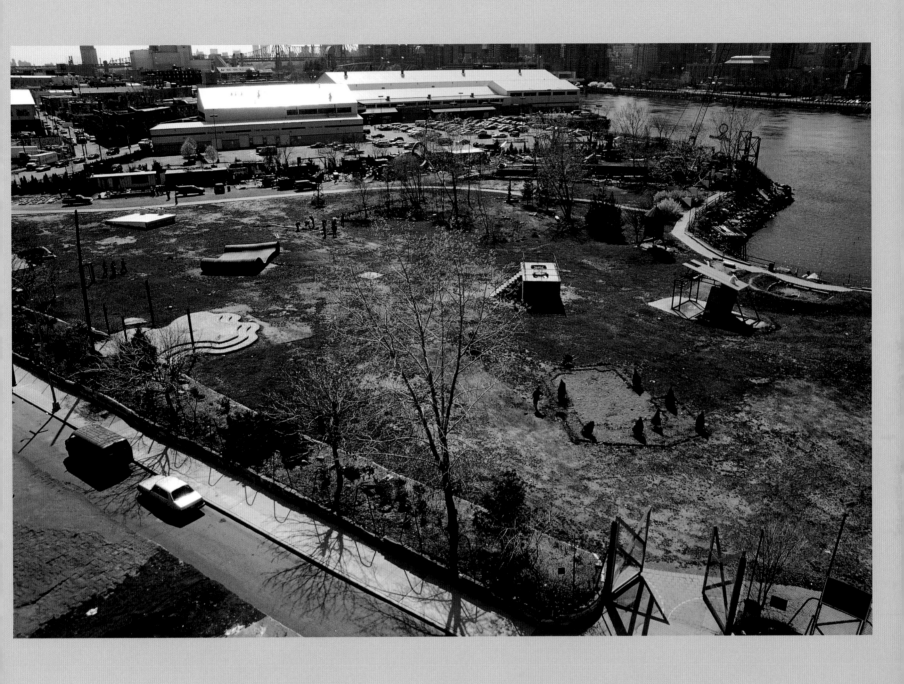

Park overview, 2000

BETH CAMPBELL, *The Novelty*, 2000

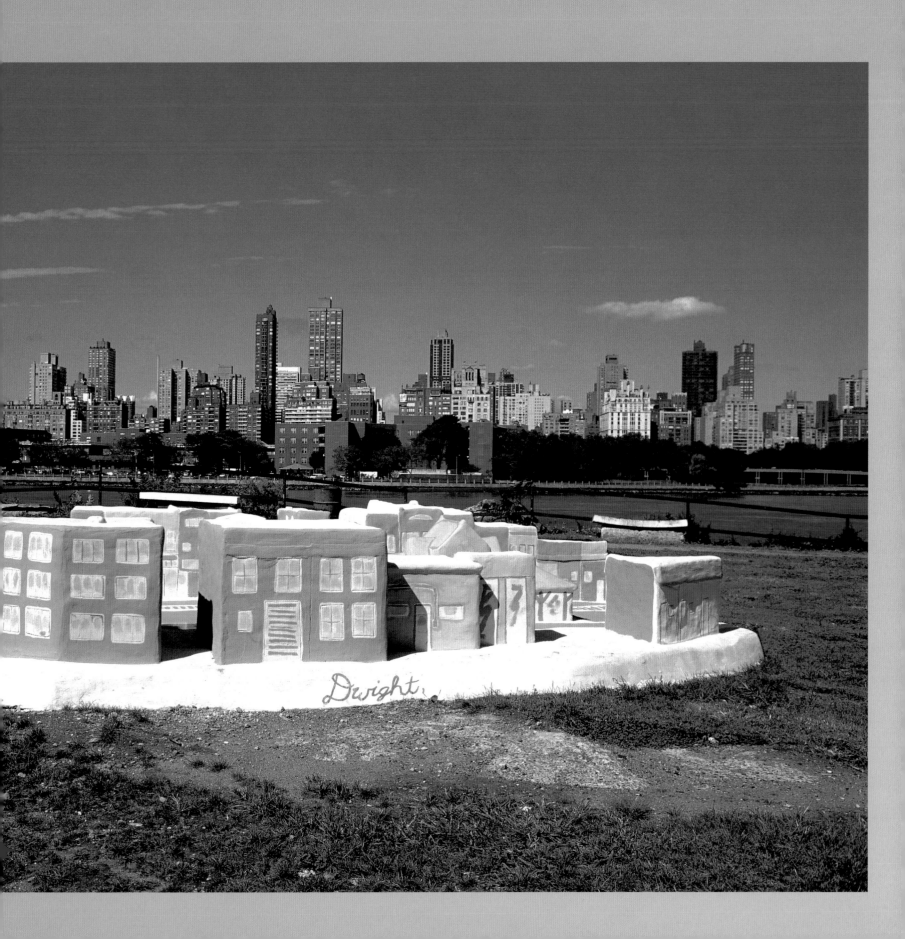

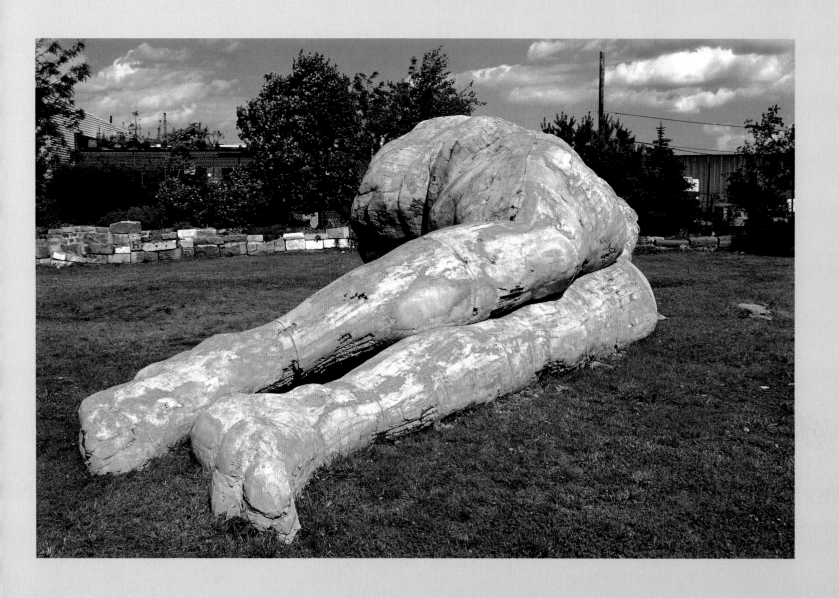

LEDELLE MOE, *Untitled,* 2000

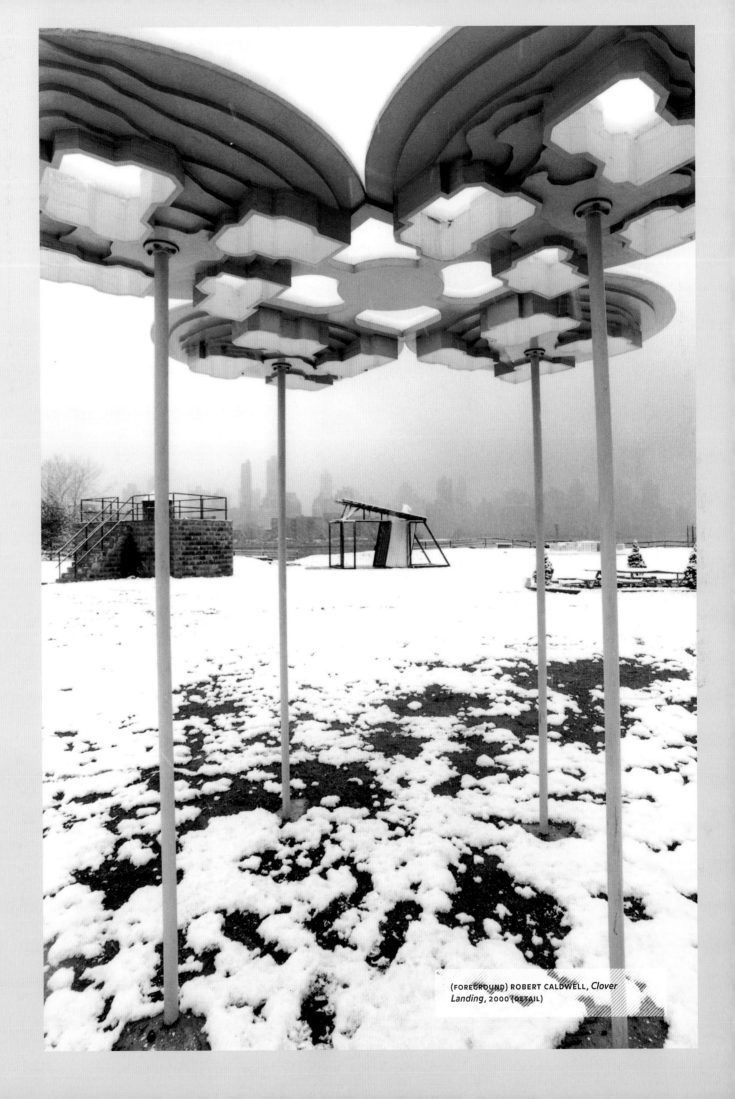

(FOREGROUND) ROBERT CALDWELL, *Clover Landing*, 2000 (DETAIL)

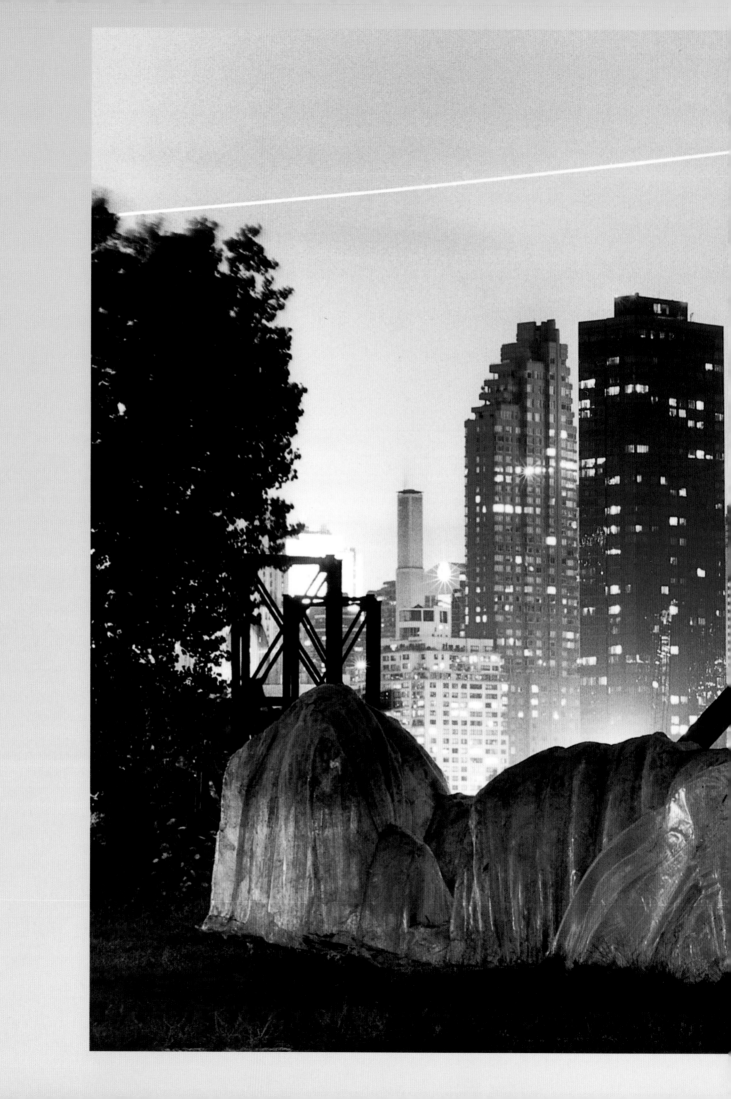

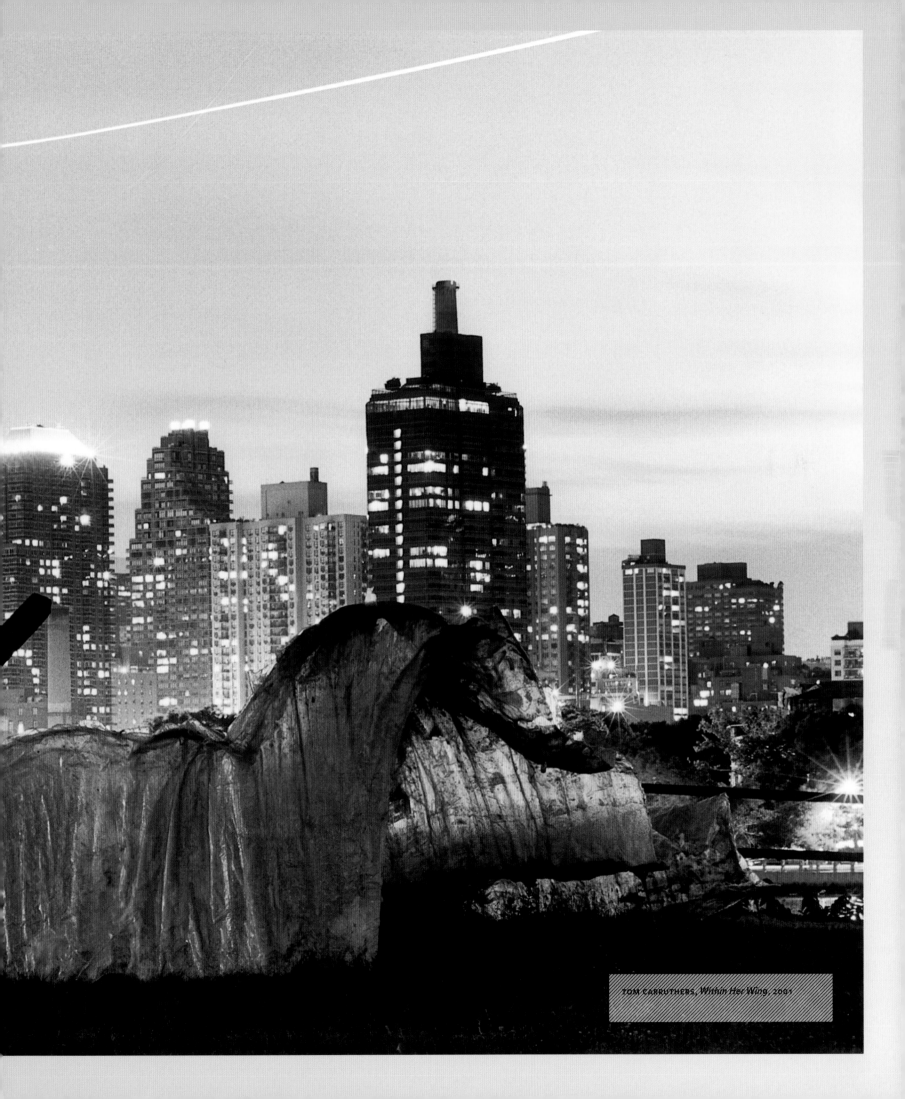

TOM CARRUTHERS, *Within Her Wing*, 2001

CHARLES GOLDMAN, *E-Z Maze (Zig-Zag)*©,
2001 (DETAIL)

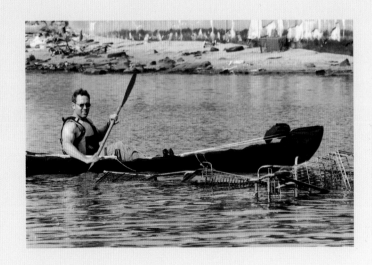

(TOP) CLARA WILLIAMS, *Lovers' Point (Prelude)*, 2001 (DETAIL) (BOTTOM) Bob Braine kayaking in Hallets Cove, 2001

Installing Lars Fisk's *Slum Ball*, 2001

"The Park provides the city
with a valuable lesson on how to
build on local assets to improve
the infrastructure for the
artistic community, as well as
for the community in general."

NEIL KLEIMAN,
Vice President, Seedco, and former Director,
Center for an Urban Future

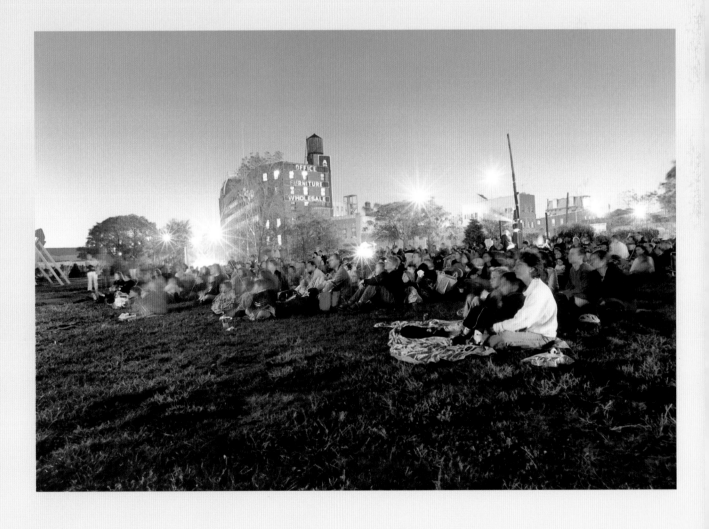

"Evenings at the Picture Show" outdoor film
festival, organized by The Museum of Modern
Art and Socrates Sculpture Park, 2002

DIANA BALMORI

The Landscape That Could

Sculpture parks are new landscapes invented in the second half of the twentieth century, and within this genre, Socrates Sculpture Park is unique. I was first introduced to Socrates when asked by its board four years ago to consider how to incorporate a new piece of land and make better use of its superb water's edge. Observing the Park and its activities over these years, I have come to understand what makes it so unique—not just unique, but a model.

As a genre, sculpture parks have accumulated enough examples to become a landscape type and are now simply waiting to have their vital signs registered by a smart historian. Perhaps the sculptors' move in the 1960s out into the landscape and away from museums—Mark di Suvero's included—was the trigger for this new type. Of course, the mix of sculpture and landscape has long existed in innumerable classical and Renaissance gardens, or more dramatically still in later gardens such as the sixteenth-century Bomarzo in the Lazio region of Italy. However, these historical connections aside, the twentieth-century sculpture park is a new invention, though perhaps not a particularly felicitous one. Lack of adequate space around each sculpture or ill-suited neighboring pieces, poor siting, and not incorporating the site in the placement of the sculpture mean that, with few exceptions, the sculpture park has not seemed a promising genre.

Socrates is one of those exceptions, and an example that can take the sculpture park out of the conundrums that plague most of them. What makes Socrates's basic relation to its site different is that it is a workspace for artists. Its scrappy, worn-out ground, its industrial neighborhood, its poetic setting on the East River, and its grand view of Manhattan may be considered either assets or liabilities, but they do not modify its great invention as a laboratory for new sculptors. Artists can experiment and labor with the space and equipment, for Socrates is a place for sculptors to work in and to be seen by the public as they work. Once completed, their artwork can be viewed by visitors on the site for several months.

The atmosphere, the casual display of the work in progress, and the resulting finished pieces on temporary display give the Park a freedom which more museum-like settings cannot achieve. Not all sculpture parks can be this. But as a type, all could benefit from Socrates' grand coup of its passage from passive to active. That, I think, is Socrates Sculpture Park's uniqueness and why it should sit for a portrait as a model of a landscape that could.

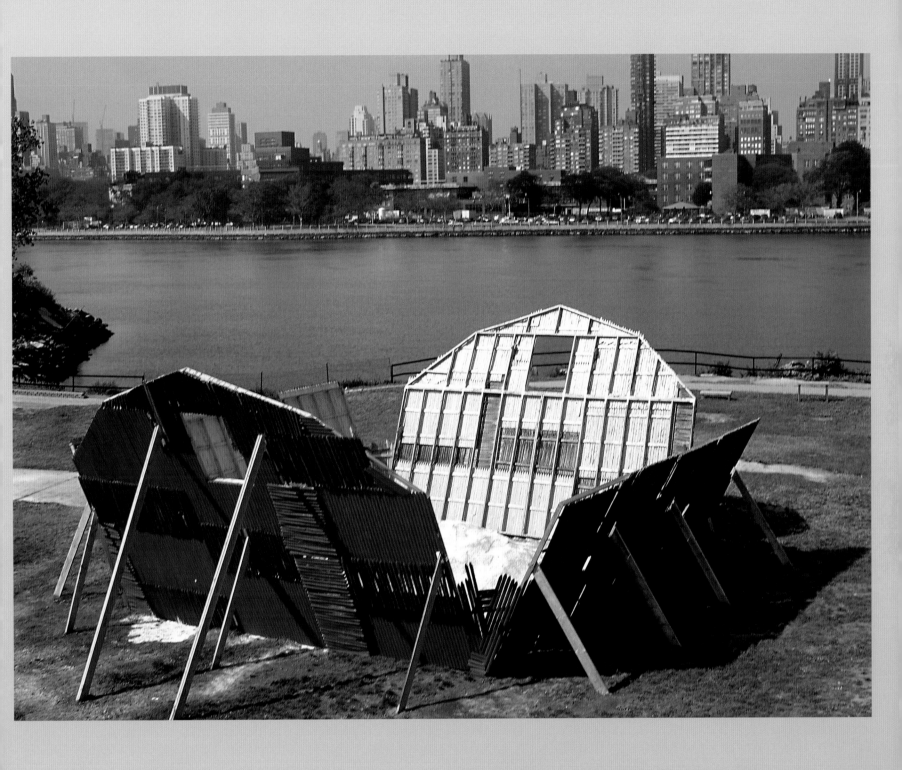

JEFFREY HATFIELD, *Lot of Salt,* 2002

"I have experienced Socrates from a few different perspectives. One snowy wintry day, I participated on a panel to review submissions, which involved spending a day with the entire Socrates team in their Long Island City offices. It was an inspiring day of viewing lots (and lots) of slides and engaging in a genuine dialogue about new work with a dedicated and committed group.

Out of that day came 'Yard.' I will never forget going to the Park to see that exhibition— it was a gray but beautiful spring day, and the image of Jason Middlebrook's Gnome sculptures against the New York skyline is forever imprinted in my mind. Another highlight for me was when Jude Tallichet lit up the entire Park in mid-February, charging our bleak winter with some hope. And most recently, for the exhibition 'Sport,' Type A presented *Prize Folly*—a monumental form of a male athletic cup fallen and broken. Juxtaposed with the concrete garden of Manhattan, the piece was a perfect and poignant fit. The opportunity to participate in exhibitions at Socrates has been a wonderful experience for all of the artists who have been given the chance."

SARA MELTZER, Director, Sara Meltzer Gallery

JENNIFER ZACKIN, *Pachakúti*, 2002

PETER KREIDER, *Derby Dusting*, 2002 (DETAIL)

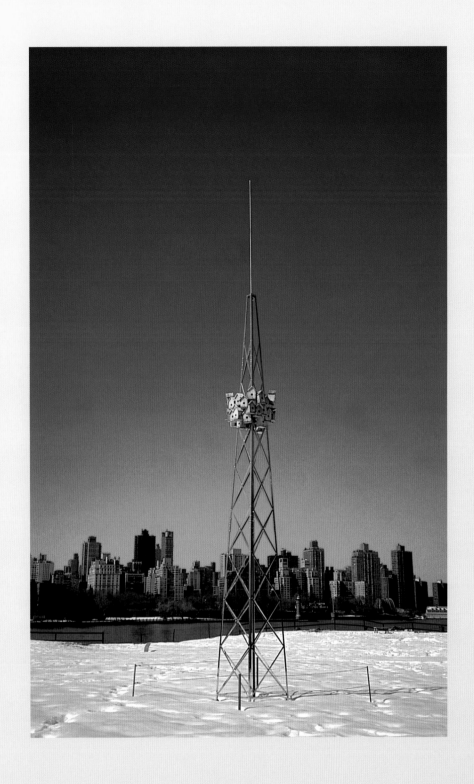

PETER COFFIN, *Untitled (Fixed Tower, Fast Times)*, 2002

"After the 'EAF04' show,
friends asked me if I was getting
any feedback about the piece,
and I would always answer
that the most feedback I
received was when I was actually
out there building it in the
Park and talking to the people
who were walking by."

MARIE LORENZ, artist

CAREY ANN SCHAEFER, *Chain-Link Fence*, 2002
(DETAIL)

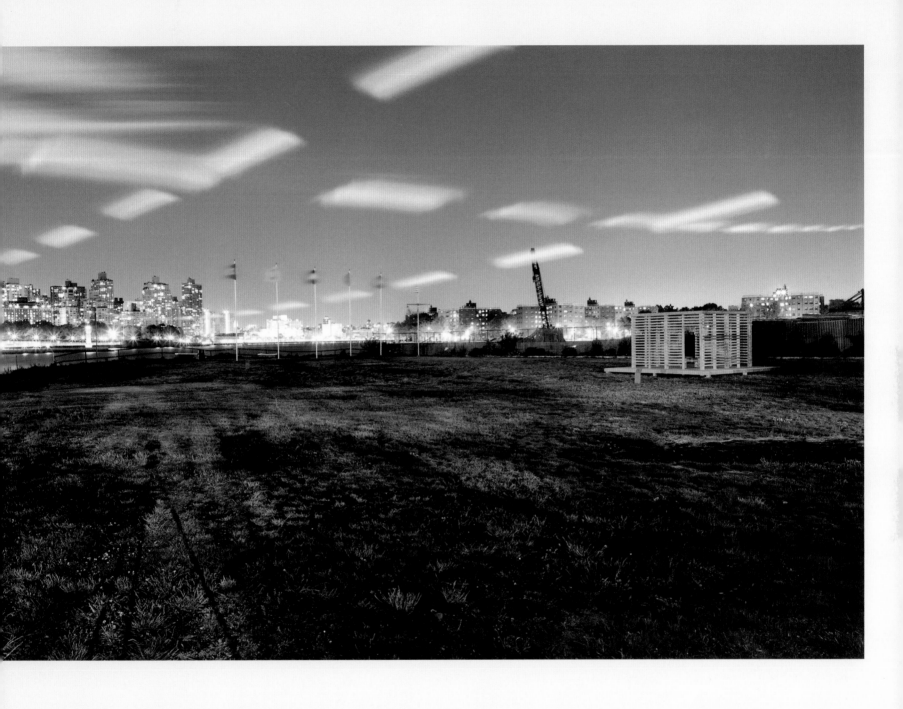

Park overview, 2002

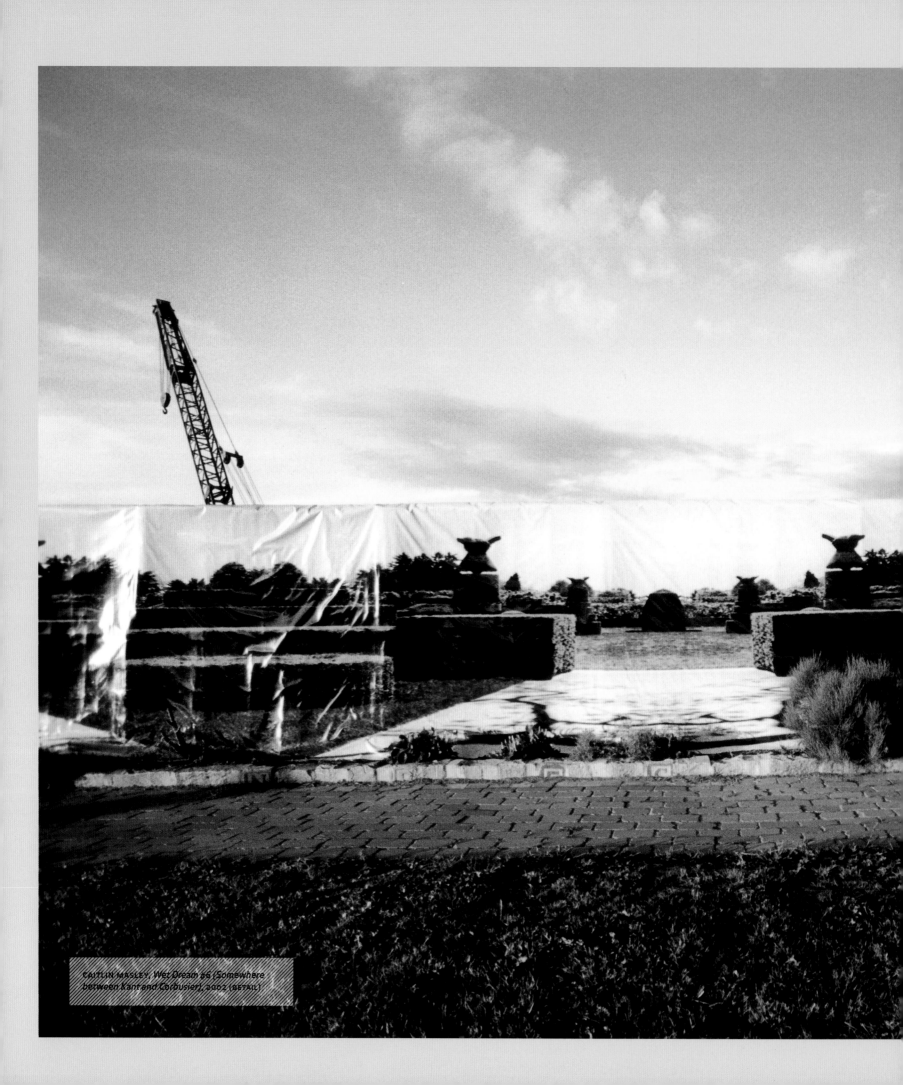

CAITLIN MASLEY, Wet Dream #6 (Somewhere between Kant and Corbusier), 2002 (DETAIL)

ALYSON BAKER

Open Studio

For many artists, Socrates Sculpture Park offers a first opportunity to produce work on a large scale, work on-site in an outdoor environment, and present their artwork in a context not described or defined by the traditional parameters of a gallery or museum. Here, the sculptures and installations are often built near or on the site where they are displayed, making Socrates as much a studio as it is an exhibition venue.

One of the most unique aspects of the Park is the transparency that is afforded the production phase of the creative process. Regular visitors see the artists working and sculptures emerging from raw or recycled materials, and they gain an understanding of the imagination and labor required to make a work of art. The artistic practice—something that is usually quite private and solitary—becomes a public process: the artists are interacting with their audiences, even as they grapple with the conceptual and physical challenges of their pieces.

Production at Socrates is often a struggle, and while the end result may not always be what the artist had imagined or intended, it is a valuable learning process. In addition to those issues that artists regularly confront in making their work, at Socrates they must also address engineering and structural demands to create pieces strong enough to withstand wind and weather, and the uses (intended or otherwise) that their sculptures will take on through public interaction. And they must do this in a space that is not protected from the elements—at the Park, rain, heat, cold, sunlight, and darkness all affect how and when an artist can work.

As one of the few cultural venues that allows for struggle and failure, trial and error, Socrates acts as a place for experimentation and risk taking. The pressures of the art market do not exist here. The Park provides a supportive environment where artists can find collaborators and volunteers, donated materials and services, and many interested and eager partners to help them realize their ideas. It is left to the artists, however, to determine their own methods of working and the degree to which they will accept the input and assistance of others.

As a prime example of this, last summer a young artist—one of the Park's Emerging Artist Fellowship recipients—was working on a large, complicated, and technically demanding sculpture. She was employing a new medium, and on a scale that she had never tried before; hundreds of pounds of material had to be worked slowly and meticulously through a time-consuming and physically challenging process. She was at the Park every day, often into the night. But as the opening day of the exhibition approached, she suffered a devastating setback when one of the components of her sculpture dropped from the gantry. This accident cost her days of work, at a time when the deadline was tight. We suggested that she get some assistance, and our studio manager brought her to a local architectural casting company. As soon as she entered the shop, the staff recognized her and knew why she had come; they had been visiting the Park on their lunch breaks and had been watching her progress over the previous months. They were eager to help and quite curious about her project, so production was moved from the Park to their shop a few blocks away, where they labored with the artist after hours and into the early hours of the morning to finish the piece. On the morning of the opening, technicians from Socrates and Spacetime went to the shop and loaded the sculptures onto the boom truck, drove them back to the Park, and rigged them into place—completing the process as the first visitors arrived for the exhibition.

By providing artists with financial and technical support and an environment in which they are free to follow their ambitions, struggle and be challenged, and develop their work without the restrictions of the traditional art world, Socrates Sculpture Park has become a laboratory where experimentation and innovation expand, reinvent, and redefine art in public spaces.

(LEFT) Elise Ferguson, 2003
(RIGHT) ALYSON SHOTZ, *Mirrored Fence*, 2003

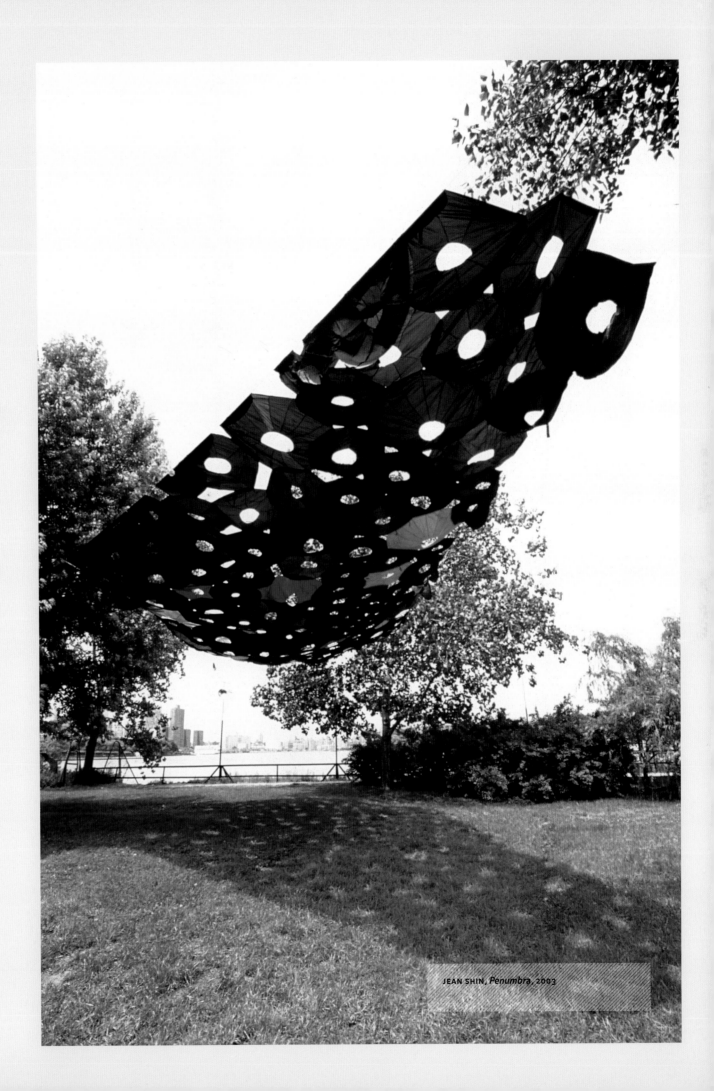

JEAN SHIN, *Penumbra*, 2003

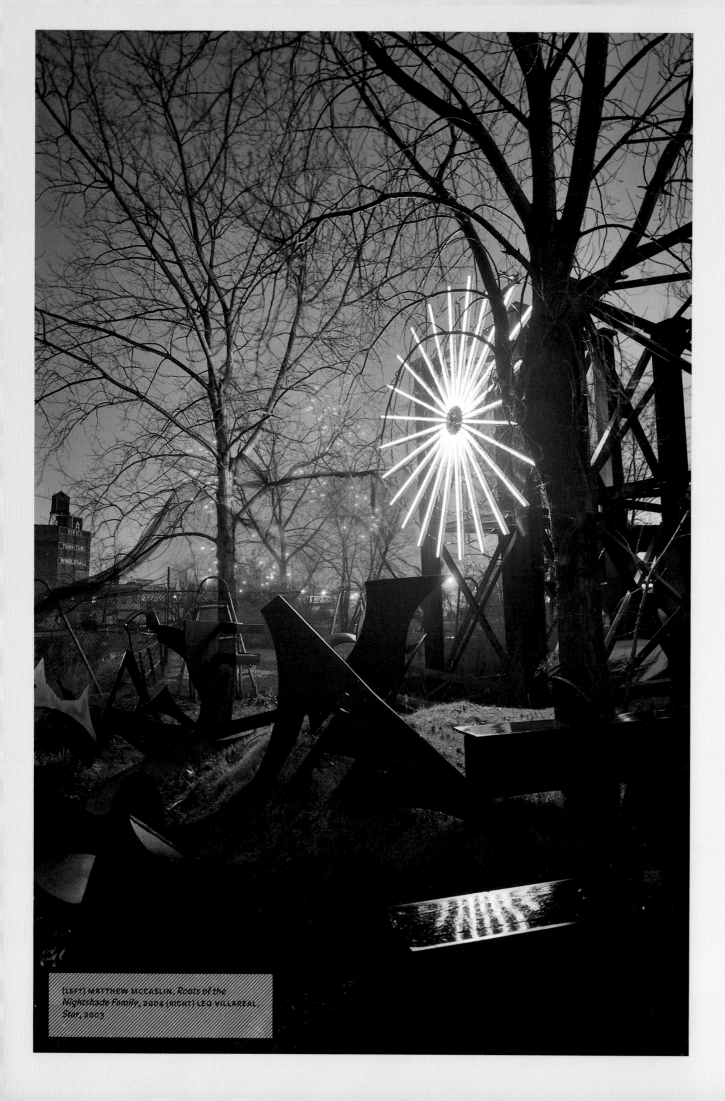

(LEFT) MATTHEW MCCASLIN, *Roots of the Nightshade Family*, 2004 (RIGHT) LEO VILLAREAL *Star*, 2003

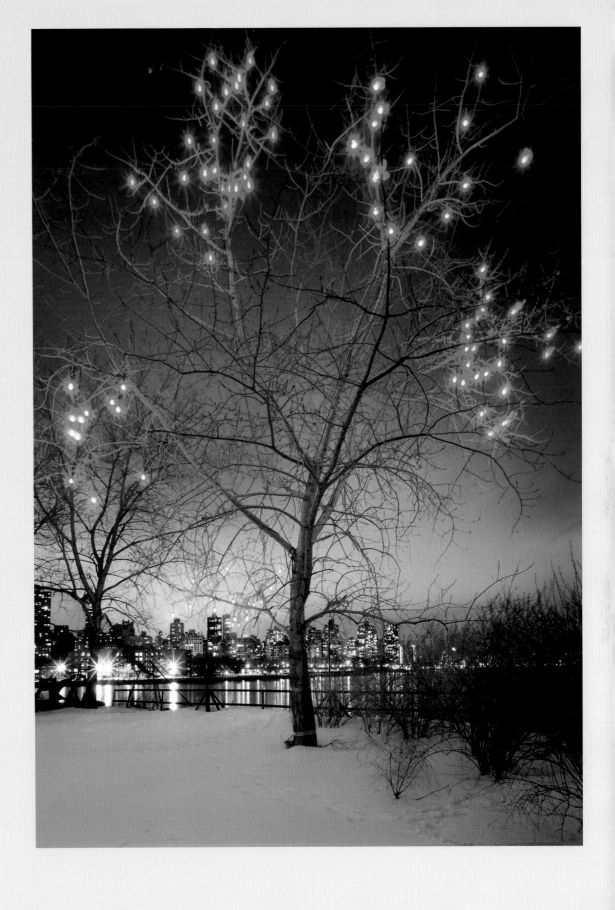

MATTHEW MCCASLIN, *Roots of the Nightshade Family*, 2004

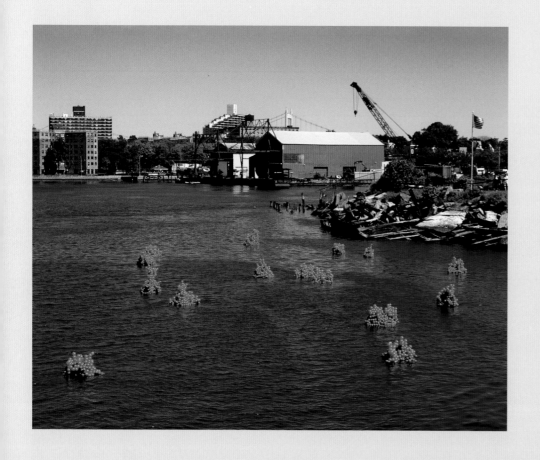

MCKENDREE KEY, *Hallets Cove*, 2003

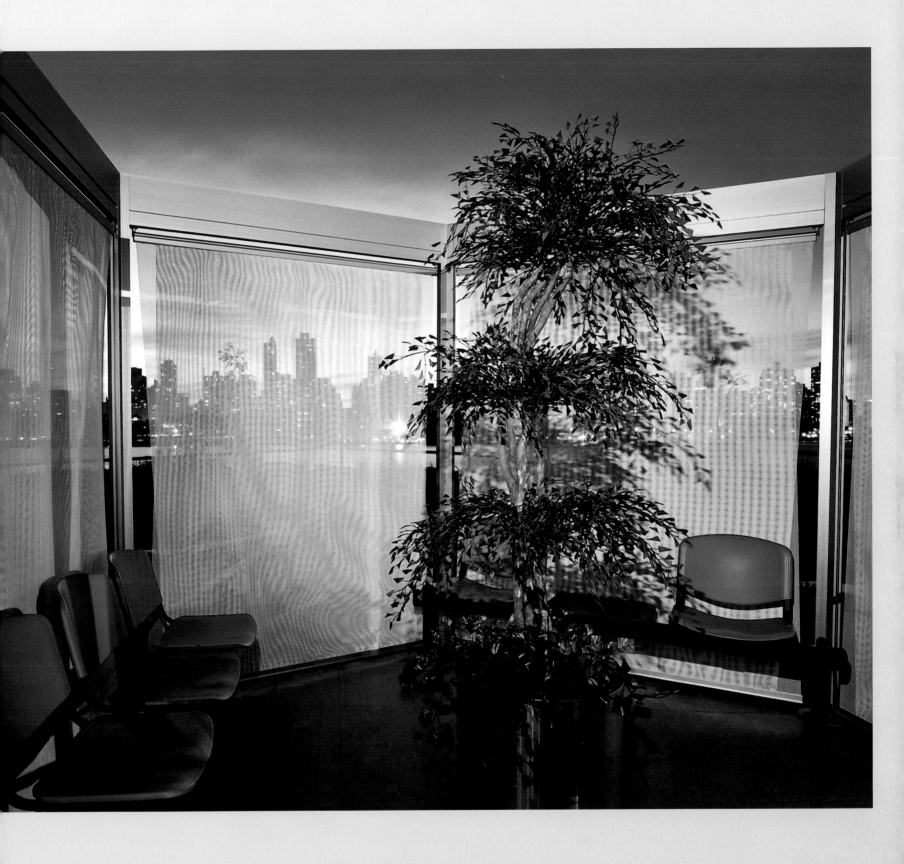

JANE BENSON, *The Waiting Room*, 2003
(DETAIL)

SARAH OPPENHEIMER, *Parallel*, 2003 (DETAIL)

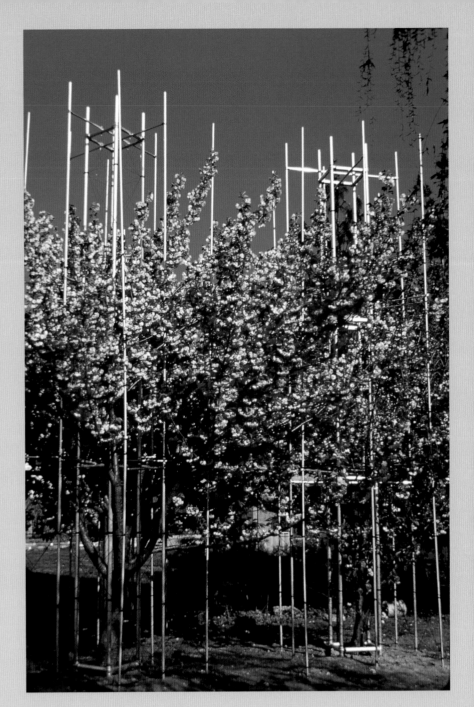

"Socrates was an invigorating and open playground for me. It provided me with the space, the framework (funds, equipment, advice, visibility), and the freedom to experiment and build a significant new project in public, and in nature. These are unique to Socrates, and invaluable for emerging artists like myself, for local residents, and for art audiences, who usually experience art within the confines of a white cube.

Socrates has been an amazing springboard for new directions—from learning how to pour cement and work from a cherry picker, to developing my practice in the context of public environments, to expanding my network for future opportunities. The support I've gained, and continue to gain, from Socrates is immeasurable."

ELAINE GAN, artist

ELAINE GAN, *It's a Hard Knock Life (For Us),* 2004 (DETAIL)

Orly Genger, 2004

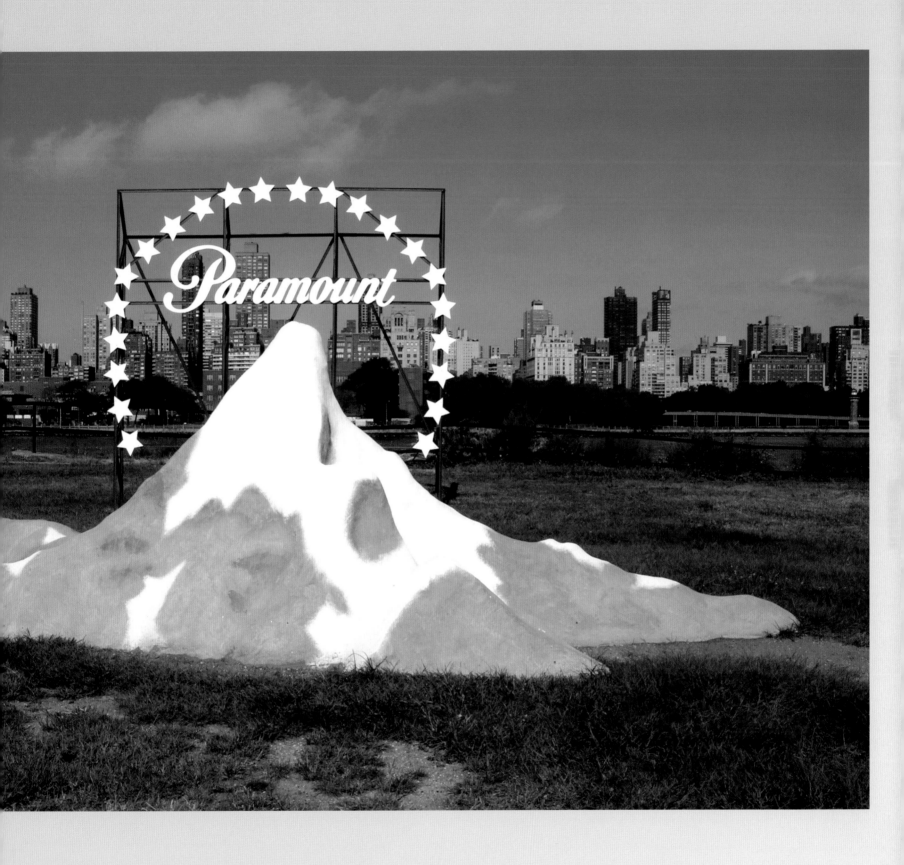

JACOB DYRENFORTH, *Opening Credits (New York)*, 2004

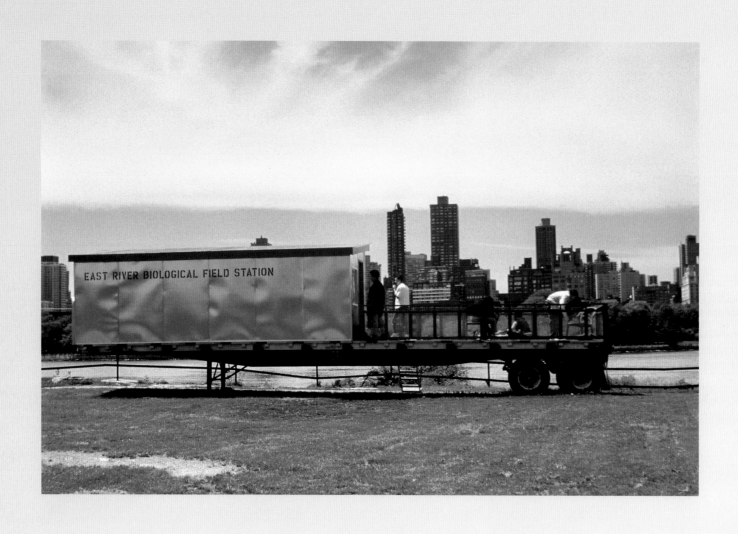

MARK DION, *East River Biological Field Station*, 2004

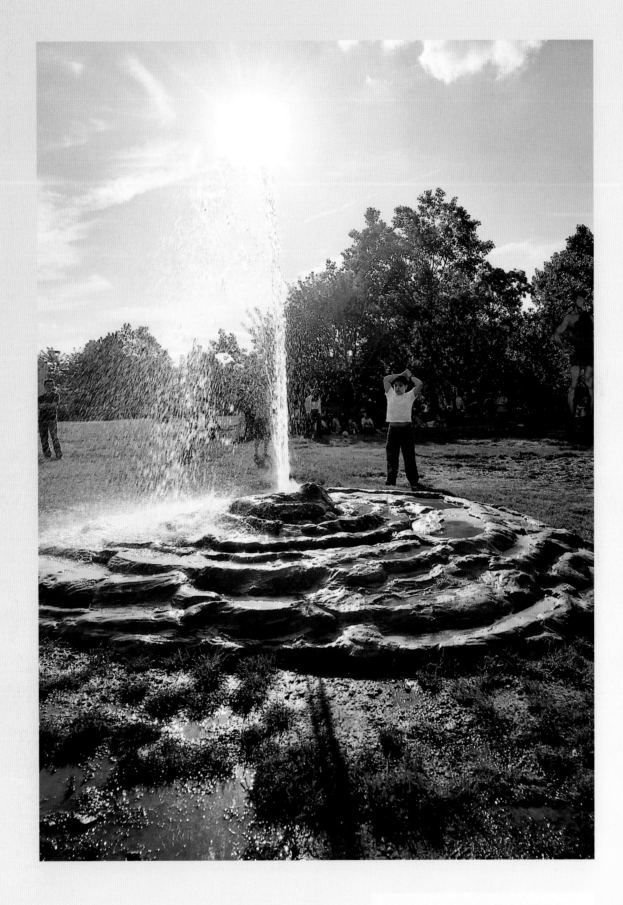

JOHN STONEY, *Remember Me (1/10th scale sympathetic model of Old Faithful geyser)*, 2004

ANNA CRAYCROFT, *Lo! The Fiery Whirlpool!*,
2004

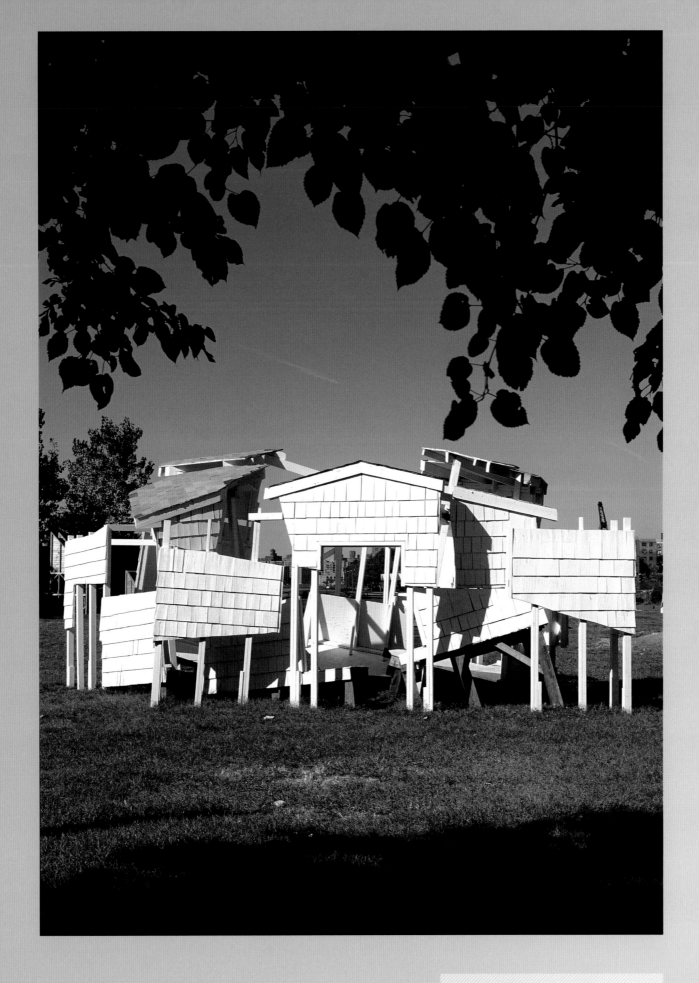

ISIDRO BLASCO, *Just Before*, 2004

MARIE LORENZ, *Man is man wherever you find him*, 2004 (DETAIL)

JANE AND LOUISE WILSON, *The New Brutalism II*,
2004

(LEFT) MICHAEL JOO, *Pipeline Walk (.0237 calories per inch)*, 2003–4 (RIGHT) COLLIER SCHORR, *Reaching (H.T)*, 2002–5

ANNE THULIN, [sport] 3: *to deviate from type,*
2005 (DETAIL)

(TOP) JON CONNER, *Self-Sufficient Barnyard (The annual amount of livestock needed to feed a family of four)*, 2004 (DETAIL) (BOTTOM) PETER SIMENSKY, *Eyes on the Prize*, 2005 (PERFORMANCE)

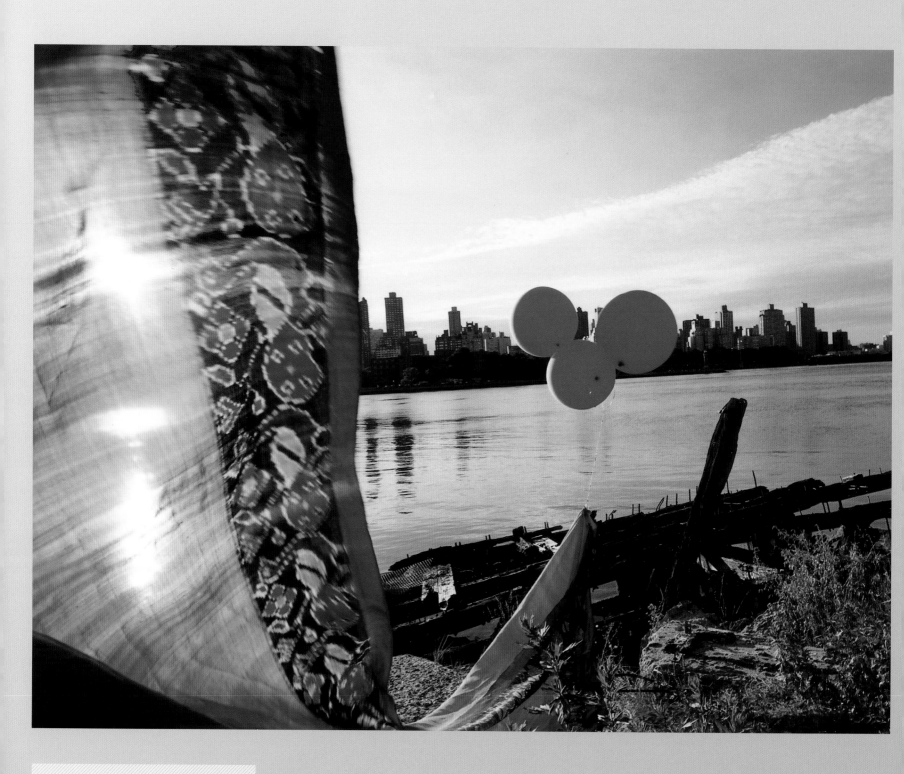

JESAL KAPADIA, *Flying Saree*, 2000–2003
(DETAIL)

Compared with other venues for public art and the unofficial contexts where contemporary art is being shown in New York, Socrates Sculpture Park presents a unique situation. Recent criticism of public art and site-specific artistic practice—from the discourse generated by the "democratic" process surrounding the removal and destruction of Richard Serra's *Tilted Arc*,[1] to Miwon Kwon's inquiry into site-specific art making that operates as a provision of "critical artistic service"[2]—does not quite apply here, in part because the Park began under the most idealistic of terms: local community members and artists transformed what had been an illicit dumping ground into a site for exhibiting sculpture. Today, Socrates continues as an exceptional, noncorporate, unprivatized, and open outdoor environment for sculptural artwork in New York. The rarity of such unfettered outdoor venues indicates that artistic expression in the public realm is indeed limited in space, time, and content, as made clear by the removal of John Ahearn's sculptural portraits of local residents in the South Bronx from their original site in the Bronx (which have found refuge at Socrates until further notice). Rarer still is a site for public art that addresses sculptural practice for the disciplines with which it overlaps and intersects: film, installation, architecture, performance, and socially based artworks.

In an era of rapid urban development and architectural impermanence Socrates has embraced the time-based quality of public art. In 2003 Socrates launched "Float" as a biannual exhibition to support emerging approaches to sculpture including performative, ephemeral, and time-based projects. In the inaugural season of "Float," for example, Peter Walsh offered a clambake meal to Park visitors in *Mercernaria mercernaria* (2003), a project named for the hard-shell clams used to make wampumpeag, or wampum, the complex currency of Algonquin gift economies. Using the social exchange of relational aesthetics, Walsh also addressed the Park's location on the East River. An earlier iteration of *Mercernaria mercernaria* had been organized several years before in the city's Financial District, where Pearl Street was once a shoreline filled with oyster shells, making it an appropriate context for the piece.

Vanishing Points

SARA REISMAN

The role of interaction must also be considered in making a work relevant to a public body that forms at a given site. Vydavy sindikat, a Brooklyn-based group whose name in Russian means "you collective," staged a series of Public Gatherings (2005–6) which were documented through group photographs tracing the spontaneous formation of community in selected locations. For two days during "Float 2005," vydavy sindikat photographed a group of friends together with other passersby, highlighting the relationships between various people in disparate places and overlapping communities. Several of the Park's regular visitors came back on the second day in anticipation of receiving a group photo and to reconnect with this newly formed community.

Likewise, Claudia Joskowicz's *Two-Second Love Stories* is an interactive work that has adjusted to the need for mobile artistic engagement in the public realm. In its presentation at Socrates Sculpture Park in "Float 2005," this narrative project involved the distribution of T-shirts bearing photographs of the neighborhood around the Park combined with phrases overheard within the Park and the surrounding streets. Snapshots of daily life, the shirts were distributed each day during the exhibition; visitors could take shirts in their size from dispensers installed on the Park's southern gate. The "two-second love stories," modeled after fotonovelas, were circulated—and continue to echo—in an unknown orbit. Joskowicz's piece is contingent on the public's desire to take and wear these T-shirts that retell snippets of a story about the local community within its own space and beyond. Resembling commodity objects of desire, their value lies in the dialogue they produce when they are worn.

Although the works of Joskowicz, vydavy sindikat, and Walsh are participatory, they are not beholden to fixed social standards nor are they meant to bridge gaps in our political system. Public art need not be democratic in its selection and activation, so long as it can be presented in democratic spaces where multiple communities intersect and can interact with the artwork on their own terms. With its ability to adapt to new modes of interaction created by artistic projects, Socrates Sculpture Park is a democratic space where the public can develop a reciprocal relationship with art unrestricted by mandates beyond creative expression itself.

1 Dwight Ink, former Acting Administrator, General Services Administration, quotes Serra as having said "...art is not democratic. It is not for the people." This statement is recontextualized to support Ink's decision to remove *Tilted Arc,* when Serra may have been addressing the fact that public opinion was being polled to determine the piece's appropriateness for Federal Plaza in New York. See Sherrill Jordan, *Public Art, Public Controversy: The Tilted Arc on Trial* (New York: ACA Books, A Program of the American Council for the Arts, 1987), 162.
2 Miwon Kwon, *One Place After Another: Site-Specific Art and Locational Identity* (Cambridge: MIT Press, 2002), 50.

DAVE HARDY, *I Can See Your House from Here*, 2005

"Participating in the exhibition 'Field' was an extraordinary learning experience. With the expert guidance of the entire community at Socrates Sculpture Park, I was able to realize a project unlike any I had created before. For me, working with Socrates provided not only a crash course in public sculpture, but also the chance to see how ambitious works can come to pass when an institution rallies with energy, dedication, and resolve."

HOPE GINSBURG, artist

DAVID SHAPIRO, *Left for Dead*, 2005 (DETAIL)

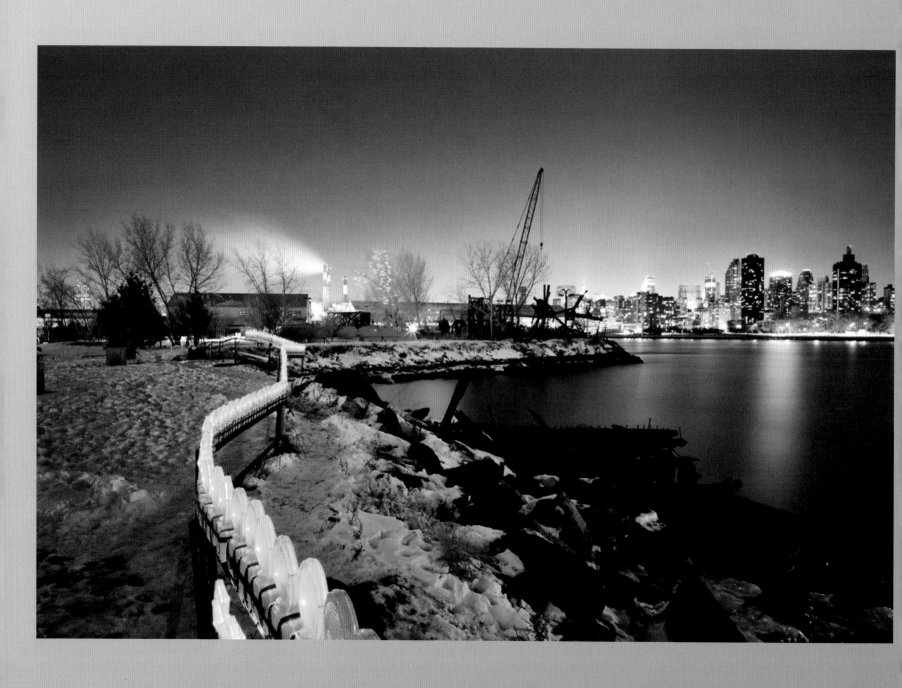

(FOREGROUND) JUDE TALLICHET, *Flash Park*, 2004
(DETAIL)

What if...

Something that
that artists have taught me
is to remember to look.
Theirs is an activity of careful
concentration and close attention.
They wonder. They consider.
They propose. What if?

Mark said, "What if artists put
work into the lot down the street?"
This was not that radical, coming from a
man who had a long list of equally
unlikely "what ifs" in his past, such
as "what if I live in a tree house," "what
if I make art," and "what if I ignore
my prognosis and walk." So I suppose
asking New York City for a lease,
gathering up neighbors and artists to
clear the site, and creating a sculpture
park seemed like a "what if" that could
easily come to be.

When I started working for Mark in
1987, a few months after the Park
opened, I had no idea who he was, or
what any of this stuff was at Socrates,
and what it was supposed to be doing.
One of the first pieces I remember
seeing at the Park was Sal Romano's
Moonshadow II, which was in the
"Inaugural Exhibition." It was made up
of several black rectangular volumes,
arranged next to a long reflecting pool.
The top element, seemingly dense
and weighty, turned gently in the wind.
It was incongruous and elegant

and beautiful in this odd, hard-
scrabble field of weeds. And I looked
at it. And I loved it.

Over the next twenty years,
the artists who exhibited at the Park
continued to astonish me with the
range of "what ifs" they envisioned.
They saw sculpture in the ground,
on the ground, in the water, in the trees,
in the air. They saw a multitude
of possibility, and we who visited the
Park experienced that infinite
possibility as well.

Socrates began with a modest
proposition to put art in an unused,
garbage-filled lot down the street.
This "what if" has unfolded over twenty
years to become an internationally
renowned sculpture park open 365 days
a year, presenting over five hundred
artists in over fifty exhibitions,
providing arts and education classes to
thousands of students on-site and
in school, and hosting an annual film
series and concerts, performances,
circuses and Halloween harvest
festivals—all of which are free. What
if, indeed!

It is easy not to see what is in
front of you when you work on
something daily. It is easy not to see
the sky, not to see the water, not
to see the art. And it is easy to forget
what you have seen. This book is
a reminder of what was there. It is a
reminder to see, to look.

Exhibition History

1986–2005

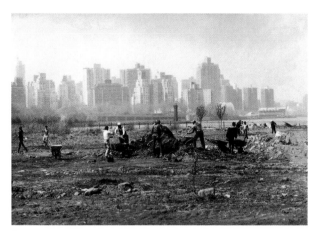

Site preparation,
1986

Inaugural Exhibition

SEPTEMBER 28, 1986–MARCH 31, 1987

Vito Acconci
Bill & Mary Buchen
Rosemarie Castoro
Mark di Suvero
Melvin Edwards
Lauren Ewing
Linda Fleming
Richard Mock
Owen Morrel
Florence Neal
Paul Pappas
Scott Pfaffman
Salvatore Romano
Richard Stankiewicz
William Tucker

Sculpture: Walk On/Sit Down/Go Through

MAY 17–SEPTEMBER 15, 1987

Vincent Ciulla & Paul Narkiewicz
Dennis Connors
Susan Crowder
Terry Lee Dill
Mark di Suvero
Cristos Gianakos
Edward Mayer
Richard Nonas
Jody Pinto
Rudolph Serra
Alan Sonfist
Robert Stackhouse
Gene Thompson

Outside In

OCTOBER 26–NOVEMBER 27, 1987

Vivien Abrams
Bill & Mary Buchen
Rosemarie Castoro
Dennis Connors
Susan Crowder
Chris Dashke
Tony de Varco
Terry Lee Dill
Mark di Suvero
Melvin Edwards
Heide Fasnacht
Thomas Faulkner
Claudia Fitch
Linda Fleming
Gene Flores
James Garvey
Cristos Gianakos
Kate Hunt
Germaine Keller
Helen Lessick
Ed Mayer
Richard Mock
Owen Morrel
John Morse
Florence Neal
Richard Nonas
Paul Pappas
Sara Pasti
Scott Pfaffman
Jody Pinto
Marilyn Reynolds
Salvatore Romano
Guy Scohy
Rudolph Serra
Robert Stackhouse
Gene Thompson
Dirk Van Dall
Ursula von Rydingsvard

Mark di Suvero and visitors at the
opening of "Sculpture: Walk On/Sit Down/
Go Through," 1987

Artists Choose Artists

NOVEMBER 7, 1987–MARCH 15, 1988

Miriam Bloom
Floris Brasser
Pam Brown
Tom Clancy
Malcolm Cochran
Houston Conwill
Tom Doyle
Ronald Ervolino & Luis Vera
Claudia Fitch
Gene Flores
Peter Forakis
Wenda Habenicht
Grace Knowlton
Page Ogden
Ed Rothfarb
Jim Swank
George Wyllie

Sculptors Working

MAY 22, 1988–MARCH 15, 1989

Brian Albert
Ilan Averbuch
Mike Cadwell
Tom Christopher
Chris Dashke
Mark di Suvero
Gene Flores
Eric Gould
Michael Hall
Maren Hassinger
Lisa Hein
Dave King
Zoran Mojsilov
Alison Saar
Margo Sawyer
David Seccombe
Tony Smith

Sculpture City

MAY 7, 1989–MARCH 11, 1990

Lillian Ball
Tom Bills
Riccardo Biondi
Ronald Bladen
Bill & Mary Buchen
Mark di Suvero
Ron Fondaw
Scott Gilliam & Dick Robinson

Mark Gordon
Kenny Greenberg
Klaus Illi
Henner Kuckuck
Helen Lessick
Donald Lipski
Elaine Lorenz
Zoran Mojsilov
John Morse
Robert Ressler
Matthew Tanteri
Paul Wallach
Tim Watkins

No Man's Land

APRIL 8, 1990–MARCH 8, 1991

Ed Andrews
Gloria Bornstein
Bård Breivik
Jonas Dos Santos
Patrick Dougherty
Heide Fasnacht
Linda Fleming
Mary Frank
Charles Ginnever
Robin Hill

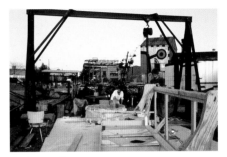

Outdoor studio, 1992

Exhibition signage, 1988

Installing Eve Sussman's *Schmuller*, 1992

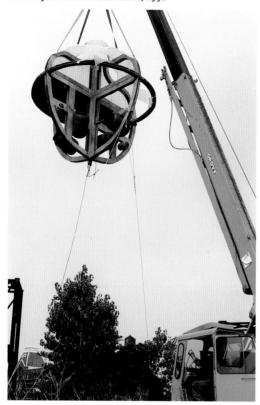

Ken Hiratsuka
Ray Kelly
Howard McCalebb
Jeffry Mitchell
Jesse Moore
Manuel Neri
Beverly Pepper
Diane Pieri
Vicki Scuri & Keith Oliver
Sebastian (Enrique Carbajal)
Tony Stanzione
Mary Ann Unger
Susanne Wibroe

International Young Sculptors Program

APRIL 28, 1991–APRIL 26, 1992

Tono Framis Aballa
Claude Bredif
Toni Giro i Fontanals
Juan Fernandez Lopez
Ali Mroivil
Jörg Schulze-Bünte
Edouard Vatinel

Grass Roots Art Energy

APRIL 28, 1991–APRIL 26, 1992

Inken Boje
Lionel Chalaye
Emilio Cruz
Guy Dill
Mark di Suvero
Don Harvey
Tadashi Hashimoto
Chris MacDonald
Georges Meurdras
Gail Rothschild
John Sanders
Merle Temkin
Peter Tilgner
Gabriel Warren
Catherine Widgery

Full Life

JUNE 7, 1992–MAY 2, 1993

Elisa Arimany
Joanne Brockley
Jean Clareboudt
Mark di Suvero
Keith Haring
Bruce Johnson
Pierre Plattier
Don Porcaro
Guy Scohy
Richard Stankiewicz
Eve Sussman
Anthe Zacharias

50NY93

MAY 23–AUGUST 1, 1993

Antoinette Ayres
Sylvia Benitez
Suzanne Bocanegra
Lee Boroson
Maria Cocchiarelli
Zachary Coffin
Nancy Cohen
John Crawford

Irving Sandler, Chakaia Booker, and
Lucy Sandler, 1994

Jim Donahue
Ellen Driscoll
Peter Dudek
Chris Duncan
Andrew Dunnill
Barbara Edelstein & Jian-Jun Zhang
Thomas Faulkner
Jeanne Flanagan
Gary Fredriksen
Del Geist
Michel Gerard
Mark Hadjipateras
Nade Haley
Sally Heller
Howard Kalish
Linda Kaplan
Sheree Kaslikowski
Bozidar Kemperle
Wendy Klemperer
David Kramer
David Krepfle
Simon Lee
Gregg LeFevre
Christopher Lesnewski
Kate Loye
George Mansfield
Susan Martin
Andrew Moore
Jiro Naito
Itty Neuhaus
Kurt Novak
Marsha Pels
Kathleen H. Ruiz
Shuli Sade
Erik Saxon
Alison Slon
Tony Stanzione
Jay Swift
Kazumi Tanaka
Lee Tribe
Jens Veneman
Darin Wacs
Karin Waisman
Gloria Williams

International 93-94

OCTOBER 31, 1993–APRIL 30, 1995

PART I
John Ahearn
Eduardo Chillida
Blane de St. Croix
Johann Feilacher
Bob Haozous
Jene Highstein
Rebecca Howland

Chris MacDonald
Jesus Bautista Moroles
Darrell Petit
Susanne Wibroe

PART II
Gunilla Bandolin
Chakaia Booker
John Borba
Roland Cognet
Mark di Suvero
Beth Galston
Barbara Grygutis
John Hock
Win Knowlton
Wendy Lehman
Peter Lundberg
Andrew Miller
Scott Moore
Jack Pospisil
Robert Ressler
Alberto Riano
Nancy Rubins
Zuzana Rudavska
Arthur Simms

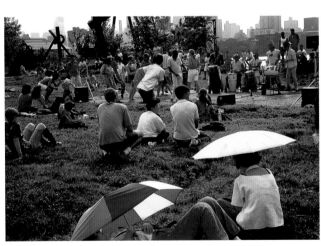

Opening of "Full Life," 1992

Pop Up

MAY 21, 1995–MARCH 31, 1996

Robbie Barber
Shaun Cassidy
Fuller Cowles & Connee Mayeron
Danilo Danziger
Elizabeth Egbert
Ted Garner
Kathleen Gilrain
Karin Giusti
Claes Hake
Ingrid Hartlieb
Brad Kahlhamer

RENA JULIETA HANANO, *I Have I Have
Nothing*, 1998

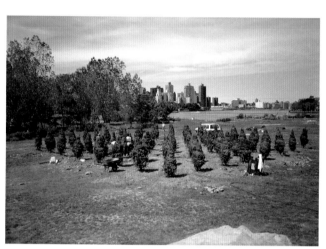

Installing The E-Team's *Christmas Tree
Farm for Self-Cutters*, 2001

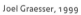

Joel Graesser, 1999

Craig Kraft
Elaine Lorenz
Deborah Masters
Laura McCallum
Brigitte Nahon
James Sadek
Michael Yue Tong

10th Anniversary
MAY 19, 1996–APRIL 1, 1997

Magdalena Abakanowicz
Ilan Averbuch
Colin Chase
John Clement
Kurt DelBanco
Mark di Suvero
Andrew Dunnill
Jackie Ferrara
Linda Fleming
Gene Flores
John Henry
Jon Isherwood
Sheree Kaslikowski
Renee Kildow
Peter Lundberg
Sandy MacLeod
George Mansfield & Kazumi Tanaka
Isamu Noguchi
Tom Otterness
Joel Perlman
Darrell Petit
Tom Rose
Michael Sarff
Sol Sax
George Segal
Suzy Surek
Elyn Zimmerman

From the Ground Up
MAY–SEPTEMBER 1997

Ron Baron
Luisa Caldwell
Gordon Everett Chandler
Esperanza Cortes
Gillian Jagger
Jae-Choul Jeoung
Monika Kulicka
Ian McLaughlin
Nick Micros
Ray Neufeld
Margie Neuhaus
Quido Sen
Marsha Trattner
John Van Alstine

Bernar Venet
J.J. Veronis

International 97
SEPTEMBER 1997–MAY 1998

Chakaia Booker
Emilie Benes Brzezinski
Václav Fiala
Tadashi Hashimoto
Karl Jensen
Nina Levy
Adéla Matasová
Vojtěch Míča
Alena Ort
Michael Richards
Lukás Rittstein
Vytautas Žaltauskas
Peter Zimmermann

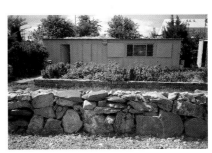

Park office, 2001
(FOREGROUND) KIRSTEN MOSHER,
glam rocks, 2001 (DETAIL)

Escape Velocity
MAY 17–AUGUST 31, 1998

David Baskin
John Beech
Miggy Buck
Mark di Suvero
Robert Hickman
Tim Kaulen
Wendy Klemperer
Christine Koch
Christopher Lesnewski
Robert Lobe
Jiro Naito
Alissa Neglia
Bob Seng
Jane South

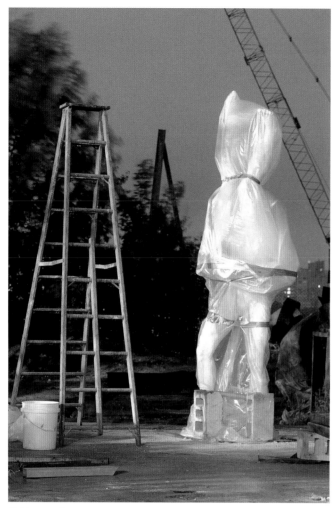

Outdoor studio, 1997

All That Is Solid
SEPTEMBER 20, 1998–APRIL 15, 1999

Laurent Baude
John Bjerklie
Alberto Cavalieri
Aris de Bakker
Kouichiro Fujii
Gail Goldsmith
Rena Julieta Hanono
James Huang
Mike Rathbun
Ward Shelley
Christine Tarkowski

7,840,800 cu ft
MAY 16–AUGUST 15, 1999

Sylvia Benitez
Susan Burek
Chris Doyle
Nancy Goldenberg
Sook Jin Jo
Ellen Lesperance
Slawomir Marzec
Vallessa Monk
Carl Scholz
Howard Schwartzberg
Knut Wold

Ozymandias
SEPTEMBER 26, 1999–APRIL 15, 2000

Mathieu Borysevicz
Daniel Coleman
Yoshiko Kanai
David Krepfle
Linda Lee
Kellie Murphy
Douglas Ross
Dread Scott
Kazuakei Sugi

Onceremoved
JUNE 4–SEPTEMBER 1, 2000

Ric Fry
DeWitt Godfrey
Rebecca Graves
Tom Kotik
Claire Lesteven
Bradley McCallum
Ledelle Moe
Abby Pervil
Eliza Proctor
Augustine Romero

The Space Around the Architect
SEPTEMBER 17, 2000–APRIL 15, 2001

Robert Barnstone
Robert Caldwell
Beth Campbell
Francesco Finizio
Peter Gould
Susan Griswold
Michael Krondl
STRETCH

Helen Marshall, left, Mark di Suvero,
and Ivana Mestrovic, right, at the opening
of "View," 2002

Beyond City Limits

MAY 20–AUGUST 25, 2001

Bob Braine
Tom Carruthers
Charles Goldman
Kirsten Mosher
Clara Williams

Open Space

SEPTEMBER 23–NOVEMBER 15, 2001

Robert Blackson

GREGORY CREWDSON, *Untitled, 2001–2002*, 2003

EAF01

2001 EMERGING ARTIST FELLOWSHIP
EXHIBITION
SEPTEMBER 23, 2001–APRIL 14, 2002

Katrin Asbury & Shawn Greene
Sanford Biggers
The E-Team
Lars Fisk
Frank J. Meuschke
Alan Wiener

View

MAY 19–AUGUST 18, 2002

Stephan Apicella-Hitchcock
Joyce Burstein
Peter Eudenbach
Tamara Gubernat
Peter Kreider

Patrick Meagher
Samuel Nigro
Carey Ann Schaefer
Gedi Sibony
Steed Taylor

Open Space

JUNE 30–OCTOBER 6, 2002

Yoko Inoue & Troy Richards

Open Space

APRIL 19, 2002–MARCH 30, 2003

Joel Graesser

Broadway Billboard

APRIL 23–DECEMBER 2, 2002

Miles Coolidge

EAF02

2002 EMERGING ARTIST FELLOWSHIP
EXHIBITION
SEPTEMBER 22, 2002–MARCH 30, 2003

Paolo Arao
Matthew Bakkom
Alejandro Cesarco
Peter Coffin
Elizabeth Demaray
Jeffrey Hatfield
Eric Hongisto
Caitlin Masley
Jennifer Monick
Jennifer Zackin

Broadway Billboard

DECEMBER 2, 2002–FEBRUARY 27, 2003

Claire Corey

Broadway Billboard

MARCH 4–MAY 8, 2003

Rosemary Laing

Yard

MAY 11–AUGUST 3, 2003

Andrea Bowers
Gregory Crewdson
Adam Cvijanovic
Elise Ferguson
Rosemarie Fiore
Maximilian Goldfarb
Lisa Hein & Bob Seng
Martine Kaczynski

Charles Goldman, 2001

Pia Lindman
Jason Middlebrook
Erin Shirreff
Alyson Shotz
Venske & Spänle
Weinthaler

Open Space
JUNE 15–AUGUST 10, 2003

Jean Shin

Open Space
JUNE 15–AUGUST 31, 2003

Anissa Mack

Float 2003
AUGUST 9–31, 2003

Ryan Buyssens
Cletus Dalglish-Schommer & Christopher Ho
flotsam
Mark Gagnon
Jesal Kapadia
Dylan Lorenz
Alisdair MacRae
Raimundas Malasauskas
Brian O'Connell
Lisa Oppenheim
Marc Robinson
Jon Rubin
Austin Thomas
Oscar Tuazon
Peter Walsh

Open Space
AUGUST 24–OCTOBER 26, 2003

Jesse Bercowetz
Matt Bua
Sabine Heinlein

Broadway Billboard
AUGUST 27, 2003–MAY 7, 2004

Edward Burtynsky

EAF03
2003 EMERGING ARTIST FELLOWSHIP
EXHIBITION
SEPTEMBER 7, 2003–FEBRUARY 8, 2004

Jane Benson
Rob de Mar
Lilah Freedland
Wade Guyton
Corin Hewitt
McKendree Key
Ross Knight
Sarah Oppenheimer
Halsey Rodman
Trevor Stafford

Winter Light
DECEMBER 1, 2003–FEBRUARY 29, 2004

Matthew McCaslin
Jude Tallichet
Leo Villareal

Open Space
MARCH 21–JUNE 6, 2004

Harrell Fletcher

Field
MAY 16–AUGUST 1, 2004

Patrick Armacost
Mark Dion
Elaine Gan
Hope Ginsburg
Michael Joo
Catarina Leitão
Pam Lins
Ethan Long
Mitch Miller
Lisi Raskin
John Stoney

Flicker
JUNE 12, 2004

Tanyth Berkeley
Justine Cooper & Joey Stein
Shaun Gladwell
Trevor Morgan
Ann Weathersby

EAF04

2004 EMERGING ARTIST FELLOWSHIP
EXHIBITION
SEPTEMBER 12, 2004—MARCH 6, 2005

Justin Beal
Isidro Blasco
Anna Craycroft
Jacob Dyrenforth
Orly Genger
Marie Lorenz
Christian Nguyen
Karyn Olivier
Leslie Reed
Mark Shunney

Broadway Billboard

SEPTEMBER 27, 2004—MAY 1, 2005

Jane & Louise Wilson

Open Space

MAY 15—JUNE 12, 2005

Jon Conner

Sport

MAY 15—AUGUST 7, 2005

Nicholas Arbatsky
Ron Baron
Tory Fair
Satch Hoyt
Alix Lambert
Tim Laun
Collier Schorr
Peter Simensky
Anne Thulin
Type A
Lee Walton
Allison Wiese

Float 2005

AUGUST 13—28, 2005

Soledad Arias
Kabir Carter
Monika Goetz
Sabrina Gschwandtner
Ryan Humphrey
Akiko Ichikawa
Claudia Joskowicz
Trong G. Nguyen
Michelle Rosenberg
Chrysanne Stathacos
vydavy sindikat
Douglas Weathersby

EAF05

2005 EMERGING ARTIST FELLOWSHIP
EXHIBITION
SEPTEMBER 10, 2005—MARCH 5, 2006

Marc Ganzglass
Dave Hardy
Klara Hobza
Margaret Lee
Noah Loesberg
Kelly Parr
Hanna Sandin
David Shapiro
Hyungsub Shin
Jonathan VanDyke

KARYN OLIVIER, *It's Not Over*
'til It's Over, 2004

Open Space

NOVEMBER 11, 2005—MARCH 5, 2006

Coke Wisdom O'Neal

Broadway Billboard

DECEMBER 19, 2005—MARCH 26, 2006

Christopher Yockey

List of Artists

Abakanowicz, Magdalena
Aballa, Tono Framis
Abrams, Vivien
Acconci, Vito
Ahearn, John
Albert, Brian
Ames, Adam (Type A)
Andrews, Ed
Apicella-Hitchcock, Stephan
Arao, Paolo
Arbatsky, Nicholas
Arias, Soledad
Arimany, Elisa
Armacost, Patrick
Asbury, Katrin
Averbuch, Ilan
Ayres, Antoinette

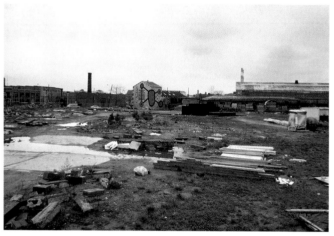

Site preparation,
1986

Bakkom, Matthew
Ball, Lillian
Bandolin, Gunilla
Barber, Robbie
Barnstone, Robert
Baron, Ron
Baskin, David
Baude, Laurent
Beal, Justin
Beech, John
Benitez, Sylvia
Benson, Jane
Bercowetz, Jesse
Berkeley, Tanyth
Biggers, Sanford
Bills, Tom
Biondi, Riccardo
Bjerklie, John
Blackson, Robert
Bladen, Ronald
Blasco, Isidro

Bloom, Miriam
Bocanegra, Suzanne
Boje, Inken
Booker, Chakaia
Borba, John
Bordwin, Andrew (Type A)
Bornstein, Gloria
Boroson, Lee
Borysevicz, Mathieu
Bowers, Andrea
Braine, Bob
Brasser, Floris
Bredif, Claude
Breivik, Bård
Brockley, Joanne
Brown, Pam
Brzezinski, Emilie Benes
Bua, Matt
Buchen, Bill
Buchen, Mary
Buck, Miggy
Burek, Susan
Burstein, Joyce
Burtynsky, Edward
Buyssens, Ryan

Cadwell, Mike
Caldwell, Luisa
Caldwell, Robert
Campbell, Beth
Carruthers, Tom
Carter, Kabir
Cassidy, Shaun
Castoro, Rosemarie
Cavalieri, Alberto
Cesarco, Alejandro
Chalaye, Lionel
Chandler, Gordon Everett
Chase, Colin
Chillida, Eduardo
Christopher, Tom
Ciulla, Vincent
Clancy, Tom
Clareboudt, Jean

Ian McLaughlin, 1997

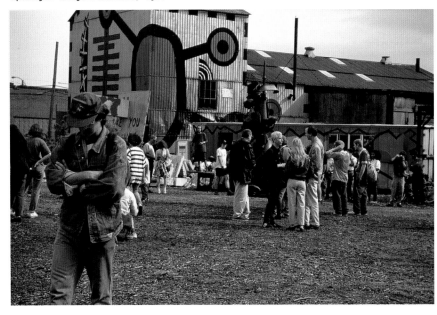

Clement, John
Cocchiarelli, Maria
Cochran, Malcolm
Coffin, Peter
Coffin, Zachary
Cognet, Roland
Cohen, Nancy
Coleman, Daniel
Conner, Jon
Connors, Dennis
Conwill, Houston
Coolidge, Miles
Cooper, Justine
Corey, Claire
Cortes, Esperanza
Cowles, Fuller
Crawford, John
Craycroft, Anna
Crewdson, Gregory
Crowder, Susan
Cruz, Emilio
Cvijanovic, Adam

Dalglish-Schommer, Cletus
Danziger, Danilo
Dashke, Chris
de Bakker, Aris
de Mar, Rob
de St. Croix, Blane
de Varco, Tony
DelBanco, Kurt
Demaray, Elizabeth
Dermansky, Julie
di Suvero, Mark
Dill, Guy
Dill, Terry Lee
Dion, Mark
Donahue, Jim
Dos Santos, Jonas
Dougherty, Patrick
Doyle, Chris
Doyle, Tom
Driscoll, Ellen
Dudek, Peter
Duncan, Chris
Dunnill, Andrew
Dyrenforth, Jacob

Edelstein, Barbara
Edwards, Melvin
Egbert, Elizabeth
Ervolino, Ronald
Eudenbach, Peter
Ewing, Lauren

Fair, Tory
Fasnacht, Heide
Faulkner, Thomas
Feilacher, Johann
Ferguson, Elise
Ferrara, Jackie
Fiala, Václav
Finizio, Francesco
Fiore, Rosemarie
Fisk, Lars
Fitch, Claudia
Flanagan, Jeanne
Fleming, Linda
Fletcher, Harrell
Flores, Gene
Fondaw, Ron
Fontanals, Toni Giro i
Forakis, Peter
Frank, Mary
Fredriksen, Gary
Freedland, Lilah
Fry, Ric
Fujii, Kouichiro

Gagnon, Mark
Galston, Beth
Gan, Elaine
Ganzglass, Marc
Garner, Ted
Garvey, James
Geist, Del
Genger, Orly

ROBERT RESSLER, *On Fertile Ground*, 1994

223

Enrico Martignoni, 1994

Jason Middlebrook,
2003

Gerard, Michel
Gianakos, Cristos
Gilliam, Scott
Gilrain, Kathleen
Ginnever, Charles
Ginsburg, Hope
Giusti, Karin
Gladwell, Shaun
Godfrey, DeWitt
Goetz, Monika
Goldenberg, Nancy
Goldfarb, Maximilian
Goldman, Charles
Goldsmith, Gail
Gordon, Mark
Gould, Eric
Gould, Peter
Graesser, Joel
Graves, Rebecca
Greenberg, Kenny
Greene, Shawn
Griswold, Susan
Grygutis, Barbara
Gschwandtner, Sabrina
Gubernat, Tamara
Guyton, Wade

Habenicht, Wenda
Hadjadj, Bruno
Hadjipateras, Mark
Hake, Claes
Haley, Nade
Hall, Michael
Haney, Vanessa
Hanono, Rena Julieta
Haozous, Bob
Hardy, Dave
Haring, Keith
Hartlieb, Ingrid
Harvey, Don
Hashimoto, Tadashi
Hassinger, Maren
Hatfield, Jeffrey
Hein, Lisa
Heinlein, Sabine
Heller, Sally
Helpern, Barbara
Henry, John
Hepper, Carol
Hewitt, Corin
Hickman, Robert
Highstein, Jene
Hill, Robin
Hiratsuka, Ken
Ho, Christopher
Hobza, Klara
Hock, John
Hongisto, Eric
Howland, Rebecca
Hoyt, Satch
Huang, James
Humphrey, Ryan
Hunt, Kate

Ichikawa, Akiko
Illi, Klaus
Inoue, Yoko
Isherwood, Jon

Jagger, Gillian
Jensen, Karl
Jo, Sook Jin
Johnson, Bruce
Joo, Michael
Joskowicz, Claudia
Jeoung, Jae-Choul

Kaczynski, Martine
Kahlhamer, Brad
Kahn, Holen Sabrina (flotsam)
Kalish, Howard
Kanai, Yoshiko
Kapadia, Jesal

Kaplan, Linda
Kaslikowski, Sheree
Kaulen, Tim
Keller, Germaine
Kelly, Ray
Kemperle, Bozidar
Key, McKendree
Kildow, Renee
King, Dave
Klemperer, Wendy
Knight, Ross
Knowlton, Grace
Knowlton, Win
Koch, Christine
Kotik, Tom
Kraft, Craig
Kramer, David
Kreider, Peter
Krepfle, David
Krondl, Michael
Kuckuck, Henner
Kulicka, Monika

Laing, Rosemary
Lambert, Alix
Lamprecht, Franziska (The E-Team)
Laun, Tim
Lee, Linda
Lee, Margaret
Lee, Simon
LeFevre, Gregg
Lehman, Wendy
Leitão, Catarina
Lesnewski, Christopher
Lesperance, Ellen
Lessick, Helen
Lesteven, Claire
Levy, Nina
Lindman, Pia
Lins, Pam
Lipski, Donald
Lobe, Robert
Loesberg, Noah
Long, Ethan
Lopez, Juan Fernandez
Lorenz, Dylan
Lorenz, Elaine
Lorenz, Marie
Loye, Kate
Lundberg, Peter

MacDonald, Chris
Mack, Anissa
MacLeod, Sandy
MacRae, Alisdair
Malasauskas, Raimundas

Mansfield, George
Martin, Susan
Marzec, Slawomir
Masley, Caitlin
Masters, Deborah
Matasová, Adéla
Mayer, Edward
Mayeron, Connee
McCalebb, Howard
McCallum, Bradley
McCallum, Laura
McCaslin, Matthew
McLaughlin, Ian
Meagher, Patrick
Meurdras, George
Meuschke, Frank J.
Míča, Vojtěch
Micros, Nick
Middlebrook, Jason
Miller, Andrew

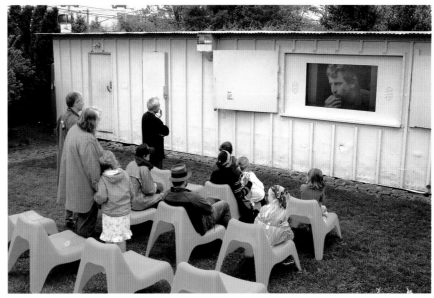

ANDREA BOWERS, *Vieja Gloria*, 2003

Miller, Mitch
Mitchell, Jeffry
Mock, Richard
Moderegger, Hajoe (The E-Team)
Moe, Ledelle
Mojsilov, Zoran
Monick, Jennifer
Monk, Vallessa
Moore, Andrew
Moore, Jesse
Moore, Scott
Morgan, Trevor
Moroles, Jesus Bautista

Morrel, Owen
Morse, John
Mosher, Kirsten
Mroivil, Ali
Murphy, Kellie

Nahon, Brigitte
Naito, Jiro
Narkiewicz, Paul
Neal, Florence
Neglia, Alissa
Neri, Manuel
Neufeld, Ray
Neuhaus, Itty
Neuhaus, Margie
Nguyen, Christian
Nguyen, Trong G.
Nigro, Samuel
Noguchi, Isamu
Nonas, Richard
Novak, Kurt

O'Connell, Brian
Ogden, Page
Olivier, Karyn
Oliver, Keith
O'Neal, Coke Wisdom
Oppenheim, Lisa
Oppenheimer, Sarah
Ort, Alena
Otterness, Tom

Pappas, Paul
Parente, Janice
Parr, Kelly
Pasti, Sara
Pels, Marsha
Pepper, Beverly
Perlman, Joel

Perreaut, Jacques
Pervil, Abby
Petit, Darrell
Pfaffman, Scott
Pieri, Diane
Pinto, Jody
Plattier, Pierre
Plechkina, Yevgeniya (vydavy sindikat)
Porcaro, Don
Pospisil, Jack
Proctor, Eliza

Raskin, Lisi
Rathbun, Mike
Reed, Leslie
Rehm, Jay (flotsam)
Ressler, Robert
Reynolds, Marilyn
Riano, Alberto
Richards, Michael
Richards, Troy
Rittstein, Lukás
Robinson, Dick
Robinson, Marc
Rodman, Halsey
Romano, Salvatore
Romero, Augustine
Rose, Thomas
Rosenberg, Michelle
Ross, Douglas
Rothfarb, Ed
Rothschild, Gail
Rubin, Jon
Rubins, Nancy
Rudavska, Zuzana
Ruiz, Kathleen H.

Saar, Alison
Sade, Shuli
Sadek, James
Sanders, John
Sandin, Hanna
Sarff, Michael
Sawyer, Margo
Sax, Sol
Saxon, Erik
Schaefer, Carey Ann
Scholz, Carl
Schorr, Collier
Schulze-Bünte, Jörg
Schwartzberg, Howard
Scohy, Guy
Scott, Dread
Scuri, Vicki
Sebastian (Enrique Carbajal)
Seccombe, David

Salvatore Romano, 1986

Jason Childers at "Socrates Live," 1988

Park overview, 1988

East River bathers, 1993

Mark di Suvero speaking at a dedication
ceremony, 1994

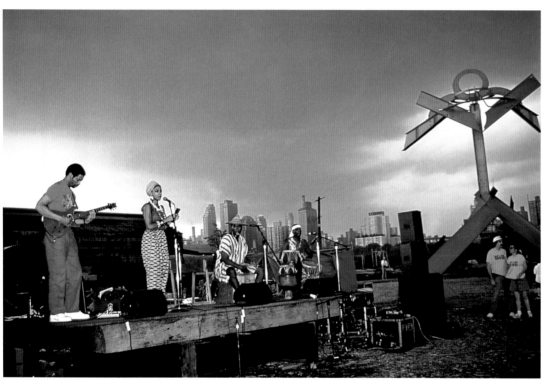

"Bongo Park," 1994

Agnes Gund, left, and Mark di Suvero, 1994

Segal, George
Seiple, Daniel (The E-Team)
Sen, Quido
Seng, Bob
Serra, Rudolph
Shapiro, David
Shelley, Ward
Shin, Jean
Shin, Hyungsub
Shirreff, Erin
Shotz, Alyson
Shunney, Mark
Sibony, Gedi
Simensky, Peter
Simms, Arthur
Sklar, Misha (vydavy sindikat)
Slon, Alison
Smith, Tony
Sonfist, Alan
South, Jane
Spänle, Gregor
Stackhouse, Robert
Stafford, Trevor
Stankiewicz, Richard
Stanzione, Tony
Stathacos, Chrysanne
Stein, Joey
Stigliano, Phyllis
Stoney, John
STRETCH
Sugi, Kazuaki
Surek, Suzy
Sussman, Eve
Swank, Jim
Swift, Jay

Tallichet, Jude
Tanaka, Kazumi
Tanteri, Matthew
Tarkowski, Christine
Taylor, Steed
Temkin, Merle
Thomas, Austin
Thompson, Gene
Thulin, Anne
Tilgner, Peter
Tong, Michael Yue
Trattner, Marsha
Tribe, Lee
Tuazon, Oscar
Tucker, William

Unger, Mary Ann

Van Alstine, John
Van Dall, Dirk

VanDyke, Jonathan
Vatinel, Edouard
Veneman, Jens
Venet, Bernar
Venske, Julia
Vera, Luis
Veronis, J. J.
Villareal, Leo
von Rydingsvard, Ursula

Wacs, Darin
Waisman, Karin
Wallach, Paul
Walsh, Peter
Walton, Lee
Warren, Gabriel
Watkins, Tim
Weathersby, Ann
Weathersby, Douglas
Weinthaler, Susan
Wibroe, Susanne
Widgery, Catherine
Wiener, Alan
Wiese, Allison
Williams, Clara
Williams, Gloria
Wilson, Jane
Wilson, Louise
Wold, Knut
Wyllie, George

Yockey, Christopher

Zacharias, Anthe
Zackin, Jennifer
Žaltauskas, Vytautas
Zhang, Jian-Jun
Zimmerman, Elyn
Zimmermann, Peter

Henry Stern, left, and Mark di Suvero, 1994

Acknowledgments

One of the problems in working on a book like this is that there is an enormous list of people who need to be acknowledged, but not enough space to adequately thank them for all they have done. However, a few things must be said: we must thank the four directors, the staff, the teachers, and the crew, whose tireless efforts and boundless energy have made Socrates what it is. We extend our gratitude to the board members, friends, and advisers who have given so generously of their time and have provided us with guidance. We also offer our thanks to the individuals and institutions who have given so generously of their money, without whom we could not do what we do, which is to provide free programming 365 days a year. We are grateful to the City of New York, both its politicians and its residents, who have supported the Park and made it theirs. We thank the artists, whose vision and passion keep us going. And finally, we must recognize Mark di Suvero, without whom this Park would not exist, nor even have been conceived.

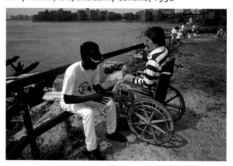

Larry Tucker, left, and Lenny Contino, 1992

MIKE CALDWELL, *Gatehouse*, 1988

SPECIAL THANKS

Katrin Asbury
Nicole Awai
Diana Balmori
Kanoa Baysa
Miles Bellamy
Peter Bellamy
Richard Bellamy
Elizabeth Berger
Charles Bergman
John Bergman, Esq.
Marek Bireline
Mariella Bisson
Paul Bloodgood
Chakaia Booker
John Borba
Flores Brasser
Mark Brodbeck
Bill & Mary Buchen
Beth Campbell
Stephanie Cash
Melissa Chaney
Diane M. Coffey
Martin Cohen
Anella Contino
Lenny Contino
Paula Cooper
Denise Corley
Renata Cottone
Anna Craycroft
Kathy Creutzburg-Enos
George Delis
Elizabeth Demaray
Emma Dewing
Nathan Diana
Mark Dion
Vinicio Donato
Anne Ellegood
Ella Mae Epps
Keith Epps
Dominique Evrard
Marcel Evrard
Michelle Evrard
Martha Ezell
Leonard Feldman, Esq.
Maya Salvado Ferrer
Lori Fierstein
Barbara Fife
Noah Fisher
Linda Fleming
Gene Flores
Barbara Flynn
Lucy Fradkin
Mary Clare Galvin
Michel Gerard
Jeff Gibson
James Gilrain
Nancy Goldenberg
Elizabeth Goldstein
Aida Gonzalez
Gail Goretsky
Janice Guy
Zach Hadlock
Nazim Hamid
Eva Hanhardt

Thomas Hanrahan
Patricia E. Harris
Gabriel Hernandez
Corin Hewitt
Laura Hoptman
Kent Johnson
Michael Joo
Matt Keegan
McKendree Key
Aaron Kirtz
Neal Klinger
Charlotta Kotik
Andrew Kreps
Monika Kulicka
Cedric Lachasse
Jaqueline Langsam
Janet Langsam
Penny Lee
Chris Lesnewski
Anna Levin
Kate D. Levin
Pippo Lionni
Vera List
Glenn D. Lowry
Thanos Maggioros
Trisha Mainiero
Elizabeth Margulies
Marie-Louise Martignoni
Matteo Martignoni
Lillian Maurer
Michael McCarthy
Jerry McClure
Lowell McKegney
Sara Meltzer
Frank J. Meuschke
Mitch Miller
Richard Mock
Patti Mock
Steven Moiser
Shamim M. Momin
Lisa Mordhorst
John Morse
Robert Nachimson
Isamu Noguchi
Richard Nonas
Someng Olsen
Nancy Owens
Susan Packard
Paul Pappas
Janice Parente
Peter Pastreich
Marina Pavlutskaya
Maurizio Pellegrin
Jerilyn Perrine
Scott Pfaffman
Harry Philbrick
Pierre Plattier
Lisa Quinones
Isabelle Radtke
Jim Radtke
Ross Radtke
Robert Ressler
Philip G. Roche
Halsey Rodman
Doug Ross
Jeffrey Rumaner

Shoji Sadao, R.A.
Renu Sahdwani
Sol Sax
Erik Schaefer
Mary Schmidt-Campbell
Monique Schubert
David Schwartz
Vincent F. Seyfried
Katy Siegel
David Simons
Robert Singleton
Lorenza A. Smith
Valerie Smith
Rebecca Smith
Jennifer Spiegler
Slaveya Starkov
Phyllis Stigliano
Eleonore Straub
Sarah Sze
Delphine Taylor
Carolee Thea
Mark Thomann
Barbara Thomas
Richard Thypin
Dirk Van Dall
Guy Vincel
Gregory Volk
Claudia Wagner
Paul Wallach
Mary Warden
Kristin Weber-Friedman
Joyce Weiner
Sam White
Christine Whittaker
Laura Williams
Ealan Wingate
Corrina Wright
Christopher Yockey
Anthe Zacharias
Andrea Zittel

The Socrates crew, 2004

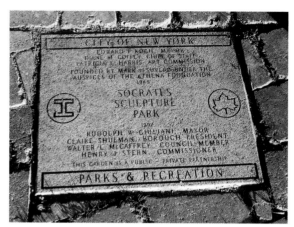

Park designation, 1996

OUR FRIENDS AT PARKS

JoAnne Amagrande-Savarese
David Bentham
Angelyn Chandler
Jane Cleaver
Amy L. Frietag
Tamara Greenfield
Patricia Hamilton
Helen Ho
Jenny Hoffner
Shirley Kindler-Penzi, RLA
Jonathan Kuhn
Dana Litvack
Emily Maxwell
Andrea Malloy
Thomas Panzone
David Ray
Adrianne Sas
Krissa K. Spence
Robert Speziale
Brian Thompson
Clare Weiss

STAFF (CURRENT)

Alyson Baker
Robyn Donohue
Deborah Fisher
Joel Graesser
Georgia Koutsoupakis
Sophia Leung
Sara Reisman
Tara Sansone
Rachel Weingeist

STAFF (FORMER)

Camilo Alverez
John Carlos Celdran
Kimberly Chang
John Clement
Maria Cocchiarelli
Zachary Coffin
Jennifer Curry
Tony DeVarco
Stephanie Diamond
Kathleen Gilrain

Lisa Gold
Gail Goretsky
James Greco
Curt Hagedorn
John Kaehny
Eugene Knecht
Simon Lee
Shaun Leonardo
Emily Liebling
Peter Lundberg
Sandy MacLeod
Enrico Martignoni
Megan Michalak
Maria Mingalone
Alissa Neglia
Nicholas Pappas
Sara Pasti
Sativa Peterson
Pricilla Piervincenti
Jason Reppert
Jacqueline Scheel
Eve Sussman
Joseph Wilner
Sandra Wong

CREW/TECHNICIANS

Safi Albright
Michael Allen
Tony Annunziato
Ronald Arthurton
Jamel Austin
Andy Bellavia
Curtis Bing
Sean Blackshear
Gavin Brady
Jeffrey Brown
Timothy Brown
Stan Cannella
Audrey Capers
Kareem Carruth
Ernest Cobb

Kevin Curry
Vivian Curry
Karen Dennis
Raymond Denson
David Diaz
Laval S. Eidtson
Jose Fermantt
Luz Fleming
Torrence Flemings
Alyssa Gerber
Andrew Gordon
Greg Gorham
Lewis Grant
Julius Green
Julius Green, Jr.
Phil Green
Sharon Green
Rasheem Green
Tyshaun Haines
Dwight Hall
Scott Hall
Terry Hall
Jermaine Hawkins
Kyle Herbin
Alfonzo Hightower
Richard Hines
Valerie Holliday
Ricky Holmes
Charles Horne
Kenneth Ingram
Calvin Jackson
Garette Jacobs
Gary Johnson
Neale Kavanagh
Larry Kinley
Colin Kohnhorst
Ernest Lago
Richard Lang
Robert Lang
Carol Lawson
Rob Lawson
Sharon Lawson

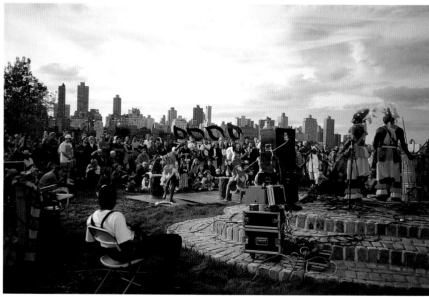

Opening of "10TH Anniversary Exhibition," 1996

Andrew Lee
Daquan Lee
Joseph Lewis
Thomas Mann
Othaniel Martin
Stephanie McCord
Gereald McKinny
William McCleese
Jacelyn Montanez
Anthony Moody
Eric Moore
La-Shawn Moore
Ronald Morris
Shariff Murdough
Anthony Odom
Michael Pallen
Emmett Parr
Edgar Perez
Billy Perez
Vladimir Perez
Anthony Price
Butch Pulley
Sharon Rich
Enrique Rosada
LaSheanna Rosario
James Rosello
William Rosello

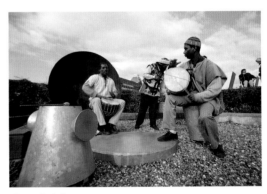

"Bongo Park," 1990

Julian Salcedo
David Schneider
Ben Shreefter
Mark Shunney
Ian Sikorski
Kenneth Simmons
Dwona Tucker
Kiley Tucker
Larry Tucker
Marcie Tucker
Yildiz Vellon
James C. Walton
David Ward
Curtis Webb
Maxine Webb
Taisheem Webb
Jamel Wheeler
Nathaniel Wheeler
Roy White
Shakiem Wray
Zina Wright

BOARD OF DIRECTORS (CURRENT)

Adrian Benepe, Ex-Officio
Gloria D'Amico
Mark di Suvero
Agnes Gund
Hugh Hardy, FAIA
Grahame Hubbard
Richard Menschel
Ivana Mestrovic
Brooke Kamin Rapaport
Reverend Alfred R. Shands III
Thomas Smith
Janice Stanton
Stuart Match Suna
Ursula von Rydingsvard

BOARD OF DIRECTORS (FORMER)

Anita Contini
Ruth Cummings-Sorenson
Monroe Denton
Susan K. Freedman
Martin Friedman
Charles Hamm
Barbara Haskell
Gregory Jones
Helen Lessick
Enrico Martignoni
John Morse
Midori Nishizawa
Sara Pasti
David Pincus
Martin Puryear
Eli Rios
Irving Sandler
Eve Sussman
Dirk Van Dall
Marika Wachtmeister

NEW YORK CITY AND STATE OFFICIALS

Hon. Michael R. Bloomberg, Mayor
Hon. Rudolph W. Giuliani
Hon. David N. Dinkins
Hon. Edward I. Koch
Hon. Betsy Gotbaum, Public Advocate, former Parks Commissioner
Hon. Christine Quinn, City Council Speaker
Hon. A. Gifford Miller
Hon. Peter Vallone, Sr.
Hon. Helen Marshall, Queens Borough President
Hon. Claire Shulman
Hon. Eric Gioia, City Council Member
Hon. Walter McCaffrey
Hon. George Onorato, State Senator
Hon. Catherine M. Nolan, State Assemblywoman

Hon. Adrian Benepe, Commissioner, Department of Parks & Recreation
Hon. Henry J. Stern
Hon. Gordon Davis
Hon. Dorothy Lewandowski, Queens Borough Commission
Hon. Richard P. Murphy
Hon. Robert W. Walsh, Commissioner, Department of Small Business Services

"Bongo Park," 1990

DONORS

36th Ave Business Association
5th & Sunset Enterprises
A&D Steel
The Shuree Abrams Foundation
Ace Wire & Cable Co., Inc.
Adirondack Direct
The Aldrich Contemporary Art Museum
Alma Realty
Altria Group, Inc.
America the Beautiful
American Express Publishing Co.
The American Federation of Art
American Pipe & Tank Lining Co.
Annie's Homegrown, Inc.
Harold Anthony, Inc.
Architectural Molded Composites
Steven Arnerich & Karen Hatch
Aronson Foundation
Art Horizons International, Inc.
Art Matters
Barbara Arthur
Artificial Imaging
Astoria Federal Savings
Astoria Historical Society
Astoria Performing Arts Center
Atelier 4
Athena Foundation
Atlas Transit Mix Corporation
Lily Auchincloss Foundation, Inc.
Auto Magic Transport
AvalonBay Communities, Inc.
Ilan Averbuch
Milton & Sally Avery Arts Foundation
Antoinette Ayres
James & Dorothy Baker
Evalyn Lee & Peter Bacon
Gunilla Bandolin
Bank Street College of Education

Installing DeWitt Godfrey's,
Socrates Sculpture 2000, 2000

Bark Frameworks
Beacon Paint
Bedi-Makky Art Foundry
Bedrock Industries
H.J. Behrman
Bel Aire Diner
Belden Brick Sales & Service, Inc.
John Bergman
David Bermant Foundation:
 Color, Light, Motion
Chris Bernhardt
Bessemer Trust
Big City Graph-X & Printing
Bissett Nursery Corporation
Zachary Bluemer
Willard Boepple
Bracci Fence & Ironworks, Inc.
Bradley Family Foundation, Inc.
Bridge Marine Supply
Broadway Astoria Merchants
Brooklyn Childrens Museum
Brooklyn Mason Supply
Brooklyn Museum
Michelle Brown
Jeffrey M. Brown Associates
Bill & Mary Buchen
The Buhl Foundation, Inc.
Matt Burke
Sarah Burnes
Bush Foundation
Marlene & Mark Butler
Carnegie Corporation of New York
The Center for Arts Education
Centralized Laboratory Services
Charina Foundation
Charter Production Company
The Chase Manhattan Foundation
Benjamin Cheah
Chemical Bank
Citibank
Citizens Committee for NYC
City Parks Foundation
ClearSpan™
John Clement
Jerry Cohen
Martin Cohen
Maurice & Margo Cohen
David R. & Vivien Collens
Commerce Bank
The Compleat Sculptor
Con Edison

Consul General of Spain
Consul of France
Contractors Supply Corp.
Cooper Tools, Inc.
Cooper Union
Corona Equipment
John P. Corrieri, Inc.
Costco Wholesale
Country Importers
Stephen Covello
The Cowles Charitable Trust
Constance & Fuller Cowles
 Foundation
Creative Time
Credit Agricole
William & Gael Crimmins
Cruz Construction
Nathan Cummings Foundation
Cyro Industries
Daimler-Benz-Ag
Elaine Dannheiser Foundation
Danilo Danziger
Emme Deland
Mark di Suvero
Zoe Dictrow
Digital Verite
Terry Dill
Mark Dollar
Donjer Products Corp.
Drac, Inc.
Hyena Dragline
Ellen Driscoll
Tim & Dagney du Val
E&T Plastic Manufacturing Co.
Electric Distributors, Inc.
Electronic Arts Intermix
Andre Emmerich Gallery
eNetFurniture
Evergreen Tree Service
Experimental Television Center,
 Presentation Funds Program
Ex-Tech Industries, Inc.
Falcon Recycling Corp.
Michele Falik Kidwell-Cohen
Leonard and Susan Feinstein
Joe Fernandez
Feigen Contemporary
Fifth Floor Foundation
Fischerwerke Arthur Fischer
Thomas Fitzgibbon & Denise
 Corley

Audrey Flack
Flowers with Care
The Foundry
Maxine & Stuart Frankel
 Foundation
Amy Freeth
Fresh Direct
Hugh J. Freund
Kristin Friedman
Martin & Mildred Friedman
Friends of Catherine M. Nolan
Fund for the City of New York
Galerie Lelong
Galo Wine Distributors
GameTime
Gan-Angelo American Insurance
Sally Ganz
Garlock East
Glen Gary Corp.
Josephine Gear
Sandra Gering Gallery
Kathleen Gilrain
Joan Giroux
Glenwood Masonry Products
Glow, Inc.
The Horace W. Goldsmith
 Foundation
Goodwill Industries
The Gordon Supply, Inc.
W.R. Grace Construction Products
Gratz Industries, Inc.
Green Guerillas
Green Mountain Graphics
Greenpoint Foundation
Mina Greenstein
The Greenwall Foundation
Greiner-Maltz Co.
Barbara Grygutis
The Solomon R. Guggenheim
 Museum
Agnes Gund & Daniel Shapiro
Paul Gunther
Mark Hadjipateras
Hallets Cove Studio
Israel Halpern
hMa, hanrahan Meyers architects
Rosemary Harris
Don Harvey
Tadashi Hashimoto
Sarah Haviland
HBO
Heathcote Art Foundation
Lisa Hein

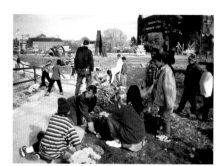

Landscaping, 1997

234

Heinz Family Foundation
Amy Hochman
William Holman
Heidi Hotzler
IKEA
Akira Ikeda Gallery
ImageKing Visual Solutions
Independence Community
 Foundation
Inverso Warehousing
Nancy Ittleson
JPMorgan Chase
Shirley Jackel
Jam Cats, Inc.
Randolph Jennings
Jerome Foundation
Jetro Cash and Carry
The J.M. Kaplan Fund, Inc.
Christine Johnsen
Johnson Atelier
Tommy Lee Jones
Peter T. Joseph Foundation
Wendy Evans Joseph
Kaplon-Belo, Inc.
Karl-Hofer Gessellschaft
Katonah Gallery
Gabrielle & Herbert Kayden
Paige & John Keeler
Elizabeth Kelley
J. Frederick Construction
Keyspan
Eugene V. Klein
Win Knowlton
The Korea Times
Korean Cultural Service NY
June Kraft
David Kramer
kt. COLOR
Eleanor Kuser
Masaaki Kusumoto
Dawn Laurel
Leifer Bros. Steel Company
Mitchell and Abby Leigh
 Foundation
Jerry Lerman
Helen Lessick
Caryn Levitt
Johanna Li
Liberty Electrical Supply, Inc.
Liberty General
Amy Liss
Muema K. Lombe
Long Island City Business
 Development Corporation
Long Island Fabric
Long Island General Supply Co.
Robert Lorr
Lower Manhattan Cultural Council
Luis Winston, Inc.
Lundberg Design
The MAT Charitable Foundation
MacArthur Holdings
Gordon & Janet MacLeod
Enrico Martignoni
Matteo Martignoni
Materials for the Arts
Mathis-Pfohl Foundation

Edward Mayer
Jason McCoy
Lowell McKegney
Elizabeth McKinney
Jennifer McSweeney
Seymour & Jacqueline Meisel
Sara Meltzer Gallery
Richard & Ronay Menschel
Merrill Lynch & Co. Foundation, Inc.
Danette Mersky
Ivana Mestrovic
MICA Lighting
Nathan Michael
Nick Micros
Middendorf Gallery
Midtown Electric Supply Corp.
Jeffrey & Virginia Miner
Mint Museum of Craft + Design
Mirella Media
Mitchell Museum
Mixed Greens
Montessori Program
Jesse Moore
MORICH Enterprises, Inc.
Mark K. Morrison Associates Ltd.
Museum of the Moving Image
Museum Services
Mutual Hardware
Nassau County Museum
National Endowment for the Arts
National Foundation for the
 Advancement of the Arts
Nebraska Board of Education
Nemo Tile Company
Ben Ness Imaging
Margie Neuhaus
Dave Neuman
NYC Business Assistance Corp.
New York City Council
New York City Department of
 Cultural Affairs

New York Community Trust
New York Foundation for the Arts
New York State Council on
 the Arts
New York Subways Advertising Co.
New York Times Company
 Foundation
New York Wa$teMatch
New York Water Taxi
Meir Newman
Newman's Own Foundation
Next Level Floral Design, Inc.
Midori Nishizawa
The Noguchi Museum
The Nolan-Lehr Group
Nollette Studios
Nolton Paper Co.
Richard Nonas
NOR-COLE
The November Fund
NYC & Co.
New York City Department of
 Youth Services
New York State Artists Workspace
 Consortium
Ralph S. O'Connor
Ocularis
Oil & Steel Gallery
New York City Department of
 Parks & Recreation
Luis Angel Parra
Partnership for After School
 Education
Partnership for Parks
Peter Pastreich
PDC Truck and Equipment Leasing
David & Ellen Peretz
Perfection Electricks
Joel Pesapane
Steve Peters
John P. Picone, Inc.

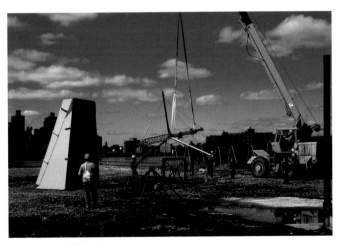

Installing Scott Gilliam's *BIG JU-JU
(Big Spirit)*, 1989

Mayor Ed Koch
and Diane M. Coffey at the
opening of "Sculpture:
Walk On/Sit Down/
Go Through," 1987

Pier 63 Maritime
Diane Pieri
The Pincus Charitable Fund
Plant Specialists
Platform Furniture
PMI
Poles McCarthy
The Pollock-Krasner Foundation
Prest-o-Sales & Service, Inc.
Product and Design
The Puffin Foundation
PUMA
Putumayo World Music
Quality Concrete of NY, Inc.
The Queens Council on the Arts
Queensboro Fence Co., Inc.
Quinn David Stamatiades Funeral
 Home
R.R. Lalena Corporation
Brooke Kamin & Richard A.
 Rapaport
Rapid Steel Supply Corp.
Carl Rapoport
Reed College
Reed Foundation
Anna Reischop
Richards & O'Neil LLP
Rock Solid Assoc., Inc.
The Ross Foundation
Royal Scapes Corp.
Oscar M. Ruebhausen Commission
 of the Greenwall Foundation
Rutt Video & Internet
Ronald Salberg
Saloon Hair Salon
Irving & Lucy Sandler
Scharff Weisberg
Roland Schinzinger
Deborah Schwartz
Kenneth Schweber
Seymour & Laura Schweber
Robert C. Scull Foundation
Sculpture Space
Seating Solutions
Security Delivery Service, Inc.
Rev. Alfred R. Shands III
Shell Foundation
John Shin & Marcia Gregory
The Jerry and Cecile Shore Fund
Charles B. Short
Showtime Networks

SignExpo TriBeCa
Richard & Steven Silver
Silvercup Studios
Skanska Slattery Associates
Bennie Slome Charitable
 Foundation
Mr. & Mrs. Thomas W. Smith
 Foundation
Smithsonian Institution
Snyder's Tree Farm
William Soghor
Soros Foundation
Spacetime C.C.
Standard Screen Supply
Janice Stanton & Ronald Windisch
Starbucks Coffee
Starry Night Fund of Tides
 Foundation
Wylie M. Stecklow
Steelcase, Inc.
Stellar Printing
Robert Sterling Clark Foundation
Phyllis Stigliano
Stillwell Supply Corp.
Storm King Art Center
Stroom HCBK
Marion Stroud
Strypemonde Foundation
Styche and Associates, Inc.
Alan Sussman
Tai Chi Society
D.H. Taylor

Dirk Van Dall
Chandra M. Varma
Gerda Veneman
Verizon
Video Data Bank
von Rydingsvard & Greengard
 Foundation
Paul Wallach
The Andy Warhol Foundation for
 the Visual Arts
The Water's Edge Restaurant
John Weber
Welpak
Paige West
Whitney Museum of American Art
Susanne Wibroe
Jeannette Wilkens
Chris Wilmarth
Working Waterfront Association
Corrina Wright
Yale University
YMS Management Assoc.
York Ladder, Inc.
Irene Young
Zabriske Gallery
Vicki Zubovic
and Anonymous Donors

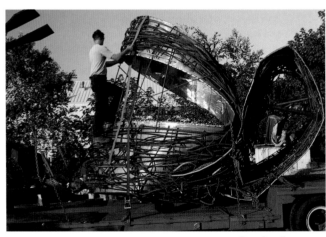

Peter Lundberg, 1997

Merle Temkin
K&D Thompson
Thypin Steel
Peter Tilgner
Tin Man Fund
The Roy and Niuta Titus
 Foundation
Tom Cat Bakery, Inc.
Trust for Public Land
The Tulip Fund
The Urban Latino Magazine
Palma Valverde
Van Alst Hardware

Awards

1985 The Art Commission of the City of New York Special Recognition Award to the Athena Foundation in cooperation with Mark di Suvero and Isamu Noguchi for Socrates Sculpture Space, a project of the Department of Parks and Terminals

1987 Doris Freedman Award awarded by the Mayor of the City of New York for greatly enriching the public environment

1988 Albert S. Bard Award of Merit for Excellence in Architecture & Urban Design from the City Club of New York

1995 Great American Public Place selected by Gianni Longo and the Lyndhurst Foundation from over 200 nominated locations from around the country that are exemplary models of our built environment

1998 America the Beautiful Fund National Recognition Award by the Natural Area Council for helping to protect the beauty of our nation

1998 Citation of Honor, Office of the President, Borough of Queens, City of New York presented to Mark di Suvero, Founder, Socrates Sculpture Park

2000 American Institute of Architects New York Chapter Special Citation in recognition for the Park's leading role in the artistic, educational and community realms of New York City and as the only public outdoor space exclusively dedicated to the creation and display of sculpture in New York City

2000 New York State Governor's Arts Award awarded by the New York State Council on the Arts for significant contributions to artistic life in the State of New York

2003 Downstate Organization Award awarded by the Alliance of New York State Arts Organizations for advancing cultural development in New York State

2004 New York City Neighborhood Development Achievement Award awarded by the City of New York Department of Small Business Services for Outstanding Achievement in Community Development

Notes on the Contributors

ALYSON BAKER is executive director of Socrates Sculpture Park.

DIANA BALMORI is a landscape architect and principal of Balmori Associates.

STEVEN L. COHEN is a research scientist working on developing vaccines. He has been photographing Socrates Sculpture Park for twenty years.

MARK DI SUVERO is an artist and the founder of Socrates Sculpture Park.

ROBYN DONOHUE is the exhibition program coordinator of Socrates Sculpture Park.

KATHLEEN GILRAIN is the executive director of Smack Mellon and was the director of Socrates Sculpture Park from 1995 to 2000.

THOMAS HANRAHAN is an architect with hMa, hanrahan Meyers architects, New York City, and Dean of the School of Architecture at Pratt Institute, Brooklyn, New York.

JEFFREY KASTNER, senior editor of *Cabinet* magazine, is a New York–based critic and journalist whose writing on art and cultural issues has appeared in publications including *Artforum*, *The Economist*, and the *New York Times*, among others. Editor of *Land and Environmental Art* (1998) and co-editor of *Plop: Recent Projects of the Public Art Fund* (2004), Kastner was most recently co-editor of *Odd Lots: Revisiting Gordon Matta-Clark's Fake Estates* (2005).

KATE D. LEVIN is the commissioner of the NYC Department of Cultural Affairs.

IVANA MESTROVIC is the director of Spacetime C.C., Mark di Suvero's studio.

JOHN MORSE is an artist and a former Socrates Sculpture Park board member.

SARA REISMAN, a curator living in New York, curated "Float" (2003 and 2005) at Socrates Sculpture Park. She is the 2005–6 Joanne Leonhardt Cassullo curatorial fellow at the New Museum of Contemporary Art, New York.

IRVING SANDLER is an art critic and historian as well as a founding board member of Socrates. An expert on the New York School and Abstract Expressionism, Sandler is author of several books including: *The Triumph of American Painting: A History of Abstract Expressionism* (1970), *The New York School Painters and Sculptors of the Fifties* (1978), *American Art of the 1960's* (1988), *Mark di Suvero at Storm King Art Center* (1996) and, most recently, *A Sweeper Up After Artists, A Memoir* (2003). He has been a professor of art history at SUNY Purchase since 1971.

STUART MATCH SUNA is the president of Silvercup Studios and the chairman of Socrates Sculpture Park.

EVE SUSSMAN is an artist and was the director of Socrates Sculpture Park from 1993 to 1995.

COKE WISDOM O'NEAL, *Boo, Alyson, Deborah, Frankie, Robyn, Ché, Tara, Olive, Rachel*, 2006

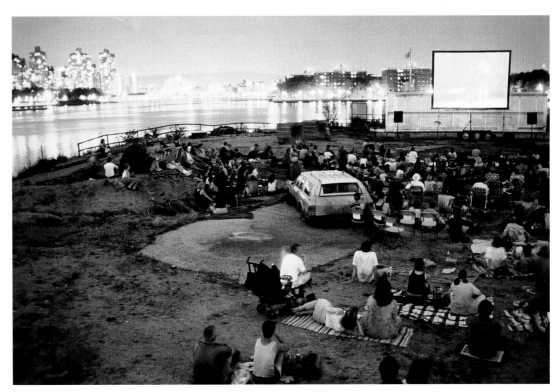

Outdoor cinema, 1999

Eve Sussman, left, and Kathleen Gilrain in the Socrates office, 1995

Credits

Project Director: Mary DelMonico
Design: Barbara Glauber and Emily Lessard/
Heavy Meta
Editorial Consultant: Sheila Schwartz
Editor: Lynn Scrabis
Proofreader: Richard G. Gallin
Printing and binding: Conti Tipocolor, Italy

Photograph credits

Steven L. Cohen: Cover, 1, 2–3, 4–5, 6–7, 12, 14, 34–35, 40–41, 44–45, 48–49, 50–51, 53, 55, 56, 61, 62–63, 67, 68, 72, 73, 76–77, 78–79, 80, 95 TOP, 96, 100–101, 102, 103, 104–105, 106, 109, 114, 117 TOP, 118, 119, 120 BOTTOM, 122, 126, 127, 128–129, 130, 132–133, 134, 136, 138, 139, 140–141, 144, 150, 151, 152, 156 BOTTOM, 161,162–163, 166–167, 168, 169, 172–173, 176, 177, 178–179, 180, 184, 185, 187, 188, 193, 196–197, 202, 205, 206–207, 208, 210–211, 213 BOTTOM, 216 TOP LEFT & BOTTOM, 218, 219, 223 BOTTOM, 224 TOP, 227, 231, 232 TOP, 233, 234 TOP & MIDDLE, 236 BOTTOM, 237, 238, 240; Alyson Baker: 157, 216 TOP RIGHT; Chris Baker: 182 TOP, 191, 201 BOTTOM, 201 TOP, 224 BOTTOM, 225; Peter Bellamy: 33, 71, 74, 75, 153; John Berens: 135, 137, 143; Stephanie Diamond: 220; Bilyana Dimitrova: 164, 171, 182 BOTTOM, 186, 192, 194, 195, 198, 199 LEFT, 199 RIGHT, 200; Robyn Donohue: 175, 190; Dominique Evrard: 46–47; Elaine Gan: 189; Kathleen Gilrain: 124; Audrey Gottlieb: 30–31; Richard Nonas: 32; Coke Wisdom O'Neal: 239 TOP; Pierre Plattier: 81, 90–91, 107, 110–111, 112, 113, 121, 123; David Tomono: 8–9, 24–25, 26, 27, 29; Socrates Sculpture Park archives: 16, 17, 18, 23, 28, 33, 36, 37, 38, 39, 42, 43, 52, 54, 59, 60, 65, 66, 69, 70, 82, 89, 92, 93, 94, 95 BOTTOM, 97, 99, 108,116, 117 BOTTOM, 120 TOP, 131 TOP & BOTTOM, 142 TOP & BOTTOM, 149, 154–155, 156 TOP, 158–159, 160, 165 TOP & BOTTOM, 174, 183, 212, 213 TOP, 214, 215, 217, 221, 222, 223 TOP, 226, 228, 229, 230, 232 BOTTOM, 234 BOTTOM, 235, 236 TOP, 239 MIDDLE & BOTTOM

Reproduction credits

© The Museo Chillida-Leku; © The Estate of Keith Haring; © The Isamu Noguchi Foundation and Garden Museum, New York, 2006; © Tom Otterness/ Licensed by VAGA, New York; © The George and Helen Segal Foundation/VAGA New York; © 2006 Estate of Tony Smith/Artist Rights Society (ARS), New York

Every effort has been made to credit the photographers and the sources; if there are errors or omissions, please contact Socrates Sculpture Park so that corrections can be made in any subsequent edition.

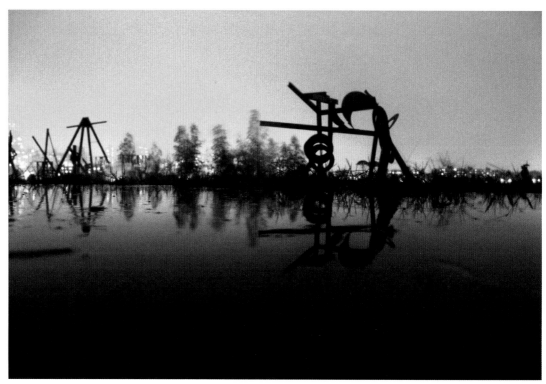

MARK DI SUVERO, *Lao Tzu*, 1992

DATE DUE

HIGHSMITH #45230

Printed
in USA